VISIONS
OF
_____ WONDER _____

In this volume of imagination and fantasy you will encounter:

RICHARD GARNETT's whimsical adventure of a pudgy little saint who enjoys cribbage and a spot of wine with a friendly demon.

ISAAC BASHEVIS SINGER's remarkable fantasy of an Earth which serves as a huge mortuary for the dear departed of Heaven.

CHARLES WILLIAMS' sinister vision of hell in an English country house, the only known short story by this master of fantasy.

JOHN AURELIO's magical encounter between four wonderful wizards and a most remarkable young man.

PAR LAGERKVIST's ironic tale of an adulterous couple who visit the underworld in an elevator.

A. E. COPPARD's charming fable of a simple man who unwittingly takes another man's sins into Heaven . . .

And nine other fantastic tales.

Other Avon Books edited by
Robert H. Boyer and Kenneth J. Zahorski

THE FANTASTIC IMAGINATION
THE FANTASTIC IMAGINATION, VOLUME II
THE PHOENIX TREE

VISIONS
OF
WONDER

An
Anthology
of Christian Fantasy

Edited by
ROBERT H. BOYER &
KENNETH J. ZAHORSKI

 AVON
PUBLISHERS OF BARD, CAMELOT, DISCUS AND FLARE BOOKS

VISIONS OF WONDER: AN ANTHOLOGY OF CHRISTIAN FANTASY is an original publication of Avon Books. This work has never before appeared in book form.

AVON BOOKS
A division of
The Hearst Corporation
959 Eighth Avenue
New York, New York 10019

First Avon Printing, October, 1981

AVON TRADEMARK REG. U. S. PAT. OFF. AND IN
OTHER COUNTRIES, MARCA REGISTRADA, HECHO EN
U. S. A.

Printed in the U. S. A.

WFH 10 9 8 7 6 5 4 3 2 1

To
The St. Norbert College Community

ACKNOWLEDGMENTS

George MacDonald, "The Castle: A Parable." Reprinted from Glenn Edward Sadler, ed., *The Gifts of the Child Christ: Fairy Tales and Stories for the Childlike*. Vol. I. (Grand Rapids, Michigan: William Eerdmans Publishing Co., 1973). Eerdmans copy reprinted from *Adela Cathcart*, 1864.

Richard Garnett, "The Bell of Saint Euschemon." Reprinted from *The Twilight of the Gods and Other Tales* (New York: Knopf, 1926).

Oscar Wilde, "The Fisherman and His Soul." Reprinted from *The Writings of Oscar Wilde* (New York: Wm. H. Wise & Company, 1931).

Selma Lagerlöf, "In the Temple," in *Christ Legends*. Translated by Velma Swanston Howard. Copyright 1908 by Holt, Rinehart and Winston. Copyright 1936 by Velma Swanston Howard. Reprinted by permission of Holt, Rinehart and Winston, Publishers.

Verner von Heidenstam, "St. Erik and the Abducted Maiden," in *The Swedes and Their Chieftains* (New York: The American-Scandinavian Foundation, 1925). Translated by Charles Wharton Stork. Reprinted by permission of the American-Scandinavian Foundation, 127 East 73 Street, New York, NY 10021.

Walter de la Mare, "The Giant," in *Eight Tales* (Sauk City, Wisconsin: Arkham House, 1971). Reprinted by permission of Arkham House Publishers, Inc., Sauk City.

Maurice Baring, "Dr. Faust's Last Day," in *Half a Minute's Silence and Other Stories* (London: William Heinemann Ltd., 1925). Reprinted by permission of A. P. Watt Ltd. and the Estate of Maurice Baring.

John Buchan, "The Rime of True Thomas," in *The Moon Endureth: Tales and Fancies* (London: Hodder and Stoughton, 1921). Reprinted by permission of A. P. Watt Ltd. and the Estate of Lord Tweedsmuir.

Acknowledgments

A. E. Coppard, "Simple Simon," in *The Black Dog and Other Stories* (London: Jonathan Cape, 1923). Reprinted by permission of David Higham Associates Ltd., Jonathan Cape Ltd., and the Estate of A. E. Coppard.

Kenneth Morris, "The Night of Al Kadr." Reprinted from *The Theosophical Path*, Vol. IX, July-December, 1915.

Charles Williams, "Et in Sempiternum Pereant," in *London Mercury*, Vol. 33, December 1935. Reprinted by permission of David Higham Associates Ltd.

Pär Lagerkvist, "The Lift That Went Down into Hell," in *The Eternal Smile and Other Stories* (New York: Random House, 1954). Reprinted by permission of Albert Bonniers Forlag AB.

Felix Marti-Ibañez, "Amigo Heliotropo," in *All the Wonders We Seek* (New York: Clarkson N. Potter, Inc.). Reprinted by permission of Curtis Brown, Ltd. © Copyright 1954, 1962, 1963 by Felix Marti-Ibañez, M.D.

Isaac Bashevis Singer, "Jachid and Jechidah." Reprinted by permission of Farrar, Straus and Giroux, Inc. "Jachid and Jechidah" from *Short Friday* by Isaac Bashevis Singer. Copyright © 1965 by Isaac Bashevis Singer.

John R. Aurelio, "The Greatest Feat." Reprinted from *Story Sunday* by John Aurelio. © Copyright, 1978 by The Missionary Society of St. Paul the Apostle in the State of New York. Used by permission of Paulist Press.

Vera Chapman, "With a Long Spoon." Copyright © 1981 by Vera Chapman. Printed by permission of Vera Chapman.

CONTENTS

PREFACE

We are grateful to several people who helped in various ways with *Visions of Wonder*. Terry Maguire, our research assistant, shortened our task considerably by screening out many titles from our initial list of possibilities. Terry, with the guidance of Donald L. Pieters, our reference librarian, also found valuable background material on many of the stories. Sister Laurie Ann Zelten started us thinking about Christian fantasy when she asked us to direct her readings for an independent study course in the subject. Roger Schlobin acquainted us with several important but little known sources for some of our stories through his praiseworthy book *The Literature of Fantasy: A Comprehensive Annotated Bibliography of Modern Fantasy Fiction* (1979). Peggy Schlapman deciphered our scribblings in her patient manner and performed her usual miracles in completing the typescript under the hurry-up schedule. Dean Robert L. Horn and the St. Norbert Community provided the support and encouragement that made the project so pleasant and meaningful. And finally, we thank our wives, who endured much, and with martyr-like patience, during our labors.

INTRODUCTION

The critic Edmund Fuller (in *Myth, Allegory, and Gospel,* John Warwick, ed.) once hinted that C. S. Lewis's *Chronicles of Narnia* might give young people a better understanding of Christianity than the textbooks they were required to read for that purpose. Although no work by C. S. Lewis is contained in this present volume, his type of Christian fantasy, in a general way, describes what readers will find here. Some of the stories are akin to the Biblical allegory of Lewis's Narnia books; others are closer to the religious satire of Lewis's *Screwtape Letters,* the correspondence between the devils Screwtape and Wormwood. What these references to Lewis mean, for readers unacquainted with his works, is that the sixteen modern short stories contained in *Visions of Wonder* are works of high fantasy whose contents reflect Christian beliefs and attitudes.

Not very long ago we were skeptical about the merits or even the viability of a volume of Christian fantasy. We were familiar with Lewis's works and also with the theological novels of Lewis's close friend Charles Williams, but these were all novels and the works of but two authors —hardly enough, however excellent and popular they were and are, to suggest a subgenre of fantasy. Only when we discovered the little known short story by Williams included here did we decide to look in earnest for other Christian works, and we did so for two reasons: we were delighted to have found a work by Williams suitable for anthologizing, and his story was so infused with Christian thought that it admitted of no label other than Christian fantasy. Somewhat to our surprise, our review of some of our favorite writers, authors whose works we had included in one or more of our previous anthologies, rewarded us with several stories that warranted the designation of Christian fantasy: works by George MacDonald, Selma Lagerlöf, and Vera Chapman. Encouraged, we looked

further and made some delightful new acquaintances: writers like Oscar Wilde, Walter de la Mare, and Pär Lagerkvist. In fact, although it is too late to include them in this volume, we are still meeting new writers—people like Calvin Miller, creator of the fine trilogy in narrative poetry that retells much of the New Testament: *The Singer, The Song, The Finale* (1975). For now, we are pleased that we were able finally to put all skepticism aside, realizing that we had located a whole body of short fiction that deserves to be better known, works that combine the attractions of fantasy literature and Christian thought or sentiment.

When we began to reflect on the stories that we had gathered, we recognized what should have been apparent much earlier: the close connection between religious belief and fantasy literature. Fantasy literature, by definition, contains events and creatures that admit of no rational explanation. Every body of religious belief includes such events and creatures, and the narratives that embody belief in such phenomena are in fact fantasies—myth fantasies, as here defined.

Myths and faery tales belong to the category of high fantasy, while such stories as tall tales, animal fables, and Thurber-type farces are included in the category of low fantasy. In the latter group the setting is the real, or primary, world, and the rationally unexplainable phenomena have no assignable cause; they are simply anomalies. In high fantasy, by contrast, the setting is a secondary world, set apart from our familiar one, in which rationally unexplainable elements find a proper explanation in terms of magical (faery tales) or supernatural (myths) causality. The biblical narratives and later Christian narratives are in reality myth fantasies. Heaven and hell, as well as temples and other sacred places, are the secondary worlds. God and his messengers—saints, angels, and even devils (who can act only with God's permission)—provide the supernatural causality. The fact that these works are fantasies does not, of course, lessen the truths that they convey or belittle the faith that they nourish.

Another even more apparent connection between fantasy and religion is the historical one between fantasy literature and Christianity, a glowing relationship indeed. Using the

biblical narratives, so rich in allegory, as their models, early Christian writers realized the value of the narrative as both a repository of belief and an effective way of communicating such belief. Also, such writing was devotional and intended to inspire similar feelings in the audience. Thus developed Christian medieval drama; the voluminous romances of the Holy Grail; the works of Dante, Chaucer, Milton, and others down to our present day and the likes of Lewis and Williams. The saint's legend, so widespread and enduring throughout the history of the Christian Church, developed as both a popular and a literary form. As Max Luthi explains in *Once Upon a Time* (1970), the origins of the saint's legend, including the Miracles of the Virgin and the apocryphal tales about Christ, are akin to those of the local legend and the faery tale, deriving from the beliefs and superstitions of the people. The Church, however, approved of the saint's legends but frowned on the other two forms. Local legends and even saint's legends frequently dealt with the devil and various aspects of demonology, and these gave rise to a large number of tales involving the devil, such as the ubiquitous Faust legend. Some of these were approved by the Church, but many that were not still persisted, containing a strong appeal to the medieval mind, an appeal that still prevails.

The stories in *Visions of Wonder* are a part of this impressive literary tradition of Christian fantasy. They fall easily into one or another of the categories, just noted, of biblical allegories or parables, such as "The Castle"; saint's legends, such as "St. Eric"; and stories about the devil, such as "Dr. Faust's Last Day." Two of the stories, "The Fisherman and His Soul" and "The Rime of True Thomas," are faery tales within a Christian context, bringing the magic of faerie into either conflict or uneasy coexistence with the supernatural powers of God and his saints. These categories do not, however, exhaust the riches of the stories in terms of religious content. Three non-Christian writers are represented here: the Jewish writer Isaac Bashevis Singer, the theosophist Kenneth Morris, and the "religious atheist" Pär Lagerkvist. Their stories offer intriguing and sympathetic perspectives on the Christian tradition.

While the designation as Christian fantasy has been the

15

primary criterion used in the selection of stories for *Visions of Wonder*, it has not been the sole one; all of the stories included here are also high-quality literature. As in our first three Avon volumes, we have selected only stories that are effective both as literature and as fantasy. While it may be possible for a story to be of poor quality as literature and yet effective and successful as fantasy, we have avoided including such writings. In brief, our goal has been to consider seriously only those works that will hold up under the careful scrutiny of the discerning reader.

We have also attempted to incorporate a wide variety of fantasy authors whose work covers a broad span of time. Approximately 125 years of literary endeavor in the area of fantasy literature is represented here. The earliest story is George MacDonald's "The Castle: A Parable," first printed in the collection *Adela Cathcart* (1864), and the most recent is Vera Chapman's "With a Long Spoon" (1980), written expressly for this volume. Interestingly, while authors from both sides of the Atlantic are represented here, the majority are English rather than American. No doubt there are literary, theological, and sociological reasons for the abundance of Christian fantasy in British literature and the comparative lack of it in our own, but they must be explored some other time, in some other place.

Another of our goals has been to include as many selections as possible of relatively inaccessible stories and stories that for various reasons have over the years been neglected. Perhaps the most dramatic example is that of Charles Williams's "Et in Sempiternum Pereant," which, to the best of our knowledge, is seeing its first reprinting since its initial appearance in a 1935 issue of *The London Mercury*. Also difficult to locate and obtain is Selma Lagerlöf's "In the Temple," a well-crafted and touching Christian fantasy tucked away in *Christ Legends*, a 1908 volume that most libraries have now relegated to their rare-book collections. Well worth the search, but also difficult to find, are Verner von Heidenstam's *The Swedes and Their Chieftains* (1925) and Richard Garnett's *The Twilight of the Gods and Other Tales* (1926), two rich repositories of excellent short fantasy fiction that contain, respectively, "St. Erik and the Abducted Maiden" and

"The Bell of Saint Euschemon." Both A. E. Coppard and Maurice Baring are examples of writers who are quite popular and well known in their native England but who suffer from a lack of exposure and recognition in our own country. Although the novels of Pär Lagerkvist—especially his *Barabbas* (1950)—are well known throughout the Western world, his short stories, like the unforgettable "The Lift That Went Down into Hell," are not. Our campaign for further critical and popular recognition of Kenneth Morris's extraordinary accomplishments in the genre continues, as does our crusade to introduce more readers to the works of Felix Marti-Ibañez, whose "Amigo Heliotropo" is just one of the thirteen tales of "surprise and prodigy" collected in *All the Wonders We Seek* (1954).

Since 1975, when we began work on our first Avon anthology, *The Fantastic Imagination,* we have read thousands of fantasy tales. Perhaps our most pleasant discovery during this long period of exploration has been the rich diversity that exists within the genre. In *Visions of Wonder,* as in our preceding anthologies, we have attempted to take full advantage of this diversity by selecting stories that display a wide variety of settings, characters, themes, and style.

When we began our search for Christian fantasies we expected to find many stories utilizing the backdrops of heaven and hell. We did find some, but not nearly as many as we expected, and those we did find offered a gratifying variety of treatments, quickly erasing our fears of redundancy. Garnett's Paradise, for example, is a place where the saints engage in rather rowdy drinking parties, while the heaven that Coppard's Simple Simon gets to in a lift is wonderfully serene, a paradisal Xerox copy of his favorite earthly home. The descriptions of hell in Lagerkvist's "Lift" and Williams's "Et in Sempiternum Pereant" also differ, but each in its own way is a masterpiece of grotesquery. Lagerkvist's hell, which like Coppard's heaven is reached by means of an elevator, is a "modernized" nether world depicted in terms of a horribly sleazy, greasy flophouse, reminiscent of the wasteland landscape through which J. Alfred Prufrock passes on his way to the room where the "women come and go/Talking of Michelangelo." Fully as unpleasant is the Dantesque hell so vividly de-

scribed in Williams's "Et in Sempiternum Pereant," but whereas Mr. Smith and his tart must descend by elevator far below the earth's crust to reach hell, Lord Arglay unsuspectingly discovers it in a rather innocuous-looking cottage in the tranquil English countryside. But there are many other interesting realms between heaven and hell, like the marvelous Temple in Lagerlöf's story, and our authors explore several of them. Readers of *Visions of Wonder* will discover many fantastic secondary worlds on, above, and below the face of the earth.

As might be expected, these diverse and exotic settings are inhabited by equally diverse and exotic beings: some are mortals, some are gods, and some hail from the fantastic realm of faerie. A character who appears most frequently, however, and who is certainly one of the most fascinating, is the devil. True to mythical form, he appears in sundry guises. In Wilde's "The Fisherman and His Soul," for example, he appears at a witches' sabbath as a handsome Spanish caballero resplendent in plumed hat, suit of black velvet, and riding gloves "gauntleted with gilt lace"; also "strangely handsome in a swarthy and shadowed way" is Chapman's Satan, a charming and smooth-talking fiend who has a clandestine rendezvous with the adventurous Abbess of Shaston in "With a Long Spoon"; more monstrous, however, are the two devils featured in Lagerkvist's "Lift": one, apparently *the* Devil, is "stylishly dressed in tails" that grotesquely hang on the "hairy top" of his vertebra, "as on a rusty nail," while the second, one of the Devil's minions, is "fat, fawning, with large breasts and purple powder caked on the moustache around her mouth," while "around the horns in her forehead she [has] twined tufts of hair . . . fastened . . . with small blue silk ribbons." Fortunately, not all of the angels in our selections are fallen. The heavenly variety are also represented, and here again there is great diversity in treatment. While the heavenly visitant that Peter sees in de la Mare's "The Giant" is magnificent and stately, with eyes as "pure as the white flame of the Holy Ones," the angel San Miguel, in Marti-Ibañez's "Amigo Heliotropo," appears on earth as a "tall, emaciated" young man with a "gaunt dark face," who, at times, displays clumsiness and uncertainty. An anthology of Christian fantasy would, of course, be incomplete without

a selection or two with Christ as a character. Two such tales are John Aurelio's "The Greatest Feat," where Christ makes His appearance in a brief, rather ambiguous fashion, and Lagerlöf's "In the Temple," where Christ appears as a twelve-year-old boy.

The themes of our Christian fantasy selections are both substantive and provocative. Most, as might be expected, deal with the conflict between good and evil. In those stories featuring devil figures, as in Chapman's "Long Spoon" and Baring's "Dr. Faust's Last Day," the motif of the temptation of evil is prominent. Balancing this motif is the equally prominent one of the transforming power of love, which is especially well treated in "The Fisherman and His Soul" and "Amigo Heliotropo." Not all of our authors are content with a serious approach, however; more whimsical and satirical treatments of good and evil are found in "Simple Simon" and "The Bell of Saint Eusche-mon."

Stylistic contrasts abound in *Visions of Wonder*. What a difference, for example, between the spare, almost telegraphic, prose style of Verner von Heidenstam's "St. Erik," and the dense, sometimes tortuous and convoluted style of Williams's "Et in Sempiternum Pereant." What a difference, too, between the Horatian satire and elfish whimsicality characteristic of both Garnett and Coppard and the serious, parable-like quality of Lagerlöf's "In the Temple." While it is true that both Marti-Ibañez and Lagerkvist are alike in their splendid handling of imagery, the former concentrates on images of purity and light, while the latter focuses on repulsive visual, tactile, and olfactory imagery that makes the reader feel a desperate need for a cleansing shower. Then, too, there is the stately verbal architecture of MacDonald's allegorical "The Castle" standing in rather sharp contrast to the undulating, spontaneous rhythms of John Buchan's "The Rime of True Thomas." *Visions of Wonder* is truly a stylistic sampler, with something for nearly every taste.

In conclusion, we should take note of the effect of fantasy, and especially of Christian fantasy. When Tolkien talks about fantasy in his essay "On Fairy-Stories," he singles out the "Consolation of the Happy Ending" as the source of the "joy, which is one of the things that fairy-

stories can produce supremely well." It is in this context that he coins the term *eucatastrophe* (good catastrophe) to further explain the happy ending. While eucatastrophe recognizes that evil occurs in the secondary world of faerie, it also recognizes at least by implication that the story doesn't end there. As Tolkein puts it, eucatastrophe denies "universal final defeat and in so far is *evangelium*," that is, gospel or good news. In other words, the eucatastrophe or consolation of the faery tale or of fantasy is similar to that of the Gospels, especially the narrative of the Resurrection. Indeed, to quote Tolkien once again, "the Gospels contain a fairy-story, or a story of a larger kind which embraces all the essence of fairy-stories." The Gospels contain many marvels "and among the marvels is the greatest and most complete conceivable eucatastrophe," and thus the greatest source of "joy."

George MacDonald

(1824–1905)

If one were to nominate a candidate for father of modern fantasy, George MacDonald would be a leading contender, on the basis of dates, number, and influence of his faery tales. At the same time, MacDonald's fantasies are infused with Christianity. *Phantastes,* 1858, an adult work and his first fantasy was the work that C. S. Lewis credited with the baptism of his imagination. The two Curdie books, *The Princess and the Goblin* (1872) and *The Princess and Curdie,* were early formative influences on W. H. Auden and J. R. R. Tolkien. *At the Back of the North Wind* (1871) has been a steady favorite with children and discerning adults for over a hundred years. The demand for MacDonald's works has resulted in two fine collections that have recently made his short stories more accessible: *The Gifts of the Child Christ: Fairy Tales and Stories for the Childlike* (1973) and *The Complete Fairy Tales of George MacDonald* (1977). Most recently Glenn Sadler has resurrected *The Portent* (1979), a story involving second sight, originally published in 1864, and he has edited *The Fairy Stories of George MacDonald* in four volumes (1980). No volume with "Christian fantasy" in its title would be thinkable without a selection by George MacDonald.

George MacDonald, Scottish clergyman, poet, novelist, essayist, and writer of fairy tales, was born in Huntly, Aberdeenshire, the son of a farmer. He attended Aberdeen University from 1840–1845, where he took prizes in chemistry and natural philosophy. After preparing for the ministry at Independent College, Highbury, he assumed his duties as Congregationalist pastor at Arundel, England, in 1850. Mainly because of theological disagreements with his congregation, MacDonald left the ministry after three years and became a writer, teacher, and lecturer. He made

a highly successful lecture tour of the United States in 1872–1873, speaking on literary and theological topics. So successful was he that he was offered a lucrative pastorate in New York City. He preferred, however, to return to England, where he was less wealthy but more at home. Despite nagging poverty, ill health, and the loss of four of his eleven children, MacDonald led a full, vigorous, and rewarding life, for him most rewarding when reading one of his faery tales to his adoring family.

While MacDonald's children's stories combine a delightful verbal and satiric humor with serious considerations, his adult fantasies are typically more reflective and directly religious. Such is the case with "The Castle: A Parable." As the title indicates, the story is a parable, and as such employs various levels of meaning, literal and allegorical. On the literal level, the story and its theme are quite accessible. On the level of allegory, two interpretations work together quite nicely, one philosophical and one biblical. In terms of philosophy, the equations between characters and abstractions are fairly clear-cut: the elder brother is reason, concerned with truth; the eldest sister is imagination, whose object is beauty; the rebellious siblings are the senses, in quest of pleasures and freedom from restraint. Only when the proper hierarchy prevails, however, can true freedom be had. In biblical terms, the equations of characters with virtues are not so refined. The symbolism is considerably more complex. Basically, however, one recognizes intellectually and responds affectively to the biblical-archetypal elements of temptation and fall, death and resurrection, flood and rainbow. Note that the biblical allegory merges Old and New Testaments. While the story offers none of the MacDonald humor, it does illustrate another of his trademarks, a brilliant use of imagery and detail, as the descriptions of the castle and of the thunderstorm demonstrate.

THE CASTLE: A PARABLE

by George MacDonald

On the top of a high cliff, forming part of the base of a great mountain, stood a lofty castle. When or how it was built, no man knew; nor could anyone pretend to understand its architecture. Everyone who looked upon it felt that it was lordly and noble; and where one part seemed not to agree with another, the wise and modest dared not to call them incongruous, but presumed that the whole might be constructed on some higher principle of architecture than they yet understood. What helped them to this conclusion was, that no one had ever seen the whole of the edifice; that, even of the portion best known, some part or other was always wrapt in thick folds of mist from the mountain; and that, when the sun shone upon this mist, the parts of the building that appeared through the vaporous veil, were strangely glorified in their indistinctness, so that they seemed to belong to some aerial abode in the land of the sunset; and the beholders could hardly tell whether they had ever seen them before, or whether they were now for the first time partially revealed.

Nor, although it was inhabited, could certain information be procured as to its internal construction. Those who dwelt in it often discovered rooms they had never entered before; yea, once or twice, whole suites of apartments, of which only dim legends had been handed down from former times. Some of them expected to find, one day, secret places, filled with treasures of wondrous jewels, amongst which they hoped to light upon Solomon's ring, which had for ages disappeared from the earth, but which had controlled the spirits, and the possession of which made a man simply what a man should be, the king of the world. Now and then, a narrow, winding stair, hitherto untrodden, would bring them forth on a new turret, whence new prospects of the

circumjacent country were spread out before them. How many more of these there might be, or how much loftier, no one could tell. Nor could the foundations of the castle in the rock on which it was built be determined with the smallest approach to precision. Those of the family who had given themselves to exploring in that direction, found such a labyrinth of vaults and passages, and endless successions of down-going stairs, out of one underground space into a yet lower, that they came to the conclusion that at least the whole mountain was perforated and honeycombed in this fashion. They had a dim consciousness, too, of the presence, in those awful regions, of beings whom they could not comprehend. Once, they came upon the brink of a great black gulf, in which the eye could see nothing but darkness: they recoiled in horror; for the conviction flashed upon them that that gulf went down into the very central spaces of the earth, of which they had hitherto been wandering only in the upper crust; nay, that the seething blackness before them had relations mysterious, and beyond human comprehension, with the far-off voids of space, into which the stars dare not enter.

At the foot of the cliff whereon the castle stood, lay a deep lake, inaccessible save by a few avenues, being surrounded on all sides with precipices, which made the water look very black, although it was as pure as the night sky. From a door in the castle, which was not to be otherwise entered, a broad flight of steps, cut in the rock, went down to the lake, and disappeared below its surface. Some thought the steps went to the very bottom of the water.

Now in this castle there dwelt a large family of brothers and sisters. They had never seen their father or mother. The younger had been educated by the elder, and these by an unseen care and ministration, about the sources of which they had, somehow or other, troubled themselves very little, for what people are accustomed to, they regard as coming from nobody; as if help and progress and joy and love were the natural crops of Chaos or old Night. But Tradition said that one day—it was utterly uncertain *when* —their father would come, and leave them no more; for he was still alive, though where he lived nobody knew. In the meantime all the rest had to obey their eldest brother, and listen to his counsels.

But almost all the family was very fond of liberty, as they called it; and liked to run up and down, hither and thither, roving about, with neither law nor order, just as they pleased. So they could not endure their brother's tyranny, as they called it. At one time they said that he was only one of themselves, and therefore they would not obey him; at another, that he was not like them, and could not understand them, and *therefore* they would not obey him. Yet, sometimes, when he came and looked them full in the face, they were terrified, and dared not disobey, for he was stately, and stern and strong. Not one of them loved him heartily, except the eldest sister, who was very beautiful and silent, and whose eyes shone as if light lay somewhere deep behind them. Even she, although she loved him, thought him very hard sometimes; for when he had once said a thing plainly, he could not be persuaded to think it over again. So even she forgot him sometimes, and went her own ways, and enjoyed herself without him. Most of them regarded him as a sort of watchman, whose business it was to keep them in order; and so they were indignant and disliked him. Yet they all had a secret feeling that they ought to be subject to him; and after any particular act of disregard, none of them could think, with any peace, of the old story about the return of their father to his house. But indeed they never thought much about it, or about their father at all; for how could those who cared so little for their brother, whom they saw every day, care for their father whom they had never seen?—One chief cause of complaint against him was, that he interfered with their favorite studies and pursuits; whereas he only sought to make them give up trifling with earnest things, and seek for truth, and not for amusement, from the many wonders around them. He did not want them to turn to other studies, or to eschew pleasures; but, in those studies, to seek the highest things most, and other things in proportion to their true worth and nobleness. This could not fail to be distasteful to those who did not care for what was higher than they. And so matters went on for a time. They thought they could do better without their brother; and their brother knew they could not do at all without him, and tried to fulfill the charge committed into his hands.

At length, one day, for the thought seemed to strike

them simultaneously, they conferred together about giving a great entertainment in their grandest rooms to any of their neighbors who chose to come, or indeed to any inhabitants of the earth or air who would visit them. They were too proud to reflect that some company might defile even the dwellers in what was undoubtedly the finest palace on the face of the earth. But what made the thing worse, was, that the old tradition said that these rooms were to be kept entirely for the use of the owner of the castle. And, indeed, whenever they entered them, such was the effect of their loftiness and grandeur upon their minds, that they always thought of the old story, and could not help believing it. Nor would the brother permit them to forget it now; but, appearing suddenly amongst them, when they had no expectation of being interrupted by him, he rebuked them, both for the indiscriminate nature of their invitation, and for the intention of introducing anyone, not to speak of some who would doubtless make their appearance on the evening in question, into the rooms kept sacred for the use of the unknown father. But by this time their talk with each other had so excited their expectations of enjoyment, which had previously been strong enough, that anger sprung up within them at the thought of being deprived of their hopes, and they looked each other in the eyes; and the look said: "We are many, and he is one—let us get rid of him, for he is always finding fault, and thwarting us in the most innocent pleasures;—as if we would wish to do anything wrong!" So without a word spoken, they rushed upon him; and although he was stronger than any of them, and struggled hard at first, yet they overcame him at last. Indeed some of them thought he yielded to their violence long before they had the mastery of him; and this very submission terrified the more tender-hearted among them. However, they bound him, carried him down many stairs, and, having remembered an iron staple in the wall of a certain vault, with a thick rusty chain attached to it, they bore him thither, and made the chain fast around him. There they left him, shutting the great gnarring brazen door of the vault, as they departed for the upper regions of the castle.

Now all was in a tumult of preparation. Everyone was talking of the coming festivity; but no one spoke of the

deed they had done. A sudden paleness overspread the face, now of one, and now of another; but it passed away, and no one took any notice of it; they only plied the task of the moment the more energetically. Messengers were sent far and near, not to individuals or families, but publishing in all places of concourse a general invitation to any who chose to come on a certain day, and partake for certain succeeding days, of the hospitality of the dwellers in the castle. Many were the preparations immediately begun for complying with the invitation. But the noblest of their neighbors refused to appear; not from pride, but because of the unsuitableness and carelessness of such a mode. With some of them it was an old condition in the tenure of their estates, that they should go to no one's dwelling except visited in person, and expressly solicited. Others, knowing what sorts of persons would be there, and that, from a certain physical antipathy, they could scarcely breathe in their company, made up their minds at once not to go. Yet multitudes, many of them beautiful and innocent as well as gay, resolved to appear.

Meanwhile the great rooms of the castle were got in readiness—that is, they proceeded to deface them with decorations; for there was a solemnity and stateliness about them in their ordinary condition, which was at once felt to be unsuitable for the lighthearted company so soon to move about in them with the self-same carelessness with which men walk abroad within the great heavens and hills and clouds. One day, while the workmen were busy, the eldest sister, of whom I have already spoken, happened to enter, she knew not why. Suddenly the great idea of the mighty halls dawned upon her, and filled her soul. The so-called decorations vanished from her view, and she felt as if she stood in her father's presence. She was at once elevated and humbled. As suddenly the idea faded and fled, and she beheld but the gaudy festoons and draperies and paintings which disfigured the grandeur. She wept and sped away. Now it was too late to interfere, and things must take their course. She would have been but a Cassandra-prophetess to those who saw but the pleasure before them. She had not been present when her brother was imprisoned; and indeed for some days had been so wrapt in her own business, that she had taken but little heed of anything that was going

on. But they all expected her to show herself when the company was gathered; and they had applied to her for advice at various times during their operations.

At length the expected hour arrived, and the company began to assemble. It was a warm summer evening. The dark lake reflected the rose-colored clouds in the west, and through the flush rowed many gaily-painted boats, with various colored flags, towards the massy rock on which the castle stood. The trees and flowers seemed already asleep, and breathing forth their sweet dream-breath. Laughter and low voices rose from the breast of the lake to the ears of the youths and maidens looking forth expectant from the lofty windows. They went down to the broad platform at the top of the stairs in front of the door to receive their visitors. By degrees the festivities of the evening commenced. The same smiles flew forth both at eyes and lips, darting like beams through the gathering crowd. Music, from unseen sources, now rolled in billows, now crept in ripples through the sea of air that filled the lofty rooms. And in the dancing halls, when hand took hand, and form and motion were moulded and swayed by the indwelling music, it governed not these alone, but, as the ruling spirit of the place, every new burst of music for a new dance swept before it a new and accordant odor, and dyed the flames that glowed in the lofty lamps with a new and accordant stain. The floors bent beneath the feet of the time-keeping dancers. But twice in the evening some of the inmates started, and the pallor occasionally common to the household overspread their faces, for they felt underneath them a counter-motion to the dance, as if the floor rose slightly to answer their feet. And all the time their brother lay below in the dungeon, like John the Baptist in the castle of Herod, when the lords and captains sat around, and the daughter of Herodias danced before them. Outside, all around the castle, brooded the dark night unheeded; for the clouds had come up from all sides, and were crowding together overhead. In the unfrequent pauses of the music, they might have heard, now and then, the gusty rush of a lonely wind, coming and going no one could know whence or whither, born and dying unexpected and unregarded.

But when the festivities were at their height, when the external and passing confidence which is produced between

superficial natures by a common pleasure, was at the full, a sudden crash of thunder quelled the music, as the thunder quells the noise of the uplifted sea. The windows were driven in, and torrents of rain, carried in the folds of a rushing wind, poured into the halls. The lights were swept away; and the great rooms, now dark within, were darkened yet more by the dazzling shoots of flame from the vault of blackness overhead. Those that ventured to look out of the windows saw, in the blue brilliancy of the quick-following jets of lightning, the lake at the foot of the rock, ordinarily so still and so dark, lighted up, not on the surface only, but down to half its depth; so that, as it tossed in the wind, like a tortured set of writhing flames, or incandescent half-molten serpents of brass, they could not tell whether a strong phosphorescence did not issue from the transparent body of the waters, as if earth and sky lightened together, one consenting source of flaming utterance.

Sad was the condition of the late plastic mass of living form that had flowed into shape at the will and law of the music. Broken into individuals, the common transfusing spirit withdrawn, they stood drenched, cold, and benumbed, with clinging garments; light, order, harmony, purpose departed, and chaos restored; the issuings of life turned back on their sources, chilly and dead. And in every heart reigned that falsest of despairing convictions, that this was the only reality, and that was but a dream. The eldest sister stood with clasped hands and down-bent head, shivering and speechless, as if waiting for something to follow. Nor did she wait long. A terrible flash and thunderpeal made the castle rock; and in the pausing silence that followed, her quick sense heard the rattling of a chain far off, deep down; and soon the sound of heavy footsteps, accompanied with the clanking of iron, reached her ear. She felt that her brother was at hand. Even in the darkness, and amidst the bellowing of another deep-bosomed cloud-monster, she knew that he had entered the room. A moment after, a continuous pulsation of angry blue light began, which, lasting for some moments, revealed him standing amidst them, gaunt, haggard, and motionless; his hair and beard untrimmed, his face ghastly, his eyes large and hollow. The light seemed to gather around him as a center. Indeed some believed that it throbbed and radiated from his person, and

not from the stormy heavens above them. The lightning had rent the wall of his prison, and released the iron staple of his chain, which he had wound about him like a girdle. In his hand he carried an iron fetter-bar, which he had found on the floor of the vault. More terrified at his aspect than at all the violence of the storm, the visitors, with many a shriek and cry, rushed out into the tempestuous night. By degrees, the storm died away. Its last flash revealed the forms of the brothers and sisters lying prostrate, with their faces on the floor, and that fearful shape standing motionless amidst them still.

Morning dawned, and there they lay, and there he stood. But at a word from him, they arose and went about their various duties, though listlessly enough. The eldest sister was the last to rise; and when she did, it was only by a terrible effort that she was able to reach her room, where she fell again on the floor. There she remained lying for days. The brother caused the doors of the great suite of rooms to be closed, leaving them just as they were, with all the childish adornment scattered about, and the rain still falling in through the shattered windows. "Thus let them lie," said he, "till the rain and frost have cleansed them of paint and drapery: no storm can hurt the pillars and arches of these halls."

The hours of this day went heavily. The storm was gone, but the rain was left; the passion had departed, but the tears remained behind. Dull and dark the low misty clouds brooded over the castle and the lake, and shut out all the neighborhood. Even if they had climbed to the loftiest known turret, they would have found it swathed in a garment of clinging vapor, affording no refreshment to the eye, and no hope to the heart. There was one lofty tower that rose sheer a hundred feet above the rest, and from which the fog could have been seen lying in a gray mass beneath; but that tower they had not yet discovered, nor another close beside it, the top of which was never seen, nor could be, for the highest clouds of heaven clustered continually around it. The rain fell continuously, though not heavily, without; and within, too, there were clouds from which dropped the tears which are the rain of the spirit. All the good of life seemed for the time departed,

and their souls lived but as leafless trees that had forgotten the joy of the summer, and whom no wind prophetic of spring had yet visited. They moved about mechanically, and had not strength enough left to wish to die.

The next day the clouds were higher, and a little wind blew through such loopholes in the turrets as the false improvements of the inmates had not yet filled with glass, shutting out, as the storm, so the serene visitings of the heavens. Throughout the day, the brother took various opportunities of addressing a gentle command, now to one and now to another of his family. It was obeyed in silence. The wind blew fresher through the loopholes and the shattered windows of the great rooms, and found its way, by unknown passages, to faces and eyes hot with weeping. It cooled and blessed them.—When the sun arose the next day, it was in a clear sky.

By degrees, everything fell into the regularity of subordination. With the subordination came increase of freedom. The steps of the more youthful of the family were heard on the stairs and in the corridors more light and quick than ever before. Their brother had lost the terrors of aspect produced by his confinement, and his commands were issued more gently, and oftener with a smile, than in all their previous history. By degrees his presence was universally felt through the house. It was no surprise to anyone at his studies, to see him by his side when he lifted up his eyes, though he had not before known that he was in the room. And although some dread still remained, it was rapidly vanishing before the advances of a firm friendship. Without immediately ordering their labors, he always influenced them, and often altered their direction and objects. The change soon evident in the household was remarkable. A simpler, nobler expression was visible on all the countenances. The voices of the men were deeper, and yet seemed by their very depth more feminine than before; while the voices of the women were softer and sweeter, and at the same time more full and decided. Now the eyes had often an expression as if their sight was absorbed in the gaze of the inward eyes; and when the eyes of two met, there passed between those eyes the utterance of a conviction that both meant the same thing. But the change was,

31

of course, to be seen more clearly, though not more evidently, in individuals.

One of the brothers, for instance, was very fond of astronomy. He had his observatory on a lofty tower, which stood pretty clear of the others, towards the north and east. But hitherto, his astronomy, as he had called it, had been more of the character of astrology. Often, too, he might have been seen directing a heaven-searching telescope to catch the rapid transit of a fiery shooting star, belonging altogether to the earthly atmosphere, and not to the serene heavens. He had to learn that the signs of the air are not the signs of the skies. Nay, once, his brother surprised him in the act of examining through his longest tube a patch of burning heath upon a distant hill. But now he was diligent from morning till night in the study of the laws of the truth that has to do with stars; and when the curtain of the sunlight was about to rise from before the heavenly worlds which it had hidden all day long, he might be seen preparing his instruments with that solemn countenance with which it becometh one to look into the mysterious harmonies of Nature. Now he learned what law and order and truth are, what consent and harmony mean; how the individual may find his own end in a higher end, where law and freedom mean the same thing, and the purest certainty exists without the slightest constraint. Thus he stood on the earth, and looked to the heavens.

Another, who had been much given to searching out the hollow places and recesses in the foundations of the castle, and who was often to be found with compass and ruler working away at a chart of the same which he had been in process of constructing, now came to the conclusion, that only by ascending the upper regions of his abode, could he become capable of understanding what lay beneath; and that, in all probability, one clear prospect, from the top of the highest attainable turret, over the castle as it lay below, would reveal more of the idea of its internal construction, than a year spent in wandering through its subterranean vaults. But the fact was, that the desire to ascend wakening within him had made him forget what was beneath; and having laid aside his chart for a time at least, he was now to be met in every quarter of the upper parts, searching and striving upward, now in one direction, now in another;

and seeking, as he went, the best outlooks into the clear air of outer realities.

And they began to discover that they were all meditating different aspects of the same thing; and they brought together their various discoveries, and recognized the likeness between them; and the one thing often explained the other, and combining with it helped to a third. They grew in consequence more and more friendly and loving; so that every now and then, one turned to another and said, as in surprise, "Why, you are my brother!"—"Why, you are my sister!" And yet they had always known it.

The change reached to all. One, who lived on the air of sweet sounds, and who was almost always to be found seated by her harp or some other instrument, had, till the late storm, been generally merry and playful, though sometimes sad. But for a long time after that, she was often found weeping, and playing little simple airs which she had heard in childhood—backward longings, followed by fresh tears. Before long, however, a new element manifested itself in her music. It became yet more wild, and sometimes retained all its sadness, but it was mingled with anticipation and hope. The past and the future merged in one; and while memory yet brought the raincloud, expectation threw the rainbow across its bosom—and all was uttered in her music, which rose and swelled, now to defiance, now to victory; then died in a torrent of weeping.

As to the eldest sister, it was many days before she recovered from the shock. At length, one day, her brother came to her, took her by the hand, led her to an open window, and told her to seat herself by it, and look out. She did so; but at first saw nothing more than an unsympathizing blaze of sunlight. But as she looked, the horizon widened out, and the dome of the sky ascended, till the grandeur seized upon her soul, and she fell on her knees and wept. Now the heavens seemed to bend lovingly over her, and to stretch out wide cloud-arms to embrace her; the earth lay like the bosom of an infinite love beneath her, and the wind kissed her cheek with an odor of roses. She sprang to her feet, and turned, in an agony of hope, expecting to behold the face of the father, but there stood only her brother, looking calmly though lovingly on her emotion. She turned again to the window. On the hilltops

rested the sky: Heaven and Earth were one; and the prophecy awoke in her soul, that from betwixt them would the steps of the father approach.

Hitherto she had seen but Beauty; now she beheld truth. Often had she looked on such clouds as these, and loved the strange ethereal curves into which the winds moulded them; and had smiled as her little pet sister told her what curious animals she saw in them, and tried to point them out to her. Now they were as troops of angels, jubilant over her new birth, for they sang, in her soul, of beauty, and truth, and love. She looked down, and her little sister knelt beside her.

She was a curious child, with black, glittering eyes, and dark hair; at the mercy of every wandering wind; a frolicsome, daring girl, who laughed more than she smiled. She was generally in attendance on her sister, and was always finding and bringing her strange things. She never pulled a primrose, but she knew the haunts of all the orchis tribe, and brought from them bees and butterflies innumerable, as offerings to her sister. Curious moths and glowworms were her greatest delight; and she loved the stars, because they were like the glowworms. But the change had affected her too; for her sister saw that her eyes had lost their glittering look, and had become more liquid and transparent. And from that time she often observed that her gaiety was more gentle, her smile more frequent, her laugh less bell-like; and although she was as wild as ever, there was more elegance in her motions, and more music in her voice. And she clung to her sister with far greater fondness than before.

The land reposed in the embrace of the warm summer days. The clouds of heaven nestled around the towers of the castle; and the hearts of its inmates became conscious of a warm atmosphere—of a presence of love. They began to feel like the children of a household, when the mother is at home. Their faces and forms grew daily more and more beautiful, till they wondered as they gazed on each other. As they walked in the gardens of the castle, or in the country around, they were often visited, especially the eldest sister, by sounds that no one heard but themselves, issuing from woods and waters; and by forms of love that lightened out of flowers, and grass, and great rocks. Now and then the young children would come in with a slow, stately step,

and, with great eyes that looked as if they would devour all the creation, say that they had met the father amongst the trees, and that he had kissed them; "And," added one of them once, "I grew so big!" But when others went out to look, they could see no one. And some said it must have been the brother, who grew more and more beautiful, and loving, and reverend, and who had lost all traces of hardness, so that they wondered they could ever have thought him stern and harsh. But the eldest sister held her peace, and looked up, and her eyes filled with tears. "Who can tell," thought she, "but the little children know more about it than we?"

Often, at sunrise, might be heard their hymn of praise to their unseen father, whom they felt to be near, though they saw him not. Some words thereof once reached my ear through the folds of the music in which they floated, as in an upward snowstorm of sweet sounds. And these are some of the words I heard—but there was much I seemed to hear, which I could not understand, and some things which I understood but cannot utter again.

"We thank thee that we have a father, and not a maker; that thou hast begotten us, and not moulded us as images of clay; that we have come forth of thy heart, and have not been fashioned by thy hands. It *must* be so. Only the heart of a father is able to create. We rejoice in it, and bless thee that we know it. We thank thee for thyself. Be what thou art—our root and life, our beginning and end, our all in all. Come home to us. Thou livest; therefore we live. In thy light we see. Thou art—that is all our song."

Thus they worship, and love, and wait. Their hope and expectation grow ever stronger and brighter, that one day, ere long, the Father will show himself amongst them, and thenceforth dwell in his own house for evermore. What was once but an old legend has become the one desire of their hearts.

And the loftiest hope is the surest of being fulfilled.

Richard Garnett

(1835–1906)

Like the studious Prospero of Shakespeare's *The Tempest*, Richard Garnett considered a well-stocked library "dukedom large enough." Garnett's particular dukedom was large enough indeed, taking the form of the magnificent Library of the British Museum, his place of employment for nearly half a century. A noted librarian, poet, critic, biographer, and man of letters, Garnett was born at Lichfield, Staffordshire, the eldest son of the Reverend Richard Garnett, onetime assistant keeper of printed books in the British Museum. Garnett received much of his early education in his London home, although he did spend some time at the Reverend Marcus's rather prestigious private school. Young Richard was somewhat of a prodigy, showing special aptitude in the languages. As a matter of fact, by the tender age of fourteen he had already read many of the Greek, Latin, French, German, and Italian classics in the original languages. In this respect, as in many others, he followed in his father's footsteps, since the Reverend Garnett was also noted for his remarkable facility with foreign languages.

A major turning point in Garnett's life came in 1850. He was fifteen years old, and attending the Whalley Grammar School, when his father died. His educational career now hung in the balance. Although some of his relatives offered to help him through either Oxford or Cambridge, Garnett chose not to accept their charity and decided instead to seek a position in the British Museum. Taken on as a clerk, he served in this capacity from 1851 to 1875, when he was promoted to the position of assistant keeper of printed books, the same post his father had held years earlier. In 1890, Garnett became chief keeper of the Museum, a high office that he held, with distinction,

36

until his retirement in 1899. He died seven years later at Hampstead, London, on April 13, 1906.

Garnett, of course, not only worked with books, he also wrote them. His writing career began in 1858 with the publication of *Primula,* a collection of his verse, and over the next fifty years he established himself as one of England's most versatile and learned authors. Besides writing enough poetry to fill several volumes, he wrote biographies of such luminaries as Milton, Carlyle, Emerson, and Blake; translated several works from the Greek, Italian, Spanish, Portuguese, and German; proved his value as a perceptive literary historian with works such as *The Age of Dryden* (1895) and *History of Italian Literature* (1897); and contributed many fine articles to *The Encyclopedia Brittanica* and the *Dictionary of National Biography*. It is little wonder that in 1883 he was awarded the honorary degree of LL.D. at Edinburgh University for his outstanding accomplishments as researcher, writer, and translator.

"The Bell of Saint Euschemon" is one of twenty-eight satirical prose fables contained in *The Twilight of the Gods* (1888), a celebrated collection that features some of Garnett's finest original work. In "Saint Euschemon," as in most of his other stories, Garnett employs Horatian rather than Juvenalian satire. He asks us to smile and chuckle at the foibles and idiosyncracies of his characters; he does not ask us to feel contempt or strong moral indignation. Garnett, it should be pointed out, did not see life through rose-colored glasses; he simply managed to keep his sense of humor intact while viewing it. Indeed, it is Garnett's mischievous, irrepressible sense of humor, in combination with his fondness for the unexpected and the bizarre, which makes "Saint Euschemon" so titillating and memorable. The scenes he describes remain indelibly etched in the reader's mind: the three saints becoming tipsy, and quarrelsome, at a paradisal drinking party; Saint Euschemon and the devil contentedly sitting in the belfry of the Epinal Church "with a smoking can of hot spiced wine between them, finishing a close game of cribbage"; and the Bishop of Metz planting a kiss on the lips of a woman of "transcendent loveliness," who, much to his astonishment, turns out to be the devil in disguise. This is vintage Garnett.

It is important to note, however, that beneath the play-

ful narrative is a sturdy foundation of careful research and scholarship—another Garnett hallmark. There is little doubt, for example, that the many necromantic terms bandied about by the bishop and the sorcerer when they are trying to exorcize the demon-inhabited bell of Saint Euschemon show an author who possesses a considerable familiarity with the literature of the black arts. It is also apparent that Garnett did his homework on the history of the bell, in particular its long and intimate association with the Christian Church. Ultimately, however, it is what Garnett does with the information he gleans from his research and reading that must fascinate and impress us. It is one thing to know about the common medieval practice of consecrating or "baptizing" bells in honor of saints, and of ringing bells to dispel advancing thunderstorms; it is quite another to develop these ideas into a coherent Christian fantasy. Garnett's amazing facility as a literary alchemist makes us wonder if perhaps some night, while poring over the antique volumes in his bookish domain, he did indeed discover the secret whereabouts of the elusive philosopher's stone.

THE BELL OF SAINT EUSCHEMON

by Richard Garnett

The town of Epinal, in Lorraine, possessed in the Middle Ages a peal of three bells, respectively dedicated to St. Eulogius, St. Eucherius, and St. Euschemon, whose tintinnabulation was found to be an effectual safeguard against all thunderstorms. Let the heavens be ever so murky, it was merely requisite to set the bells ringing, and no lightning flashed and no thunderpeal broke over the town, nor was the neighboring country within hearing of them ravaged by hail or flood.

One day the three saints, Eulogius, Eucherius, and Euschemon, were sitting together, exceedingly well content with themselves and everything around them, as indeed they had every right to be, supposing that they were in Paradise. We say supposing, not being for our own part entirely able to reconcile this locality with the presence of certain cans and flagons, which had been fuller than they were.

"What a happy reflection for a saint," said Eulogius, who was rapidly passing from the mellow stage of good fellowship to the maudlin, "that even after his celestial assumption he is permitted to continue a source of blessing and benefit to his fellow-creatures as yet dwelling in the shade of mortality! The thought of the services of my bell, in averting lightning and inundation from the good people of Epinal, fills me with indescribable beatitude."

"*Your* bell!" interposed Eucherius, whose path had lain through the mellow to the quarrelsome. "*Your* bell, quotha! You had as good clink this cannakin" (suiting the action to the word) "as your bell. It's my bell that does the business."

"I think you might put in a word for *my* bell," inter-

39

posed Euschemon, a little squinting saint, very merry and friendly when not put out, as on the present occasion.

"Your bell!" retorted the big saints, with incredible disdain; and, forgetting their own altercation, they fell so fiercely on their little brother that he ran away, stopping his ears with his hands, and vowing vengeance.

A short time after this fracas, a personage of venerable appearance presented himself at Epinal, and applied for the post of sacristan and bellringer, at that time vacant. Though he squinted, his appearance was far from disagreeable, and he obtained the appointment without difficulty. His deportment in it was in all respects edifying; or if he evinced some little remissness in the service of saints Eulogius and Eucherius, this was more than compensated by his devotion to the hitherto somewhat slighted Saint Euschemon. It was indeed observed that candles, garlands, and other offerings made at the shrines of the two senior saints were found to be transferred in an unaccountable and mystical manner to the junior, which induced experienced persons to remark that a miracle was certainly brewing. Nothing, however, occurred until, one hot summer afternoon, the indications of a storm became so threatening that the sacristan was directed to ring the bells. Scarcely had he begun than the sky became clear, but instead of the usual rich volume of sound, the townsmen heard with astonishment a solitary tinkle, sounding quite ridiculous and unsatisfactory in comparison. St. Euschemon's bell was ringing by itself.

In a trice priests and laymen swarmed to the belfry, and indignantly demanded of the sacristan what he meant.

"To enlighten you," he responded. "To teach you to give honor where honor is due. To unmask those canonized impostors."

And he called their attention to the fact that the clappers of the bells of Eulogius and Eucherius were so fastened up that they could not emit a sound, while that of Euschemon vibrated freely.

"Ye see," he continued, "that these sound not at all, yet is the tempest stayed. Is it not thence manifest that the virtue resides solely in the bell of the blessed Euschemon?"

The argument seemed conclusive to the majority, but those of the clergy who ministered at the altars of Eulogius

and Eucherius stoutly resisted, maintaining that no just decision could be arrived at until Euschemon's bell was subjected to the same treatment as the others. Their view eventually prevailed, to the great dismay of Euschemon, who, although firmly convinced of the virtue of his own bell, did not in his heart disbelieve in the bells of his brethren. Imagine his relief and amazed joy when, upon his bell being silenced, the storm, for the first time in the memory of the oldest inhabitant, broke with full fury over Epinal, and, for all the frantic pealing of the other two bells, raged with unspeakable fierceness until his own was brought into requisition, when, as if by enchantment, the rain ceased, the thunderclouds dispersed, and the sun broke out gloriously from the blue sky.

"Carry him in procession!" shouted the crowd.

"Amen, brethren; here I am," rejoined Euschemon, stepping briskly into the midst of the troop.

"And why in the name of Zernebock should we carry *you?*" demanded some, while others ran off to lug forth the image, the object of their devotion.

"Why, verily," Euschemon began, and stopped short. How indeed was he to prove to them that he *was* Euschemon? His personal resemblance to his effigy, the work of a sculptor of the idealistic school, was in no respect remarkable; and he felt, alas! that he could no more work a miracle than you or I. In the sight of the multitude he was only an elderly sexton with a cast in his eye, with nothing but his office to keep him out of the workhouse. A further and more awkward question arose, how on earth was he to get back to Paradise? The ordinary method was not available, for he had already been dead for several centuries; and no other presented itself to his imagination.

Muttering apologies, and glad to be overlooked, Euschemon shrank into a corner, but slightly comforted by the honors his image was receiving at the hands of the good people of Epinal. As time wore on he became pensive and restless, and nothing pleased him so well as to ascend to the belfry on moonlight nights, scribbling disparagement on the bells of Eulogius and Eucherius, which had ceased to be rung, and patting and caressing his own, which now did duty for all three. With alarm he noticed one night an incipient crack, which threatened to become a serious flaw.

41

"If this goes on," said a voice behind him, "I shall get a holiday."

Euschemon turned round, and with indescribable dismay perceived a gigantic demon, negligently resting his hand on the top of the bell, and looking as if it would cost him nothing to pitch it and Euschemon together to the other side of the town.

"Avaunt, fiend," he stammered, with as much dignity as he could muster, "or at least remove thy unhallowed paw from my bell."

"Come, Eusky," replied the fiend, with profane familiarity, "don't be a fool. You are not *really* such an ass as to imagine that your virtue has anything to do with the virtue of this bell?"

"Whose virtue then?" demanded Euschemon.

"Why truly," said the demon, "mine! When this bell was cast I was imprisoned in it by a potent enchanter, and so long as I am in it no storm can come within sound of its ringing. I am not allowed to quit it except by night, and then no further than an arm's length: this, however, I take the liberty of measuring by my own arm, which happens to be a long one. This must continue, as I learn, until I receive a kiss from some bishop of distinguished sanctity. Thou hast done some bishoping in thy time, peradventure?"

Euschemon energetically protested that he had been on earth but a simple laic, which was indeed the fact, and was also the reason why Eulogious and Eucherius depised him, but which, though he did not think it needful to tell the demon, he found a singular relief under present circumstances.

"Well," continued the fiend, "I wish he may turn up shortly, for I am half dead already with the banging and booming of this infernal clapper, which seems to have grown much worse of late; and the blessings and the crossings and the aspersions which I have to go through are most repugnant to my tastes, and unsuitable to my position in society. Bye-bye, Eusky; come up tomorrow night." And the fiend slipped back into the bell, and instantly became invisible.

The humiliation of poor Euschemon on learning that he was indebted for his credit to the devil is easier to imagine

than to describe. He did not, however, fail at the rendezvous next night, and found the demon sitting outside the bell in a most affable frame of mind. It did not take long for the devil and the saint to become very good friends, both wanting company, and the former being apparently as much amused by the latter's simplicity as the latter was charmed by the former's knowingness. Euschemon learned numbers of things of which he had not had the faintest notion. The demon taught him how to play cards (just invented by the Saracens), and initiated him into divers "arts, though unimagined, yet to be," such as smoking tobacco, making a book on the Derby, and inditing queer stories for Society journals. He drew the most profane but irresistibly funny caricatures of Eulogius and Eucherius, and the rest of the host of heaven. He had been one of the demons who tempted St. Anthony, and retailed anecdotes of that eremite which Euschemon had never heard mentioned in Paradise. He was versed in all scandal respecting saints in general, and Euschemon found with astonishment how much about his own order was known downstairs. On the whole he had never enjoyed himself so much in his life; he became proficient in all manner of minor devilries, and was ceasing to trouble himself about his bell or his ecclesiastical duties, when an untoward incident interrupted his felicity.

It chanced that the Bishop of Metz, in whose diocese Epinal was situated, finding himself during a visitation journey within a short distance of the town, determined to put up there for the night. He did not arrive until nightfall, but word of his intention having been sent forward by a messenger, the authorities, civil and ecclesiastical, were ready to receive him. When, escorted in state, he had arrived at the house prepared for his reception, the mayor ventured to express a hope that everything had been satisfactory to his Lordship.

"Everything," said the bishop emphatically. "I did indeed seem to remark one little omission, which no doubt may be easily accounted for."

"What was that, my Lord?"

"It hath," said the bishop, "usually been the practice to receive a bishop with the ringing of bells. It is a laudable custom, conducive to the purification of the air and the dis-

comfiture of the prince of the powers thereof. I caught no sound of chimes on the present occasion, yet I am sensible that my hearing is not what it was."

The civil and ecclesiastical authorities looked at each other. "That graceless knave of a sacristan!" said the Mayor.

"He hath indeed of late strangely neglected his charge," said a priest.

"Poor man, I doubt his wits are touched," charitably added another.

"What!" exclaimed the bishop, who was very active, very fussy, and a great stickler for discipline. "This important church, so renowned for its three miraculous bells, confided to the tender mercies of an imbecile rogue who may burn it down any night! I will look to it myself without losing a minute."

And in spite of all remonstrances, off he started. The keys were brought, the doors flung open, the body of the church thoroughly examined, but neither in nave, choir, or chancel could the slightest trace of the sacristan be found.

"Perhaps he is in the belfry," suggested a chorister.

"We'll see," responded the bishop, and bustling nimbly up the ladder, he emerged into the open belfry in full moonlight.

Heavens! what a sight met his eye! The sacristan and the devil sitting *vis-à-vis* close by the miraculous bell, with a smoking can of hot spiced wine between them, finishing a close game of cribbage.

"Seven," declared Euschemon.

"And eight are fifteen," retorted the demon, marking two.

"Twenty-three and pair," cried Euschemon, marking in his turn.

"And seven is thirty."

"Ace, thirty-one, and I'm up."

"It *is* up with you, my friend," shouted the bishop, bringing his crook down smartly on Euschemon's shoulders.

"Deuce!" said the devil, and vanished into his bell.

When poor Euschemon had been bound and gagged, which did not take very long, the bishop briefly addressed the assembly. He said that the accounts of the bell which had reached his ears had already excited his apprehensions.

He had greatly feared that all could not be right, and now his anxieties were but too well justified. He trusted there was not a man before him who would not suffer his flocks and his crops to be destroyed by tempest fifty times over rather than purchase their safety by unhallowed means. What had been done had doubtless been done in ignorance, and could be made good by a mulct to the episcopal treasury. The amount of this he would carefully consider, and the people of Epinal might rest assured that it should not be too light to entitle them to the benefit of a full absolution. The bell must go to his cathedral city, there to be examined and reported on by the exorcists and inquisitors. Meanwhile he would himself institute a slight preliminary scrutiny.

The bell was accordingly unhung, tilted up, and inspected by the combined beams of the moonlight and torchlight. Very slight examination served to place the soundness of the bishop's opinion beyond dispute. On the lip of the bell were engraven characters unknown to every one else, but which seemed to affect the prelate with singular consternation.

"I hope," he exclaimed, "that none of you know anything about these characters! I earnestly trust that none can read a single one of them. If I thought anybody could I would burn him as soon as look at him!"

The bystanders hastened to assure him that not one of them had the slightest conception of the meaning of the letters, which had never been observed before.

"I rejoice to hear it," said the bishop. "It will be an evil day for the church when these letters are understood."

And next morning he departed, carrying off the bell, with the invisible fiend inside it; the cards, which were regarded as a book of magic; and the luckless Euschemon, who shortly found himself in total darkness, the inmate of a dismal dungeon.

It was some time before Euschemon became sensible of the presence of any partner in his captivity, by reason of the trotting of the rats. At length, however, a deep sigh struck upon his ear.

"Who art thou?" he exclaimed.

"An unfortunate prisoner," was the answer.

"What is the occasion of thy imprisonment?"

"Oh, a mere trifle. A ridiculous suspicion of sacrificing a child to Beelzebub. One of the little disagreeables that must occasionally occur in our profession."

"*Our* profession!" exclaimed Euschemon.

"Art thou not a sorcerer?" demanded the voice.

"No," replied Euschemon, "I am a saint."

The warlock received Euschemon's statement with much incredulity, but becoming eventually convinced of its truth—

"I congratulate thee," he said. "The devil has manifestly taken a fancy to thee, and he never forgets his own. It is true that the bishop is a great favorite with him also. But we will hope for the best. Thou hast never practiced riding a broomstick? No? 'Tis pity; thou mayest have to mount one at a moment's notice."

This consolation had scarcely been administered ere the bolts flew back, the hinges grated, the door opened, and jailers bearing torches informed the sorcerer that the bishop desired his presence.

He found the bishop in his study, which was nearly choked up by Euschemon's bell. The prelate received him with the greatest affability, and expressed a sincere hope that the very particular arrangements he had enjoined for the comfort of his distinguished prisoner had been faithfully carried out by his subordinates. The sorcerer, as much a man of the world as the bishop, thanked his Lordship, and protested that he had been perfectly comfortable.

"I have need of thy art," said the bishop, coming to business. "I am exceedingly bothered—flabbergasted were not too strong an expression—by this confounded bell. All my best exorcists have been trying all they know with it, to no purpose. They might as well have tried to exorcise my mitre from my head by any other charm than the offer of a better one. Magic is plainly the only remedy, and if thou canst disenchant it, I will give thee thy freedom."

"It will be a tough business," observed the sorcerer, surveying the bell with the eye of a connoisseur. "It will require fumigations."

"Yes," said the bishop, "and suffumigations."

"Aloes and mastic," advised the sorcerer.

"Aye," assented the bishop, "and red sanders."

"We must call in Primeumaton," said the warlock.

46

"Clearly," said the bishop, "and Amioram."

"Triangles," said the sorcerer.

"Pentacles," said the bishop.

"In the hour of Methon," said the sorcerer.

"I should have thought Tafrac," suggested the bishop, "but I defer to your better judgment."

"I can have the blood of a goat?" queried the wizard.

"Yes," said the bishop, "and of a monkey also."

"Does your Lordship think that one might venture to go so far as a little unweaned child?"

"If absolutely necessary," said the bishop.

"I am delighted to find such liberality of sentiment on your Lordship's part," said the sorcerer. "Your Lordship is evidently of the profession."

"These are things which stuck by me when I was an inquisitor," explained the bishop, with some little embarrassment.

Ere long all arrangements were made. It would be impossible to enumerate half the crosses, circles, pentagrams, naked swords, crossbones, chafing dishes, and vials of incense which the sorcerer found to be necessary. The child was fortunately deemed superfluous. Euschemon was brought up from his dungeon, and, his teeth chattering with the fright and cold, set beside his bell to hold a candle to the devil. The incantations commenced, and speedily gave evidence of their efficacy. The bell trembled, swayed, split open, and a female figure of transcendent loveliness attired in the costume of Eve stepped forth and extended her lips towards the bishop. What could the bishop do but salute them? With a roar of triumph the demon resumed his proper shape. The bishop swooned. The apartment was filled with the fumes of sulphur. The devil soared majestically out of the window, carrying the sorcerer under one arm and Euschemon under the other.

It is commonly believed that the devil good-naturedly dropped Euschemon back again into Paradise, or wheresoever he might have come from. It is even added that he fell between Eulogious and Eucherius, who had been arguing all the time respecting the merits of their bells, and resumed his share in the discussion as if nothing had happened. Some maintain, indeed, that the devil, chancing to be in want of a chaplain, offered the situation to Eusche-

mon, by whom it was accepted. But how to reconcile this assertion with the undoubted fact that the duties of the post in question are at present ably discharged by the Bishop of Metz, in truth we see not. One thing is certain: thou wilt not find Euschemon's name in the calendar, courteous reader.

The mulct to be imposed upon the parish of Epinal was never exacted. The bell, ruptured beyond repair by the demon's violent exit, was taken back and deposited in the museum of the town. The bells of Eulogius and Eucherius were rung freely on occasion; but Epinal has not since enjoyed any greater immunity from storms than the contiguous districts. One day an aged traveler, who had spent many years in Heathenesse and in whom some discerned a remarkable resemblance to the sorcerer, noticed the bell, and asked permission to examine it. He soon discovered the inscription, recognized the mysterious characters as Greek, read them without the least difficulty—

$$\text{Μὴ κίνει Καμαρίναν· ἀκίνητος γὰρ ἀμείνων—}$$

and favored the townsmen with this free but substantially accurate translation:—

CAN'T YOU LET WELL ALONE?

Oscar Wilde

(1854–1900)

The name Oscar Wilde evokes many different associations: aesthete, drawing-room wit, victim of middle-class morality, poet, essayist, fiction writer, creator of faery tales, and playwright. The most frequent association is that of playwright. Less often do we think of Wilde in terms of the faery tale. Yet he wrote two fine collections of them and, in "A Critical Note" to Wilde's *Complete Fairy Tales* (1945), Vyvyan Holland, Wilde's second son, comments: "It is significant that Oscar Wilde's fairy stories are used as standard works for the teaching of English in schools in nearly every European country, including those behind the Iron Curtain."

Oscar Fingal O'Flahertie Wills Wilde was born in Dublin. His father was an eminent surgeon there, but the greater influence seems to have been his mother, an ardent Irish nationalist and, more importantly for Wilde, the organizer of a sort of cultural salon in her home. Throughout his student career Wilde excelled at his studies with relatively little effort. After a year at Trinity College, Dublin, he spent the years from 1874 to 1879 at Magdalen College, Oxford. He won a first-class degree in classics in 1876 and then a first in literature in 1878. He also won the Newdigate Award for poetry while there. Wilde clearly fell under the influence of Walter Pater at Oxford and became a leading spokesman for and practitioner of aestheticism, or art for art's sake. In 1879 the young aesthete left Oxford for London, where he burst upon the social and artistic scene like a thunderstorm. His eccentric habits of dress and behavior along with his sparkling conversation and epigrammatic wit made him a favorite as a guest or a featured speaker. Not everyone found him to their taste, however. *Punch* rarely missed a chance to attack him, and W. S.

Gilbert satirized him as Bunthorne in his comic opera *Patience,* but even such lampoons brought him the gratification of being in the limelight. Wilde married Constance Lloyd in 1884, and the couple had two sons in the next two years. The marriage to a wealthy woman also brought financial stability to Wilde.

Wilde began his truly productive writing career in 1887. He became editor of a popular magazine, *Women's World,* from 1887 to 1889, and in 1888 he produced *The Happy Prince and Other Tales,* the first of his two collections of faery tales. The year 1891 was a remarkable year in which Wilde saw through to publication a collection of short stories, a collection of essays, *The Picture of Dorian Gray* (his only novel), and *A House of Pomegranates* (his second book of faery tales). The next year, 1892, brought the first of Wilde's acclaimed dramas, *Lady Windemere's Fan.* He reached the peak of his career in 1895 with the staging of *The Importance of Being Earnest.*

Wilde, in the same year of 1895, also contributed to his own abrupt decline and fall. He brought a libel suit against the Marquess of Queensberry, who had openly accused him of homosexual behavior—the Marquess used the particularly derogatory term "sodomite." Wilde was foolish to go to court over this since the notoriety alone would have destroyed his reputation, even if he had won his case. Then, when Wilde lost his case, he automatically became guilty himself of the charge of libel, and, naturally, everyone assumed that Wilde was also guilty of Queensberry's original charge. Wilde went to prison for two years, suffered bankruptcy, was estranged from his wife, and never again saw his two sons. Shortly after his release he became a Roman Catholic, following an inclination that he had long felt. He spent the last three years of his life in Paris in what amounted to exile.

"The Fisherman and His Soul" is an authentic literary faery tale, with the sea, inhabited by the merfolk, as the faeryland. The magic numbers three and seven are prominent and a magical blade plays an important part. To these more typical elements of faerie Wilde adds a witches' sabbath and the figure of the devil, dressed—as an Englishman would see him—as a Spanish gentleman. Yet another element that Wilde includes is the priestly ritual of the

Church. The presence of the devil and his minion witches adds a curious complication to what would otherwise be a relatively familiar romantic motif of the human yearning for the mysterious attractions of faerie at the peril of one's soul. The witches and their master, while they appear to be on the side of faerie, are not, but rather are trying to get the fisherman's soul for themselves. Wilde seems to be saying that there is no inherent conflict between Church and faerie (nature, paganism). In fact it is love for the mermaid that enables the fisherman to be reunited with his soul, and it is the poignant and healing love of fisherman and mermaid that brings about the satisfying resolution of the story. The story's length is perhaps excessive, yet Wilde's style, notably the piling up of exotic detail and the richness of imagery, carries the reader swiftly to the dramatic climax.

THE FISHERMAN AND HIS SOUL

by Oscar Wilde

Every evening the young Fisherman went out upon the sea, and threw his nets into the water.

When the wind blew from the land he caught nothing, or but little at best, for it was a bitter and black-winged wind, and rough waves rose up to meet it. But when the wind blew to the shore, the fish came in from the deep, and swam into the meshes of his nets, and he took them to the marketplace and sold them.

Every evening he went out upon the sea, and one evening the net was so heavy that hardly could he draw it into the boat. And he laughed, and said to himself, "Surely I have caught all the fish that swim, or snared some dull monster that will be a marvel to men, or something of horror that the great Queen will desire," and putting forth all his strength, he tugged at the coarse ropes till, like lines of blue enamel round a vase of bronze, the long veins rose up on his arms. He tugged at the thin ropes, and nearer and nearer came the circle of flat corks, and the net rose at last to the top of the water.

But no fish at all was in it, nor any monster or thing of horror, but only a little Mermaid lying fast asleep.

Her hair was as a wet fleece of gold, and each separate hair as a thread of fine gold in a cup of glass. Her body was as white ivory, and her tail was of silver and pearl. Silver and pearl was her tail, and the green weeds of the sea coiled round it; and like seashells were her ears, and her lips were like sea coral. The cold waves dashed over her cold breasts, and the salt glistened upon her eyelids.

So beautiful was she that when the young Fisherman saw her he was filled with wonder, and he put out his hand and drew the net close to him, and leaning over the side he clasped her in his arms. And when he touched her,

52

she gave a cry like a startled sea gull, and woke, and looked at him in terror with her mauve-amethyst eyes, and struggled that she might escape. But he held her tightly to him, and would not suffer her to depart.

And when she saw that she could in no way escape from him, she began to weep, and said, "I pray thee let me go, for I am the only daughter of a King, and my father is aged and alone."

But the young Fisherman answered, "I will not let thee go save thou makest me a promise that whenever I call thee, thou wilt come and sing to me, for the fish delight to listen to the song of the Seafolk and so shall my nets be full."

"Wilt thou in very truth let me go, if I promise thee this?" cried the Mermaid.

"In very truth I will let thee go," said the young Fisherman.

So she made him the promise he desired, and swore it by the oath of the Seafolk. And he loosened his arms from about her, and she sank down into the water, trembling with a strange fear.

Every evening the young Fisherman went out upon the sea, and called to the Mermaid, and she rose out of the water and sang to him. Round and round her swam the dolphins, and the wild gulls wheeled above her head.

And she sang a marvelous song. For she sang of the Seafolk who drive their flocks from cave to cave, and carry the little calves on their shoulders; of the Tritons who have long green beards, and hairy breasts, and blow through twisted conchs when the King passes by; of the palace of the King which is all of amber, with a roof of clear emerald, and a pavement of bright pearl; and of the gardens of the sea where the great filigrane fans of coral wave all day long, and the fish dart about like silver birds, and the anemones cling to the rocks, and the pinks burgeon in the ribbed yellow sand. She sang of the big whales that come down from the north seas and have sharp icicles hanging from their fins; of the Sirens who tell of such wonderful things that the merchants have to stop their ears with wax lest they should hear them, and leap into the water and be drowned; of the sunken galleys with their tall masts, and the frozen sailors clinging to the rigging,

and the mackerel swimming in and out of the open port-holes; of the little barnacles who are great travelers, and cling to the keels of the ships and go round and round the world; and of the cuttlefish who live in the sides of the cliffs and stretch out their long black arms, and can make night come when they will it. She sang of the nautilus who has a boat of her own that is carved out of an opal and steered with a silken sail; of the happy Mermen who play upon harps and can charm the great Kraken to sleep; of the little children who catch hold of the slippery porpoises and ride laughing upon their backs; of the Mermaids who lie in the white foam and hold out their arms to the mariners; and of the sea lions with their curved tusks, and the sea horses with their floating manes.

And as she sang, all the tunnyfish came in from the deep to listen to her, and the young Fisherman threw his nets round them and caught them, and others he took with a spear. And when his boat was well laden, the Mermaid would sink down into the sea, smiling at him.

Yet would she never come near him that he might touch her. Oftentimes he called to her and prayed of her, but she would not; and when he sought to seize her she dived into the water as a seal might dive, nor did he see her again that day. And each day the sound of her voice became sweeter to his ears. So sweet was her voice that he forgot his nets and his cunning, and had no care of his craft. Vermilion-finned and with eyes of bossy gold, the tunnies went by in shoals, but he heeded them not. His spear lay by his side unused, and his baskets of plaited osier were empty. With lips parted, and eyes dim with wonder, he sat idle in his boat and listened, listening till the sea mists crept round him and the wandering moon stained his brown limbs with silver.

And one evening he called to her, and said: "Little Mermaid, little Mermaid, I love thee. Take me for thy bridegroom for I love thee."

But the Mermaid shook her head. "Thou hast a human Soul," she answered. "If only thou wouldst send away thy Soul, then could I love thee."

And the young Fisherman said to himself, "Of what use is my soul to me? I cannot see it. I may not touch it. I do not know it. Surely I will send it away from me, and

much gladness shall be mine." And a cry of joy broke from his lips, and standing up in the painted boat, he held out his arms to the Mermaid. "I will send my Soul away," he cried, "and you shall be my bride, and I will be thy bridegroom, and in the depth of the sea we will dwell together, and all that thou hast sung of thou shalt show me, and all that thou desirest I will do, nor shall our lives be divided."

And the little Mermaid laughed for pleasure and hid her face in her hands.

"But how shall I send my Soul from me?" cried the young Fisherman. "Tell me how I may do it, and lo! it shall be done."

"Alas! I know not," said the little Mermaid: "The Seafolk have no souls." And she sank down into the deep, looking wistfully at him.

Now early on the next morning, before the sun was the span of a man's hand above the hill, the young Fisherman went to the house of the Priest and knocked three times at the door.

The novice looked out through the wicket, and when he saw who it was, he drew back the latch and said to him, "Enter."

And the young Fisherman passed in, and knelt down on the sweet-smelling rushes on the floor, and cried to the Priest who was reading out of the Holy Book, and said to him, "Father, I am in love with one of the Seafolk, and my Soul hindreth me from having my desire. Tell me how I can send my Soul away from me, for in truth I have no need of it. Of what value is my Soul to me? I cannot see it. I may not touch it. I do not know it."

And the Priest beat his breast, and answered, "Alack, alack, thou art mad, or hast eaten of some poisonous herb, for the Soul is the noblest part of man, and was given to us by God that we should nobly use it. There is no thing more precious than a human soul, nor any earthly thing that can be weighed with it. It is worth all the gold that is in the world, and is more precious than the rubies of the kings. Therefore, my son, think not any more of this matter, for it is a sin that may not be forgiven. And as for the Seafolk, they are lost, and they who would traffic with them are lost also. They are the beasts of the field that

know not good from evil, and for them the Lord has not died."

The young Fisherman's eyes filled with tears when he heard the bitter words of the Priest, and he rose up from his knees and said to him, "Father, the Fauns live in the forest and are glad, and on the rocks sit the Mermen with their harps of red gold. Let me be as they are, I beseech thee, for their days are as the days of flowers. And as for my Soul, what doth my Soul profit me, if it stand between me and the thing that I love?"

"The love of the body is vile," cried the Priest, knitting his brows, "and vile and evil are the pagan things God suffers to wander through His world. Accursed be the Fauns of the woodland, and accursed be the singers of the sea! I have heard them at nighttime, and they have sought to lure me from my beads. They tap at the window and laugh. They whisper into my ears the tale of their perilous joys. They tempt me with temptations, and when I would pray they make mouths at me. They are lost, I tell thee, they are lost. For them there is no heaven nor hell, and in neither shall they praise God's name."

"Father," cried the young Fisherman, "thou knowest not what thou sayest. Once in my net I snared the daughter of a King. She is fairer than the morning star, and whiter than the moon. For her body I would give my soul, and for her love I would surrender heaven. Tell me what I ask of thee, and let me go in peace."

"Away! Away!" cried the Priest: "thy leman is lost, and thou shalt be lost with her." And he gave him no blessing, but drove him from his door.

And the young Fisherman went down into the market-place, and he walked slowly, and with bowed head, as one who is in sorrow.

And when the merchants saw him coming, they began to whisper to each other, and one of them came forth to meet him, and called him by name, and said to him, "What hast thou to sell?"

"I will sell thee my Soul," he answered: "I pray thee buy it from me, for I am weary of it. Of what use is my Soul to me? I cannot see it. I may not touch it. I do not know it."

But the merchants mocked at him, and said, "Of what

use is a man's soul to us? It is not worth a clipped piece of silver. Sell us thy body for a slave, and we will clothe thee in sea purple, and put a ring upon thy finger, and make thee the minion of the great Queen. But talk not of the Soul, for to us it is nought, nor has it any value for our service."

And the young Fisherman said to himself: "How strange a thing this is! The Priest telleth me that the Soul is worth all the gold in the world, and the merchants say that it is not worth a clipped piece of silver." And he passed out of the marketplace, and down to the shore of the sea, and began to ponder on what he should do.

And at noon he remembered how one of his companions, who was a gatherer of samphire, had told him of a certain young Witch who dwelt in a cave at the head of the bay and was very cunning in her witcheries. And he set to and ran, so eager was he to get rid of his soul, and a cloud of dust followed him as he sped round the sand of the shore. By the itching of her palm the young Witch knew his coming, and she laughed and let down her red hair. With her red hair falling around her, she stood at the opening of the cave, and in her hand she had a spray of wild hemlock that was blossoming.

"What d'ye lack? What d'ye lack?" she cried, as he came panting up the steep, and bent down before her. "Fish for thy net, when the wind is foul? I have a little reed pipe, and when I blow on it the mullet come sailing into the bay. But it has a price, pretty boy, it has a price. What d'ye lack? What d'ye lack? A storm to wreck the ships, and wash the chests of rich treasure ashore? I have more storms than the wind has, for I serve one who is stronger than the wind, and with a sieve and a pail of water I can send the great galleys to the bottom of the sea. But I have a price, pretty boy, I have a price. What d'ye lack? What d'ye lack? I know a flower that grows in the valley, none knows it but I. It has purple leaves, and a star in its heart, and its juice is as white as milk. Shouldst thou touch with this flower the hard lips of the Queen, she would follow thee all over the world. Out of the bed of the King she would rise, and over the whole world she would follow thee. And it has a price, pretty boy, it has a price. What d'ye lack?

57

What d'ye lack? I can pound a toad in a mortar, and make broth of it, and stir the broth with a dead man's hand. Sprinkle it on thine enemy while he sleeps, and he will turn into a black viper, and his own mother will slay him. With a wheel I can draw the Moon from heaven, and in a crystal I can show thee Death. What d'ye lack? What d'ye lack? Tell me thy desire, and I will give it thee, and thou shalt pay me a price, pretty boy, thou shalt pay me a price."

"My desire is but for a little thing," said the young Fisherman, "yet hath the Priest been wroth with me, and driven me forth. It is but for a little thing, and the merchants have mocked at me, and denied me. Therefore am I come to thee, though men call thee evil, and whatever be thy price I shall pay it."

"What wouldst thou?" asked the Witch, coming near to him.

"I would send my Soul away from me," answered the young Fisherman.

The Witch grew pale, and shuddered, and hid her face in her blue mantle. "Pretty boy, pretty boy," she muttered, "that is a terrible thing to do."

He tossed his brown curls and laughed. "My Soul is naught to me," he answered. "I cannot see it. I may not touch it. I do not know it."

"What wilt thou give me if I tell thee?" asked the Witch, looking down at him with her beautiful eyes.

"Five pieces of gold," he said, "and my nets, and the wattled house where I live, and the painted boat in which I sail. Only tell me how to get rid of my Soul, and I will give thee all that I possess."

She laughed mockingly at him, and struck him with the spray of hemlock. "I can turn the autumn leaves into gold," she answered, "and I can weave the pale moonbeams into silver if I will it. He whom I serve is richer than all the kings of this world, and has their dominions."

"What then shall I give thee," he cried, "if thy price be neither gold nor silver?"

The Witch stroked his hair with her thin white hand. "Thou must dance with me, pretty boy," she murmured, and she smiled at him as she spoke.

"Naught but that?" cried the young Fisherman in wonder, and he rose to his feet.

"Naught but that," she answered, and she smiled at him again.

"Then at sunset in some secret place we shall dance together," he said, "and after that we have danced thou shalt tell me the thing which I desire to know."

She shook her head. "When the moon is full, when the moon is full," she muttered. Then she peered all round, and listened. A blue bird rose screaming from its nest and circled over the dunes, and three spotted birds rustled through the coarse gray grass and whistled to each other. There was no other sound save the sound of a wave fretting the smooth pebbles below. So she reached out her hand, and drew him near to her and put her dry lips close to his ear.

"Tonight thou must come to the top of the mountain," she whispered. "It is a Sabbath, and He will be there."

The young Fisherman started and looked at her, and she showed her white teeth and laughed. "Who is He of whom thou speakest?" he asked.

"It matters not," she answered. "Go thou tonight, and stand under the branches of the hornbeam, and wait for my coming. If a black dog run towards thee, strike it with a rod of willow, and it will go away. If an owl speak to thee, make it no answer. When the moon is full I shall be with thee, and we will dance together on the grass."

"But wilt thou swear to me to tell me how I may send my Soul from me?" he made question.

She moved out into the sunlight, and through her red hair rippled the wind. "By the hoofs of the goat I swear it," she made answer.

"Thou art the best of the witches," cried the young Fisherman, "and I will surely dance with thee tonight on the top of the mountain. I would indeed that thou hadst asked of me either gold or silver. But such as thy price is thou shalt have it, for it is but a little thing." And he doffed his cap to her, and bent his head low, and ran back to the town filled with a great joy.

And the Witch watched him as he went, and when he had passed from her sight she entered her cave, and

having taken a mirror from a box of carved cedarwood, she set it up on a frame, and burned vervain on lighted charcoal before it, and peered through the coils of the smoke. And after a time she clenched her hands in anger. "He should have been mine," she muttered, "I am as fair as she is."

And that evening, when the moon had risen, the young Fisherman climbed up to the top of the mountain, and stood under the branches of the hornbeam. Like a targe of polished metal the round sea lay at his feet, and the shadows of the fishing boats moved in the little bay. A great owl, with yellow sulfurous eyes, called to him by his name, but he made no answer. A black dog ran towards him and snarled. He struck it with a rod of willow, and it went away whining.

At midnight the witches came flying through the air like bats. "Phew!" they cried, as they lit upon the ground, "there is some one here we know not!" and they sniffed about, and chattered to each other, and made signs. Last of all came the young Witch, with her red hair streaming in the wind. She wore a dress of gold tissue embroidered with peacocks' eyes, and a little cap of green velvet was on her head.

"Where is he, where is he?" shrieked the witches when they saw her, but she only laughed, and ran to the hornbeam, and taking the Fisherman by the hand she led him out into the moonlight and began to dance.

Round and round they whirled, and the young Witch jumped so high that he could see the scarlet heels of her shoes. Then right across the dancers came the sound of the galloping of a horse, but no horse was to be seen, and he felt afraid.

"Faster," cried the Witch, and she threw her arms about his neck, and her breath was hot upon his face. "Faster, faster!" she cried, and the earth seemed to spin beneath his feet, and his brain grew troubled, and a great terror fell on him, as of some evil thing that was watching him, and at last he became aware that under the shadow of a rock there was a figure that had not been there before.

It was a man dressed in a suit of black velvet, cut in the Spanish fashion. His face was strangely pale, but his lips were like a proud red flower. He seemed weary, and

was leaning back toying in a listless manner with the pommel of his dagger. On the grass beside him lay a plumed hat, and a pair of riding gloves gauntleted with gilt lace, and sewn with seed pearls wrought into a curious device. A short cloak lined with sables hung from his shoulder, and his delicate white hands were gemmed with rings. Heavy eyelids drooped over his eyes.

The young Fisherman watched him, as one snared in a spell. At last their eyes met, and wherever he danced it seemed to him that the eyes of the man were upon him. He heard the Witch laugh, and caught her by the waist, and whirled her madly round and round.

Suddenly a dog bayed in the wood, and the dancers stopped, and going up two by two, knelt down, and kissed the man's hands. As they did so, a little smile touched his proud lips, as a bird's wing touches the water and makes it laugh. But there was disdain in it. He kept looking at the young Fisherman.

"Come! let us worship," whispered the Witch, and she led him up, and a great desire to do as she besought him seized on him, and he followed her. But when he came close, and without knowing why he did it, he made on his breast the Sign of the Cross, and called upon the Holy Name.

No sooner had he done so than the witches screamed like hawks and flew away, and the pallid face that had been watching him twitched with a spasm of pain. The man went over to a little wood, and whistled. A jennet with silver trappings came running to meet him. As he leapt upon the saddle he turned round, and looked at the young Fisherman sadly.

And the Witch with the red hair tried to fly away also, but the Fisherman caught her by her wrists, and held her fast.

"Loose me," she cried, "and let me go. For thou hast named what should not be named, and shown the sign that may not be looked at."

"Nay," he answered, "but I will not let thee go till thou hast told me the secret."

"What secret?" said the Witch, wrestling with him like a wild cat, and biting her foam-flecked lips.

"Thou knowest," he made answer.

Her grass-green eyes grew dim with tears, and she said to the Fisherman, "Ask me anything but that!"

He laughed, and held her all the more tightly.

And when she saw that she could not free herself, she whispered to him, "Surely I am as fair as the daughter of the sea, and as comely as those that dwell in the blue waters," and she fawned on him and put her face close to his.

But he thrust her back frowning, and said to her, "If thou keepest not the promise that thou madest to me I will slay thee for a false witch."

She grew gray as a blossom of the Judas tree, and shuddered. "Be it so," she muttered. "It is thy Soul and not mine. Do with it as thou wilt." And she took from her girdle a little knife that had a handle of green viper's skin, and gave it to him.

"What shall this serve me?" he asked of her, wondering.

She was silent for a few moments, and a look of terror came over her face. Then she brushed her hair back from her forehead, and smiling strangely she said to him, "What men call the shadow of the body is not the shadow of the body, but it the body of the Soul. Stand on the seashore with thy back to the moon, and cut away from around thy feet thy shadow, which is thy Soul's body, and bid thy Soul leave thee, and it will do so."

The young Fisherman trembled. "Is this true?" he murmured.

"It is true and I would that I had not told thee of it," she cried and she clung to his knees weeping.

He put her from him and left her in the rank grass, and going to the edge of the mountain he placed the knife in his belt and began to climb down.

And his Soul that was within called out to him and said, "Lo! I have dwelt with thee for all these years, and have been thy servant. Send me not away from thee now, for what evil have I done thee?"

And the young Fisherman laughed. "Thou hast done me no evil, but I have no need of thee," he answered. "The world is wide, and there is Heaven also, and Hell, and that dim twilight house that lies between. Go wherever thou wilt, but trouble me not, for my love is calling to me."

And his Soul besought him piteously, but he heeded it

not, but leapt from crag to crag, being surefooted as a wild goat, and at last he reached the level ground and the yellow shore of the sea.

Bronze-limbed and well-knit, like a statue wrought by a Grecian, he stood on the sand with his back to the moon, and out of the foam came white arms that beckoned to him, and out of the waves rose dim forms that did him homage. Before him lay his shadow, which was the body of his Soul, and behind him hung the moon in the honey-colored air.

And his Soul said to him, "If indeed thou must drive me from thee, send me not forth without a heart. The world is cruel, give me thy heart to take with me."

He tossed his head and smiled. "With what should I love my love if I gave thee my heart?" he cried.

"Nay, but be merciful," said his Soul: "Give me thy heart, for the world is very cruel, and I am afraid."

"My heart is my love's" he answered, "therefore tarry not, but get thee gone."

"Should I not love also?" asked his Soul.

"Get thee gone, for I have no need of thee," cried the young Fisherman, and he took the little knife with its handle of green viper's skin, and cut away his shadow from around his feet, and it rose up and stood before him, and looked at him, and it was even as himself.

He crept back, and thrust the knife into his belt, and a feeling of awe came over him. "Get thee gone," he murmured, "and let me see thy face no more."

"Nay, but we must meet again," said the Soul. Its voice was low and flutelike, and its lips hardly moved while it spoke.

"How shall we meet?" cried the young Fisherman. "Thou wilt not follow me into the depths of the sea?"

"Once every year I will come to this place, and call to thee," said the Soul. "It may be that thou will have need of me."

"What need should I have of thee?" cried the young Fisherman, "but be it as thou wilt," and he plunged into the water, and the Tritons blew their horns, and the little Mermaid rose up to meet him, and put her arms around his neck and kissed him on the mouth.

And the Soul stood on the lonely beach and watched

them. And when they had sunk down into the sea, it went weeping away over the marshes.

And after a year was over the Soul came down to the shore of the sea and called to the young Fisherman, and he rose out of the deep, and said, "Why dost thou call to me?"

And the Soul answered, "Come nearer, that I may speak with thee, for I have seen marvelous things."

So he came nearer, and couched in the shallow water, and leaned his head upon his hand and listened.

And the Soul said to him, "When I left thee I turned my face to the East and journeyed. From the East cometh everything that is wise. Six days I journeyed, and on the morning of the seventh day I came to a hill that is in the country of the Tartars. I sat down under the shade of a tamarisk tree to shelter myself from the sun. The land was dry and burnt up with the heat. The people went to and fro over the plain like flies crawling upon a disk of polished copper.

"When it was noon a cloud of red dust rose up from the flat rim of the land. When the Tartars saw it, they strung their painted bows, and having leapt upon their little horses they galloped to meet it. The women fled screaming to the wagons, and hid themselves behind the felt curtains.

"At twilight the Tartars returned, but five of them were missing, and of those that came back not a few had been wounded. They harnessed their horses to the wagons and drove hastily away. Three jackals came out of a cave and peered after them. Then they sniffed up the air with their nostrils, and trotted off in the opposite direction.

"When the moon rose I saw a campfire burning on the plain, and went towards it. A company of merchants were seated round it on carpets. Their camels were picketed behind them, and the Negroes who were their servants were pitching tents of tanned skin upon the sand, and making a high wall of prickly pear.

"As I came near them, the chief of the merchants rose up and drew his sword and asked me my business.

"I answered that I was a Prince in my own land, and that I had escaped from the Tartars, who had sought to make

me their slave. The chief smiled, and showed me five heads fixed upon long reeds of bamboo.

"Then he asked me who was the prophet of God, and I answered him Mohammed.

"When he heard the name of the false prophet, he bowed and took me by the hand, and placed me by his side. A Negro brought me some mare's milk in a wooden dish, and a piece of lamb's flesh roasted.

"At daybreak we started on our journey. I rode on a red-haired camel by the side of the chief, and a runner ran before us carrying a spear. The men of war were on either hand, and the mules followed with the merchandise. There were forty camels in the caravan, and the mules were twice forty in number.

"We went from the country of the Tartars into the country of those who curse the Moon. We saw the Gryphons guarding their gold on the white rocks, and the scaled Dragons sleeping in their caves. As we passed over the mountains we held our breath lest the snows might fall on us, and each man tied a veil of gauze before his eyes. As we passed through the valleys the Pygmies shot arrows at us from the hollows of the trees, and at nighttime we heard the wild men beating on their drums. When we came to the Tower of Apes we set fruits before them, and they did not harm us. When we came to the Tower of Serpents, we gave them warm milk in bowls of brass, and they let us go by. Three times in our journey we came to the banks of the Oxus. We crossed it on rafts of wood with great bladders of blown hide. The river horses raged against us and sought to slay us. When the camels saw them they trembled.

"The kings of each city levied tolls on us, but would not suffer us to enter their gates. They threw us bread over the walls, little maize cakes baked in honey and cakes of fine flour filled with dates. For every hundred baskets we gave them a bead of amber.

"When the dwellers in the villages saw us coming, they poisoned the wells and fled to the hill summits. We fought with the Magadae, who are born old, and grow younger and younger every year, and die when they are little children; and with the Laktroi, who say that they are the

sons of tigers, and paint themselves yellow and black; and with the Aurantes, who bury their dead on the tops of trees, and themselves live in dark caverns lest the Sun, who is their god, should slay them; and with the Krimnians, who worship a crocodile, and give it earrings of green grass, and feed it with butter and fresh fowls; and with the Auazonbae, who are dogfaced; and with the Sibans, who have horse's feet, and run more swiftly than horses. A third of our company died in battle, and a third died of want. The rest murmured against me, and said that I had brought them an evil fortune. I took a horned adder from beneath a stone and let it sting me. When they saw that I did not sicken they grew afraid.

"In the fourth month we reached the city of Illel. It was nighttime when we came to the grove that is outside the walls, and the air was sultry, for the Moon was traveling in Scorpio. We took the ripe pomegranates from the trees, and broke them, and drank their sweet juices. Then we lay down on our carpets and waited for the dawn.

"And at dawn we rose and knocked at the gate of the city. It was wrought out of red bronze, and carved with sea dragons and dragons that have wings. The guards looked down from the battlements and asked us our business. The interpreter of the caravan answered that we had come from the island of Syria with much merchandise. They took hostages, and told us that they would open the gate to us at noon, and bade us tarry till then.

"When it was noon they opened the gate, and as we entered in the people came crowding out of the houses to look at us, and a crier went round the city crying through a shell. We stood in the marketplace, and the Negroes uncorded the bales of figured cloths and opened the carved chests of sycamore. And when they had ended their task, the merchants set forth their strange wares, the waxed linen from Egypt, and the painted linen from the country of the Ethiops, the purple sponges from Tyre and the blue hangings from Sidon, the cups of cold amber and the fine vessels of glass and the curious vessels of burnt clay. From the roof of a house a company of women watched us. One of them wore a mask of gilded leather.

"And on the first day the priests came and bartered with us, and on the second day came the nobles, and on the

third day came the craftsmen and the slaves. And this is their custom with all merchants as long as they tarry in the city.

"And we tarried for a moon, and when the moon was waning, I wearied and wandered away through the streets of the city and came to the garden of its god. The priests in their yellow robes moved silently through the green trees, and on a pavement of black marble stood the rose-red house in which the god had his dwelling. Its doors were of powdered lacquer, and bulls and peacocks were wrought on them in raised and polished gold. The tilted roof was of sea-green porcelain and the jutting eaves were festooned with little bells. When the white doves flew past, they struck the bells with their wings and made them tinkle.

"In front of the temple was a pool of clear water paved with veined onyx. I lay down beside it, and with my pale fingers I touched the broad leaves. One of the priests came towards me and stood behind me. He had sandals on his feet, one of soft serpent skin and the other of bird's plumage. On his head was a miter of black felt decorated with silver crescents. Seven yellows were woven into his robe, and his frizzed hair was stained with antimony.

"And after a little while he spoke to me, and asked me my desire.

"I told him that my desire was to see the god.

"'The god is hunting,' said the priest, looking strangely at me with his small slanting eyes.

"'Tell me in what forest, and I will ride with him,' I answered.

"He combed out the soft fringes of his tunic with his long pointed nails. 'The god is asleep,' he murmured.

"'Tell me on what couch, and I will watch by him,' I answered.

"'The god is at the feast,' he cried.

"'If the wine be sweet, I will drink it with him, and if it be bitter I will drink it with him also,' was my answer.

"He bowed his head in wonder, and, taking me by the hand, he raised me up, and led me into the temple.

"And in the first chamber I saw an idol seated on a throne of jasper bordered with great orient pearls. It was carved out of ebony, and in stature was of the stature of a man. On its forehead was a ruby, and thick oil dripped

67

from its hair onto its thighs. Its feet were red with the blood of a newly slain kid, and its loins girt with a copper belt that was studded with seven beryls.

"And I said to the priest, 'Is this the god?' And he answered me, 'This is the god.'

" 'Show me the god,' I cried, 'or I will surely slay thee.' And I touched his hand, and it became withered.

"And the priest besought me, saying, 'Let my lord heal his servant, and I will show him the god.'

"So I breathed with my breath upon his hand, and it became whole again, and he trembled and led me into the second chamber, and I saw an idol standing on a lotus of jade with great emeralds. It was carved out of ivory, and in stature was twice the stature of a man. On its forehead was a chrysolite, and its breasts were smeared with myrrh and cinnamon. In one hand it held a crooked scepter of jade, and in the other a round crystal. It wore buskins of brass, and its thick neck was circled with a circle of selenites.

"And I said to the priest, 'Is this the god?' And he answered me, 'This is the god.'

" 'Show me the god,' I cried, 'or I will surely slay thee,' And I touched his eyes, and they became blind.

"And the priest besought me, saying, 'Let my lord heal his servant, and I will show him the god.'

"So I breathed with my breath upon his eyes, and the sight came back to them, and he trembled again, and led me into the third chamber, and lo! there was no idol in it, nor image of any kind, but only a mirror of round metal set on an altar of stone.

"And I said to the priest, 'Where is the god?'

"And he answered me: 'There is no god but this mirror that thou seest, for this is the Mirror of Wisdom. And it reflecteth all things that are in heaven and on earth, save only the face of him who looketh into it. This it reflecteth not, so that he who looketh into it may be wise. Many other mirrors are there, but they are mirrors of Opinion. This only is the Mirror of Wisdom. And they who possess this mirror know everything, nor is there anything hidden from them. And they who possess it not have not Wisdom. Therefore is it the god, and we worship it.' And I looked into the mirror, and it was even as he had said to me.

"And I did a strange thing, but what I did matters not, for in a valley that is but a day's journey from this place have I hidden the Mirror of Wisdom. Do but suffer me to enter into thee again and be thy servant, and thou shalt be wiser than all the wise men, and Wisdom shall be thine. Suffer me to enter into thee, and none will be as wise as thou."

But the young Fisherman laughed. "Love is better than Wisdom," he cried, "and the little Mermaid loves me."

"Nay, but there is nothing better than Wisdom," said the Soul.

"Love is better," answered the young Fisherman, and he plunged into the deep, and the Soul went weeping away over the marshes.

And after the second year was over, the Soul came down to the shore of the sea, and called to the young Fisherman and he rose out of the deep and said, "Why dost thou call to me?"

And the Soul answered, "Come nearer, that I may speak with thee, for I have seen marvelous things."

So he came nearer, and couched in the shallow water, and leaned his head upon his hand and listened.

And the soul said to him, "When I left thee, I turned my face to the South and journeyed. From the South cometh everything that is precious. Six days I journeyed along the highways that lead to the city of Ashter, along the dusty red-dyed highways by which the pilgrims are wont to go did I journey, and on the morning of the seventh day I lifted up my eyes, and lo! the city lay at my feet, for it is in a valley.

"There are nine gates to this city, and in front of each gate stands a bronze horse that neighs when the Bedouins come down from the mountains. The walls are cased with copper, and the watchtowers on the walls are roofed with brass. In every tower stands an archer with a bow in his hand. At sunrise he strikes with an arrow on a gong, and at sunset he blows through a horn of horn.

"When I sought to enter, the guards stopped me and asked of me who I was. I made answer that I was a Dervish and on my way to the city of Mecca, where there

69

was a green veil on which the Koran was embroidered in silver letters by the hands of the angels. They were filled with wonder, and entreated me to pass in.

"Inside it is even as a bazaar. Surely thou shouldst have been with me. Across the narrow streets the gay lanterns of paper flutter like large butterflies. When the wind blows over the roofs they rise and fall as painted bubbles do. In front of their booths sit the merchants on silken carpets. They have straight black beards, and their turbans are covered with golden sequins, and long strings of amber and carved peach stones glide through their cool fingers. Some of them sell galbanum and nard, and curious perfumes from the islands of the Indian Sea, and the thick oil of red roses, and myrrh and little nail-shaped cloves. When one stops to speak to them, they throw pinches of frankincense upon a charcoal brazier and make the air sweet. I saw a Syrian who held in his hands a thin rod like a reed. Gray threads of smoke came from it, and its odor as it burned was as the odor of the pink almond in spring. Others sell silver bracelets embossed all over with creamy blue turquoise stones, and anklets of brass wire fringed with little pearls, and tigers' claws set in gold, and the claws of that gilt cat, the leopard, set in gold also and earrings of pierced emerald, and finger rings of hollowed jade. From the teahouses comes the sound of the guitar, and the opium-smokers with their white smiling faces look out at the passersby.

"Of a truth thou shouldst have been with me. The wine seller's elbow their way through the crowd with great black skins on their shoulders. Most of them sell the wine of Schiraz, which is as sweet as honey. They serve it in little metal cups and strew rose leaves upon it. In the market-place stand the fruitsellers, who sell all kinds of fruit: ripe figs, with their bruised purple flesh, melons, smelling of musk and yellow as topazes, citrons and rose-apples and clusters of white grapes, round red-gold oranges, and oval lemons of green gold. Once I saw an elephant go by. Its trunk was painted with vermilion and turmeric, and over its ears it had a net of crimson silk cord. It stopped opposite one of the booths and began eating the oranges, and the man only laughed. Thou canst not think how strange a people they are. When they are glad they go to the bird

sellers and buy of them a caged bird, and set it free that their joy may be greater, and when they are sad they scourge themselves with thorns that their sorrow may not grow less.

"One evening I met some Negroes carrying a heavy palanquin through the bazaar. It was made of gilded bamboo, and the poles were of vermilion lacquer studded with brass peacocks. Across the windows hung thin curtains of muslin embroidered with beetles' wings and with tiny seed-pearls, and as it passed by a pale-faced Circassian looked out and smiled at me. I followed behind, and the Negroes hurried their steps and scowled. But I did not care. I felt a great curiosity come over me.

"At last they stopped at a square white house. There were no windows to it, only a little door like the door of a tomb. They set down the palanquin and knocked three times with a copper hammer. An Armenian in a caftan of green leather peered through the wicket, and when he saw them he opened, and spread a carpet on the ground, and the woman stepped out. As she went in, she turned round and smiled at me again. I had never seen any one so pale.

"When the moon rose I returned to the same place and sought for the house, but it was no longer there. When I saw that, I knew who the woman was, and wherefore she had smiled at me.

"Certainly thou shouldst have been with me. On the feast of the New Moon the young Emperor came forth from his palace and went into the mosque to pray. His hair and beard were dyed with rose leaves, and his cheeks were powdered with a fine gold dust. The palms of his feet and hands were yellow with saffron.

"At sunrise he went forth from his palace in a robe of silver, and at sunset he returned to it again in a robe of gold. The people flung themselves on the ground and hid their faces, but I would not do so. I stood by the stall of a seller of dates and waited. When the Emperor saw me, he raised his painted eyebrows and stopped. I stood quite still, and made him no obeisance. The people marveled at my boldness, and counseled me to flee from the city. I paid no heed to them, but went and sat with the sellers of strange gods, who by reason of their craft are abominated. When I

told them what I had done, each of them gave me a god and prayed me to leave them.

"That night, as I lay on a cushion in the teahouse that is in the Street of Pomegranates, the guards of the Emperor entered and led me to the palace. As I went in they closed each door behind me, and put a chain across it. Inside was a great court with an arcade running all round. The walls were of white alabaster, set here and there with blue and green tiles. The pillars were of green marble, and the pavements of a kind of peach-blossom marble. I had never seen anything like it before.

"As I passed across the court two veiled women looked down from a balcony and cursed me. The guards hastened on, and the butts of the lances rang upon the polished floor. They opened a gate of wrought ivory, and I found myself in a watered garden of seven terraces. It was planted with tulip cups and moonflowers, and silver-studded aloes. Like a slim reed of crystal a fountain hung in the dusky air. The cypress trees were like burnt-out torches. From one of them a nightingale was singing.

"At the end of the garden stood a little pavilion. As we approached it two eunuchs came out to meet us. Their fat bodies swayed as they walked, and they glanced curiously at me with their yellow-lidded eyes. One of them drew aside the captain of the guard, and in a low voice whispered to him. The other kept munching scented pastilles, which he took with an affected gesture out of an oval box of lilac enamel.

"After a few moments the captain of the guard dismissed the soldiers. They went back to the palace, the eunuchs following slowly behind and plucking the sweet mulberries from the trees as they passed. Once the elder of the two turned round, and smiled at me with an evil smile.

"Then the captain of the guard motioned me towards the entrance of the pavilion. I walked on without trembling, and drawing the heavy curtain aside I entered in.

"The young Emperor was stretched on a couch of dyed lion skins, and a ger-falcon perched upon his wrist. Behind him stood a brass-turbaned Nubian, naked down to the waist, and with heavy earrings in his split ears. On a table by the side of the couch lay a mighty scimitar of steel.

"When the Emperor saw me he frowned, and said to me, 'What is thy name? Knowest thou not that I am Emperor of this city?' But I made him no answer.

"He pointed with his finger at the simitar, and the Nubian seized it, and rushing forward struck at me with great violence. The blade whizzed through me, and did me no hurt. The man fell sprawling on the floor, and when he rose up his teeth chattered with terror and he hid himself behind the couch.

"The Emperor leapt to his feet, and taking a lance from a stand of arms, he threw it at me. I caught it in its flight, and brake the shaft into two pieces. He shot at me with an arrow, but I held up my hands and it stopped in midair. Then he drew a dagger from a belt of white leather, and stabbed the Nubian in the throat lest the slave should tell of his dishonor. The man writhed like a trampled snake, and a red foam bubbled from his lips.

"As soon as he was dead the Emperor turned to me, and when he had wiped away the bright sweat from his brow with a little napkin of purfled and purple silk, he said to me, 'Art thou a prophet, that I may not harm thee, or the son of a prophet, that I can do thee no hurt? I pray thee leave my city tonight, for while thou art in it I am no longer its lord.'

"And I answered him, 'I will go for half of thy treasure. Give me half of thy treasure, and I will go away.'

"He took me by the hand, and led me out into the garden. When the captain of the guard saw me, he wondered. When the eunuchs saw me, their knees shook and they fell upon the ground in fear.

"There is a chamber in the palace that has eight walls of red porphyry, and a brass-scaled ceiling hung with lamps. The Emperor touched one of the walls and it opened, and we passed down a corridor that was lit with many torches. In niches upon each side stood great wine jars filled to the brim with silver pieces. When we reached the center of the corridor the Emperor spoke the word that may not be spoken, and a granite door swung back on a secret spring, and he put his hands before his face lest his eyes should be dazzled.

"Thou couldst not believe how marvelous a place it was.

73

There were huge tortoiseshells full of pearls, and hollowed moonstones of great size piled up with red rubies. The gold was stored in coffers of elephant hide, and the golddust in leather bottles. There were opals and sapphires, the former in cups of crystal, and the latter in cups of jade. Round green emeralds were ranged in order upon thin plates of ivory, and in one corner were silk bags filled, some with turquoise stones, and others with beryls. The ivory horns were heaped with purple amethysts, and the horns of brass with chalcedonies and sards. The pillars, which were of cedar, were hung with strings of yellow lynx stones. In the flat oval shields there were carbuncles both wine colored and colored like grass. And yet I have told thee but a tithe of what was there.

"And when the Emperor had taken away his hands from before his face he said to me: 'This is my house of treasure, and half that is in it is thine, even as I promised to thee. And I will give thee camels and camel drivers, and they shall do thy bidding and take thy share of the treasure to whatever part of the world thou desirest to go. And the thing shall be done tonight, for I would not that the Sun, who is my father should see that there is in my city a man whom I cannot slay.'

"But I answered him, 'The gold that is here is thine, and the silver also is thine, and thine are the precious jewels and the things of price. As for me, I have no need of these. Nor shall I take aught from thee but that little ring that thou wearest on the finger of thy hand.'

"And the Emperor frowned. 'It is but a ring of lead,' he cried, 'nor has it any value. Therefore take thy half of the treasure and go from my city.'

" 'Nay,' I answered, 'but I will take naught but that leaden ring, for I know what is written within it, and for what purpose.'

"And the Emperor trembled, and besought me and said, 'Take all the treasure and go from my city. The half that is mine shall be thine also.'

"And I did a strange thing, but what I did matters not, for in a cave that is but a day's journey from this place have I hidden the Ring of Riches. It is but a day's journey from this place, and it waits for thy coming. He who has

this Ring is richer than all the kings of the world. Come therefore and take it, and the world's riches shall be thine."

But the young Fisherman laughed. "Love is better than Riches," he cried, "and the little Mermaid loves me."

"Nay, but there is nothing better than Riches," said the Soul.

"Love is better," answered the young Fisherman, and he plunged into the deep, and the Soul went weeping away over the marshes.

And after the third year was over, the Soul came down to the shore of the sea, and called to the young Fisherman, and he rose out of the deep and said, "Why dost thou call to me?"

And the Soul answered, "Come nearer, that I may speak with thee, for I have seen marvelous things."

So he came nearer, and couched in the shallow water, and leaned his head upon his hand and listened.

And the Soul said to him, "In a city that I know of there is an inn that standeth by a river. I sat there with sailors who drank of two different-colored wines, and ate bread made of barley, and little salt fish served in bay leaves with vinegar. And as we sat and made merry, there entered to us an old man bearing a leathern carpet and a lute that had two horns of amber. And when he had laid out the carpet on the floor, he struck with a quill on the wire strings of his lute, and a girl whose face was veiled ran in and began to dance before us. Her face was veiled with a veil of gauze, but her feet were naked. Naked were her feet, and they moved over the carpet like little white pigeons. Never have I seen anything so marvelous, and the city in which she dances is but a day's journey from this place."

Now when the young Fisherman heard the words of his Soul, he remembered that the little Mermaid had no feet and could not dance. And a great desire came over him, and he said to himself. "It is but a day's journey, and I can return to my love," and he laughed and stood up in the shallow water, and strode towards the shore.

And when he had reached the dry shore he laughed again, and held out his arms to his Soul. And his Soul gave a great cry of joy and ran to meet him, and entered into

him, and the young Fisherman saw stretched before him upon the sand that shadow of the body that is the body of the Soul.

And his Soul said to him, "Let us not tarry, but get hence at once, for the Sea-gods are jealous, and have monsters that do their bidding."

So they made haste, and all that night they journeyed beneath the moon, and all the next day they journeyed beneath the sun, and on the evening of the day they came to a city.

And the young Fisherman said to his Soul, "Is this the city in which she dances of whom thou didst speak to me?"

And his Soul answered him, "It is not this city, but another. Nevertheless let us enter in."

So they entered in and passed through the streets, and as they passed through the Street of the Jewelers the young Fisherman saw a fair silver cup set forth in a booth. And his Soul said to him, "Take that silver cup and hide it."

So he took the cup and hid it in the fold of his tunic, and they went hurriedly out of the city.

And after that they had gone a league from the city, the young Fisherman frowned, and flung the cup away, and said to his Soul, "Why didst thou tell me to take this cup and hide it, for it was an evil thing to do?"

But his Soul answered him, "Be at peace, be at peace."

And on the evening of the second day they came to a city, and the young Fisherman said to his Soul, "Is this the city in which she dances of whom thou didst speak to me?"

And his Soul answered him, "It is not this city, but another. Nevertheless let us enter in."

So they entered in, and passed through the streets, and as they passed through the Street of the Sellers of Sandals, the young Fisherman saw a child standing by a jar of water. And his Soul said to him, "Smite that child." So he smote the child till it wept, and when he had done this they went hurriedly out of the city.

And after that they had gone a league from the city the young Fisherman grew wroth, and said to his Soul, "Why

didst thou tell me to smite the child, for it was an evil thing to do?"

But his Soul answered him, "Be at peace, be at peace."

And on the evening of the third day they came to a city, and the young Fisherman said to his Soul, "Is this the city in which she dances of whom thou didst speak to me?"

And his Soul answered him, "It may be that it is in this city, therefore let us enter in."

So they entered in and passed through the streets, but nowhere could the young Fisherman find the river or the inn that stood by its side. And the people of the city looked curiously at him, and he grew afraid and said to his Soul, "Let us go hence, for she who dances with white feet is not here."

But his Soul answered, "Nay, but let us tarry, for the night is dark and there will be robbers on the way."

So he sat him down in the marketplace and rested, and after a time there went by a hooded merchant who had a cloak of cloth of Tartary, and bore a lantern of pierced horn at the end of a jointed reed. And the merchant said to him, "Why dost thou sit in the marketplace, seeing that the booths are closed and the bales corded?"

And the young Fisherman answered him, "I can find no inn in this city, nor have I any kinsman who might give me shelter."

"Are we not all kinsmen?" said the merchant. "And did not one God make us? Therefore come with me, for I have a guest chamber."

So the young Fisherman rose up and followed the merchant to his house. And when he had passed through a garden of pomegranates and entered into the house, the merchant brought him rosewater in a copper dish that he might wash his hands, and ripe melons that he might quench his thirst, and set a bowl of rice and a piece of roasted kid before him.

And after that he had finished, the merchant led him to the guest chamber, and bade him sleep and be at rest. And the young Fisherman gave him thanks, and kissed the ring that was on his hand, and flung himself down on the carpets of dyed goat's hair. And when he had covered himself with a covering of black lamb's wool he fell asleep.

And three hours before dawn, and while it was still night, his Soul waked him and said to him, "Rise up and go to the room of the merchant, even to the room in which he sleepeth, and slay him, and take from him his gold, for we have need of it."

And the young Fisherman rose up and crept towards the room of the merchant, and over the feet of the merchant there was lying a curved sword, and the tray by the side of the merchant held nine purses of gold. And he reached out his hand and touched the sword, and when he touched it the merchant started and awoke, and leaping up seized himself the sword and cried to the young Fisherman, "Dost thou return evil for good, and pay with the shedding of blood for the kindness that I have shown thee?"

And his Soul said to the young Fisherman, "Strike him," and he struck him so that he swooned, and he seized then the nine purses of gold, and fled hastily through the garden of pomegranates, and set his face to the star that is the star of morning.

And when they had gone a league from the city, the young Fisherman beat his breast, and said to his Soul, "Why didst thou bid me slay the merchant and take his gold? Surely thou art evil."

But his Soul answered him, "Be at peace, be at peace."

"Nay," cried the young Fisherman, "I may not be at peace, for all that thou hast made me to do I hate. Thee also I hate, and I bid thee tell me wherefore thou hast wrought with me in this wise."

And his Soul answered him, "When thou didst send me forth into the world thou gavest me no heart, so I learned to do all these things and love them."

"What sayest thou?" murmured the young Fisherman.

"Thou knowest," answered his Soul, "thou knowest it well. Hast thou forgotten that thou gavest me no heart? I trow not. And so trouble not thyself nor me, but be at peace, for there is no pain that thou shalt not give away, nor any pleasure that thou shalt not receive."

And when the young Fisherman heard these words he trembled and said to his Soul, "Nay, but thou art evil, and hast made me forget my love, and hast tempted me with temptations, and hast set my feet in the ways of sins."

And his Soul answered him, "Thou hast not forgotten that when thou didst send me forth into the world thou gavest me no heart. Come, let us go to another city and make merry, for we have nine purses of gold."

But the young Fisherman took the nine purses of gold, and flung them down, and trampled on them.

"Nay," he cried, "but I will have naught to do with thee, nor will I journey with thee anywhere, but even as I sent thee away before, so will I send thee away now, for thou hast wrought me no good." And he turned his back to the moon, and with the little knife that had the handle of green viper's skin he strove to cut from his feet that shadow of the body which is the body of the Soul.

Yet his Soul stirred not from him, nor paid heed to his command, but said to him, "The spell that the Witch told thee avails thee no more, for I may not leave thee, nor mayest thou drive me forth. Once in his life may a man send his Soul away, but he who receiveth back his Soul must keep it with him forever, and this is his punishment and his reward."

And the young Fisherman grew pale and clenched his hands and cried, "She was a false Witch in that she told me not that."

"Nay," answered his Soul, "but she was true to Him she worships, and whose servant she will be ever."

And when the young Fisherman knew that he could no longer get rid of his Soul, and that it was an evil Soul, and would abide with him always, he fell upon the ground weeping bitterly.

And when it was day, the young Fisherman rose up and said to his Soul, "I will bind my hands that I may not do thy bidding, and close my lips that I may not speak thy words, and I will return to the place where she whom I love has her dwelling. Even to the sea will I return, and to the little bay where she is wont to sing, and I will call to her and tell her the evil I have done and the evil thou hast wrought on me,"

And his Soul tempted him and said, "Who is thy love, that thou shouldst return to her? The world has many fairer than she is. There are the dancing girls of Samaris,

who dance in the manner of all kinds of birds and beasts. Their feet are painted with henna, and in their hands they have little copper bells. They laugh while they dance, and their laughter is as clear as the laughter of water. Come with me and I will show them to thee. For what is this trouble of thine about the things of sin? Is that which is pleasant to eat not made for the eater? Is there poison in that which is sweet to drink? Trouble not thyself, but come with me to another city. There is a little city hard by in which there is a garden of tulip trees. And there dwell in this comely garden white peacocks and peacocks that have blue breasts. Their tails when they spread them to the sun are like disks of ivory and like gilt disks. And she who feeds them dances for pleasure, and sometimes she dances on her hands and at other times she dances with her feet. Her eyes are colored with stibium, and her nostrils are shaped like the wings of a swallow. From a hook in one of her nostrils hangs a flower that is carved out of a pearl. She laughs while she dances, and the silver rings that are about her ankles tinkle like bells of silver. And so trouble not thyself any more, but come with me to this city."

But the young Fisherman answered not his Soul, but closed his lips with the seal of silence and with a tight cord bound his hands, and journeyed back to the place from which he had come, and even to the little bay where his love had been wont to sing. And ever did his Soul tempt him by the way, but he made it no answer, nor would he do any of the wickedness that it sought to make him do, so great was the power of the love that was within him.

And when he had reached the shore of the sea, he loosed the cord from his hands, and took the seal of silence from his lips, and called to the little Mermaid. But she came not to his call, though he called to her all day long and besought her.

And his Soul mocked him and said, "Surely thou hast but little joy out of thy love. Thou art as one who in time of death pours water into a broken vessel. Thou gavest away what thou hast, and naught is given to thee in return. It were better for thee to come with me, for I know where the Valley of Pleasure lies, and what things are wrought there."

But the young Fisherman answered not his Soul, but in a cleft of rock he built himself a house of wattles, and abode there for the space of a year. And every morning he called to the Mermaid, and every noon he called her again, and at nighttime he spoke her name. Yet never did she rise out of the sea to meet him, nor in any place of the sea could he find her though he sought for her in the caves and in the green water, in the pools of the tide and in the wells that are at the bottom of the deep.

And ever did his Soul tempt him with evil, and whisper of terrible things. Yet did it not prevail against him, so great was the power of his love.

And after the year was over, the Soul thought within himself, "I have tempted my master with evil, and his love is stronger than I am. I will tempt him now with good, and it may be that he will come with me."

So he spoke to the young Fisherman and said, "I have told thee of the joy of the world, and thou hast turned a deaf ear to me. Suffer me now to tell thee of the world's pain, and it may be that thou wilt hearken. For of a truth pain is the Lord of this world, nor is there anyone who escapes from its net. There be some who lack raiment, and others who lack bread. There be widows who sit in purple, and widows who sit in rags. To and fro over the fens go the lepers, and they are cruel to each other. The beggars go up and down on the highways, and their wallets are empty. Through the streets of the cities walks Famine, and the Plague sits at their gates. Come, let us go forth and mend these things, and make them not to be. Wherefore shouldst thou tarry here calling to thy love, seeing she comes not to thy call? And what is love, that thou shouldst set this high store upon it?"

But the young Fisherman answered it naught, so great was the power of his love. And every morning he called to the Mermaid, and every noon he called to her again, and at nighttime he spoke her name. Yet never did she rise out of the sea to meet him, nor in any place of the sea could he find her, though he sought for her in the rivers of the sea, and in the valleys that are under the waves, in the sea that the night makes purple, and in the sea that the dawn leaves gray.

And after the second year was over, the Soul said to the young Fisherman at nighttime, and as he sat in the wattled house alone, "Lo! now I have tempted thee with evil, and I have tempted thee with good, and thy love is stronger than I am. Wherefore will I tempt thee no longer, but I pray thee to suffer me to enter thy heart, that I may be one with thee even as before."

"Surely thou mayest enter," said the young Fisherman, "for in the days when with no heart thou didst go through the world thou must have much suffered."

"Alas!" cried the Soul, "I can find no place of entrance, so compassed about with love is this heart of thine."

"Yet I would that I could help thee," said the young Fisherman.

And as he spoke there came a great cry of mourning from the sea, even the cry that men hear when one of the Seafolk is dead. And the young Fisherman leapt up, and left his wattled house, and ran down to the shore. And the black waves came hurrying to the shore, bearing with them a burden that was whiter than silver. White as the surf it was, and like a flower it tossed on the waves. And the surf took it from the waves, and the foam took it from the surf, and the shore received it, and lying at his feet the young Fisherman saw the body of the little Mermaid. Dead at his feet it was lying.

Weeping as one smitten with pain he flung himself down beside it, and he kissed the cold red of the mouth, and toyed with the wet amber of the hair. He flung himself down beside it on the sand, weeping as one trembling with joy, and in his brown arms he held it to his breast. Cold were the lips yet he kissed them. Salt was the honey of the hair, yet he tasted it with a bitter joy. He kissed the closed eyelids, and the wild spray that lay upon their cups was less salt than his tears.

And to the dead thing he made confession. Into the shells of its ears he poured the harsh wine of his tale. He put the little hands round his neck, and with his fingers he touched the thin reed of the throat. Bitter, bitter was his joy, and full of strange gladness was his pain.

The black sea came nearer, and the white foam moaned like a leper. With white claws of foam the sea grabbled at the shore. From the palace of the Sea King came the cry of

mourning again, and far out upon the sea the great Tritons blew hoarsely upon their horns.

"Flee away," said his Soul, "for ever doth the sea come nigher, and if thou tarriest it will slay thee. Flee away, for I am afraid, seeing that thy heart is closed against me by reason of the greatness of thy love. Flee away to a place of safety. Surely thou wilt not send me without a heart into another world?"

But the young Fisherman listened not to his Soul, but called on the little Mermaid and said, "Love is better than wisdom, and more precious than riches, and fairer than the feet of the daughters of men. The fires cannot destroy it, nor can the waters quench it. I called on thee at dawn, and thou didst come to my call. The moon heard thy name, yet hadst thou no heed of me. For evilly had I left thee, and to my own hurt had I wandered away. Yet ever did thy love abide with me, and ever was it strong, nor did aught prevail against it, though I have looked upon evil and looked upon good. And now that thou art dead, surely I will die with thee also."

And his Soul besought him to depart, but he would not, so great was his love. And the sea came nearer, and sought to cover him with its waves, and when he knew that the end was at hand he kissed with mad lips the cold lips of the Mermaid, and the heart that was within him broke. And as through the fullness of his love his heart did break, the Soul found an entrance and entered in, and was one with him even as before. And the sea covered the young Fisherman with its waves.

And in the morning the Priest went forth to bless the sea, for it had been troubled. And with him went the monks and the musicians, and the candlebearers, and the swingers of censers, and a great company.

And when the Priest reached the shore he saw the young Fisherman lying drowned in the surf, and clasped in his arms was the body of the little Mermaid. And he drew back frowning, and having made the Sign of the Cross, he cried aloud and said, "I will not bless the sea nor anything that is in it. Accursed be the Seafolk, and accursed be all they who traffic with them. And as for him who for love's sake forsook God, and so lieth here with his leman slain by God's judgment, take up his body and the body of his

leman, and bury them in the corner of the Field of the Fullers, and set no mark above them, nor sign of any kind, that none may know the place of their resting. For accursed were they in their lives, and accursed shall they be in their deaths also."

And the people did as he commanded them, and in the corner of the Field of the Fullers, where no sweet herbs grew, they dug a deep pit, and laid the dead things within it.

And when the third year was over, and on a day that was a holy day, the Priest went up to the chapel, that he might show to the people the wounds of the Lord, and speak to them about the wrath of God.

And when he had robed himself with his robes, and entered in and bowed himself before the altar, he saw that the altar was covered with strange flowers that never had been seen before. Strange were they to look at, and of curious beauty, and their beauty troubled him, and their odor was sweet in his nostrils, and he felt glad, and understood not why he was glad.

And after that he had opened the tabernacle, and incensed the monstrance that was in it, and shown the fair wafer to the people, and hid it again behind the veil of veils, he began to speak to the people, desiring to speak to them of the wrath of God. But the beauty of the white flowers troubled him, and their odor was sweet in his nostrils, and there came another word into his lips, and he spoke not of the wrath of God, but of the God whose name is Love. And why he so spoke, he knew not.

And when he had finished his word the people wept, and the Priest went back to his sacristy, and his eyes were full of tears. And the deacons came in and began to unrobe him, and took from him the alb and the girdle, the maniple and the stole. And he stood as one in a dream.

And after that they had unrobed him, he looked at them and said, "What are the flowers that stand on the altar, and whence do they come?"

And they answered him, "What flowers they are we cannot tell, but they come from the corner of the Fullers' Field. And the Priest trembled, and returned to his own house and prayed.

And in the morning, while it was still dawn, he went forth with the monks and the musicians, and the candle-bearers and the swingers of censers, and a great company, and came to the shore of the sea, and blessed the sea, and all the wild things that are in it. The Fauns also he blessed, and the little things that dance in the woodland, and the bright-eyed things that peer through the leaves. All the things in God's world he blessed and the people were filled with joy and wonder. Yet never again in the corner of the Fullers' Field grew flowers of any kind, but the field remained barren even as before. Nor came the Seafolk into the bay as they had been wont to do, for they went to another part of the sea.

Selma Lagerlöf

(1858–1940)

Selma Ottiliana Lovisa Lagerlöf is one of the most eminent and beloved authors of the modern era. Her fiction, much of which appeals to all ages, has been translated into at least thirty languages and during the early part of the century brought her national and international recognition. In 1904 she was awarded the prestigious gold medal of the Swedish Academy, and in 1907 she received an honorary Doctor of Philosophy degree from Upsala University, during its Linnaeus Jubilee. Two years later, in 1909, she became the first woman ever to win the Nobel Prize in literature. Half a decade later, in 1914, she also became the first woman ever to be admitted into the exclusive Swedish Academy. Her seventieth birthday was the occasion for a national holiday in Sweden; at this time she received several more awards, including the diploma of the French Legion of Honor, the Order of St. Olaf, and the Danish Distinguished Service Medal. This latter award was particularly significant: Selma Lagerlöf's fiction for younger people had become second in popularity only to that of Hans Christian Andersen.

Lagerlöf owes a great deal of her success and popularity to her early childhood. She spent this childhood, as well as the majority of her eighty-one years, on a one hundred and forty acre farm named Mårbacka in the county of Värmland in southern Sweden. In "The Story of a Story," her slightly fictionalized account of the genesis of her first novel, she says of her early environment: "They seemed to have a greater love for books and reading there than elsewhere, and an air of restfulness and peace always pervaded it." Her love of reading and listening to stories became in fact her "keenest enjoyment," since, because of chronically poor health, she couldn't romp and play with her numerous brothers, sisters, and cousins. The stories she listened

to so avidly, many of them told by her grandmother, were about the "many legends and traditions" that "hovered about the farm" and about the dense forests and rugged lands of the Värmland province.

Miss Lagerlöf immortalized the Mårbacka farmhouse as the setting for *Gösta Berling*, the first and best known of her novels, which was published in part in 1890 and in completed form in 1894. The book became an instant success and after 1895 helped to free her from her teaching duties. She had been teaching in a school in Skåne, in the far southern portion of Sweden, since 1885. She then traveled to Italy, Palestine, and the Orient, all of which became settings for her fiction. But her most successful writings remained those about Swedish country gentry and peasants, works like her volume of short stories *From a Swedish Homestead* (1899), or her novel *The Emperor of Portugallia* (1914), which are set in the rural lands and deep, legend-laden forests of Värmland. This is also the setting for her children's stories *The Adventures of Nils* (1906–1907).

Perhaps the most outstanding trait of Lagerlöf's writing is her descriptive style, which is rich in imagery and suggestive comparisons. This style is the more remarkable for coming into being during the reign in Northern literature of an austere realism. In fact, Lagerlöf admired this literature and at first tried to apply its style to her subjects. In her fictionalized account of herself she describes the conflict: "Although her brain was filled to overflowing with stories of ghosts and mad love, of wondrously beautiful women and adventure-loving cavaliers, she tried to write about it all in calm, realistic prose." She recognized the impossibility of this, however, and made the rather courageous decision to turn away from the prevailing fashion and to gamble with a more colorful and emotional style. Her success enabled her to write about real subjects, but subjects about which a magical past still lingered and could at any moment come to the fore.

As noted above, some of Lagerlöf's early fiction was generated by her travels. Out of her trip to Italy and Sicily, for example, came *The Miracles of Anti-Christ* (1897), and out of a year's travel in Egypt, Palestine, and Greece came material for the second volume of *Jerusalem* (2 vol-

umes, 1901–1902) and also for portions of *Christ Legends* (1904). It is from this latter collection of eleven Christian fantasy stories that we have taken "In the Temple."

If any city has the potential to inspire it is Jerusalem, that holiest of cities for Christians, Moslems, and Jews. It is only natural that the Wailing Wall, all that remains of the famous Jewish Temple, would have reminded Lagerlöf of St. Luke's account (II, 41–52) of the boy Jesus in the Temple. "In the Temple," however, is not simply a retelling of St. Luke's story. The biblical account is brief and factual: Joseph, Mary, and the twelve-year old Jesus go up to Jerusalem to observe the feast of the Passover. The observance completed, Mary and Joseph, thinking Jesus is with them, begin their journey home in a company of travelers. Jesus, however, has tarried behind in the city. When they finally discover his absence they return to Jerusalem to seek him. There they find him in the Temple, "sitting in the midst of the doctors, both hearing them, and asking them questions." The amazed parents ask Jesus why he has made them worry and sorrow so, and he replies that he must be about his "Father's business." Lagerlöf takes this bare-bones narrative and fleshes it out in a very interesting fashion. First of all, she adds a human dimension lacking in the original. The reader is given the opportunity not only to see inside the mind of young Jesus, but also to see the profound concern and worry of his parents. Lagerlöf succeeds in breathing life into all three characters. Secondly, and this is perhaps the most remarkable feature of "Temple," Lagerlöf interpolates three delightful fairy-tale-like elements into her rendition: the great trumpet called the Voice of the Prince of the World, Paradise Bridge, and Righteousness' Gate. Lagerlöf's use of these elements as part of the "three tests" motif so common in high fantasy not only serves to delineate the character of Jesus, but also helps give the story its mystical atmosphere. The naturalness of the blend of fantasy and biblical account reminds us of how closely related, at least in some respects, Christ legend and fairy tale really are (note, for example, how the use of the mystical number three is characteristic of both types of literature). An ingenious and moving story, "In the Temple" is a triumph of the creative imagination.

IN THE TEMPLE

by Selma Lagerlöf
(Translated by Velma Swanston Howard)

Once there was a poor family—a man, his wife, and their little son—who walked about in the big Temple at Jerusalem. The son was such a pretty child! He had hair which fell in long, even curls, and eyes that shone like stars.

The son had not been in the Temple since he was big enough to comprehend what he saw; and now his parents showed him all its glories. There were long rows of pillars and gilded altars; there were holy men who sat and instructed their pupils; there was the high priest with his breastplate of precious stones. There were the curtains from Babylon, interwoven with gold roses; there were the great copper gates, which were so heavy that it was hard work for thirty men to swing them back and forth on their hinges.

But the little boy, who was only twelve years old, did not care very much about seeing all this. His mother told him that that which she showed him was the most marvelous in all the world. She told him that it would probably be a long time before he should see anything like it again. In the poor town of Nazareth, where they lived, there was nothing to be seen but gray streets.

Her exhortations did not help matters much. The little boy looked as though he would willingly have run away from the magnificent Temple, if instead he could have got out and played on the narrow street in Nazareth.

But it was singular that the more indifferent the boy appeared, the more pleased and happy were the parents. They nodded to each other over his head, and were thoroughly satisfied.

At last, the little one looked so tired and bored that the mother felt sorry for him. "Now we have walked too far with you," said she. "Come, you shall rest a while."

She sat down beside a pillar and told him to lie down on the ground and rest his head on her knee. He did so, and fell asleep instantly.

He had barely closed his eyes when the wife said to the husband: "I have never feared anything so much as the moment when he should come here to Jerusalem's Temple. I believed that when he saw this house of God, he would wish to stay here forever."

"I, too, have been afraid of this journey," said the man. "At the time of his birth, many signs and wonders appeared which betokened that he would become a great ruler. But what could royal honors bring him except worries and dangers? I have always said that it would be best, both for him and for us, if he never became anything but a carpenter in Nazareth."

"Since his fifth year," said the mother reflectively, "no miracles have happened around him. And he does not recall any of the wonders which occurred during his early childhood. Now he is exactly like a child among other children. God's will be done above all else! But I have almost begun to hope that our Lord in His mercy will choose another for the great destinies, and let me keep my son with me."

"For my part," said the man, "I am certain that if he learns nothing of the signs and wonders which occurred during his first years, then all will go well."

"I never speak with him about any of these marvels," said the wife. "But I fear all the while that, without my having aught to do with it, something will happen which will make him understand who he is. I feared most of all to bring him to this Temple."

"You may be glad that the danger is over now," said the man. "We shall soon have him back home in Nazareth."

"I have feared the wise men in the Temple," said the woman. "I have dreaded the soothsayers who sit here on their rugs. I believed that when he should come to their notice, they would stand up and bow before the child, and greet him as Judea's King. It is singular that they do not notice his beauty. Such a child has never before come under their eyes." She sat in silence a moment and regarded the child. "I can hardly understand it," said she. "I believed that when he should see these judges, who sit in

90

the house of the Holy One and settle the people's disputes, and these teachers who talk with their pupils, and these priests who serve the Lord, he would wake up and say: 'It is here, among these judges, these teachers, these priests, that I am born to live.' "

"What happiness would there be for him to sit shut in between these pillar aisles?" interposed the man. "It is better for him to roam on the hills and mountains round about Nazareth."

The mother sighed a little. "He is so happy at home with us!" said she. "How contented he seems when he can follow the shepherds on their lonely wanderings, or when he can go out in the fields and see the husbandmen labor. I can not believe that we are treating him wrongly, when we seek to keep him for ourselves."

"We only spare him the greatest suffering," said the man.

They continued talking together in this strain until the child awoke from his slumber.

"Well," said the mother, "have you had a good rest? Stand up now, for it is drawing on towards evening, and we must return to the camp."

They were in the most remote part of the building and so began the walk towards the entrance.

They had to go through an old arch which had been there ever since the time when the first Temple was erected on this spot; and near the arch, propped against a wall stood an old copper trumpet, enormous in length and weight, almost like a pillar to raise to the mouth and play upon. It stood there dented and battered, full of dust and spiders' webs, inside and outside, and covered with an almost invisible tracing of ancient letters. Probably a thousand years had gone by since any one had tried to coax a tone out of it.

But when the little boy saw the huge trumpet, he stopped—astonished! "What is that?" he asked.

"That is the great trumpet called the Voice of the Prince of this World," replied the mother. "With this, Moses called together the Children of Israel, when they were scattered over the wilderness. Since his time no one has been able to coax a single tone from it. But he who can do this, shall gather all the peoples of earth under his dominion."

She smiled at this, which she believed to be an old myth; but the little boy remained standing beside the big trumpet until she called him. This trumpet was the first thing he had seen in the Temple that he liked.

They had not gone far before they came to a big, wide Temple court. Here, in the mountain foundation itself, was a chasm, deep and wide—just as it had been from time immemorial. This chasm King Solomon had not wished to fill in when he built the Temple. No bridge had been laid over it; no enclosure had he built around the steep abyss. But instead, he had stretched across it a sword of steel, several feet long, sharpened, and with the blade up. And after ages and ages and many changes, the sword still lay across the chasm. Now it had almost rusted away. It was no longer securely fastened at the ends, but trembled and rocked as soon as any one walked with heavy steps in the Temple court.

When the mother took the boy in a roundabout way past the chasm, he asked: "What bridge is this?"

"It was placed there by King Solomon," answered the mother, "and we call it Paradise Bridge. If you can cross the chasm on this trembling bridge, whose surface is thinner than a sunbeam, then you can be sure of getting to Paradise."

She smiled and moved away; but the boy stood still and looked at the narrow, trembling steel blade until she called him.

When he obeyed her, she sighed because she had not shown him these two remarkable things sooner, so that he might have had sufficient time to view them.

Now they walked on without being detained, till they came to the great entrance portico with its columns, five-deep. Here, in a corner, were two black marble pillars erected on the same foundation, and so close to each other that hardly a straw could be squeezed in between them. They were tall and majestic, with richly ornamented capitals around which ran a row of peculiarly formed beasts' heads. And there was not an inch on these beautiful pillars that did not bear marks and scratches. They were worn and damaged like nothing else in the Temple. Even the floor around them was worn smooth, and was somewhat hollowed out from the wear of many feet.

Once more the boy stopped his mother and asked: "What pillars are these?"

"They are pillars which our father Abraham brought with him to Palestine from far-away Chaldea, and which he called Righteousness' Gate. He who can squeeze between them is righteous before God and has never committed a sin."

The boy stood still and regarded these pillars with great, open eyes.

"You, surely, do not think of trying to squeeze yourself in between them?" laughed the mother. "You see how the floor around them is worn away by the many who have attempted to force their way through the narrow space; but, believe me, no one has succeeded. Make haste! I hear the clanging of the copper gates; the thirty Temple servants have put their shoulders to them."

But all night the little boy lay awake in the tent, and he saw before him nothing but Righteousness' Gate and Paradise Bridge and the Voice of the Prince of this World. Never before had he heard of such wonderful things, and he couldn't get them out of his head.

And on the morning of the next day it was the same thing: he couldn't think of anything else. That morning they were to leave for home. The parents had much to do before they took the tent down and loaded it upon a big camel, and before everything else was in order. They were not going to travel alone, but in company with many relatives and neighbors. And since there were so many, the packing naturally went on very slowly.

The little boy did not assist in the work, but in the midst of the hurry and confusion he sat still and thought about the three wonderful things.

Suddenly he concluded that he would have time enough to go back to the Temple and take another look at them. There was still much to be packed away. He could probably manage to get back from the Temple before the departure.

He hastened away without telling anyone where he was going to. He didn't think it was necessary. He would soon return, of course.

It wasn't long before he reached the Temple and entered the portico where the two pillars stood.

As soon as he saw them, his eyes danced with joy. He sat down on the floor beside them, and gazed up at them. As he thought that he who could squeeze between these two pillars was accounted righteous before God and had never committed sin, he fancied he had never seen anything so wonderful.

He thought how glorious it would be to be able to squeeze in between the two pillars, but they stood so close together that it was impossible even to try it. In this way, he sat motionless before the pillars for well-nigh an hour; but this he did not know. He thought he had looked at them only a few moments.

But it happened that, in the portico where the little boy sat, the judges of the high court were assembled to help folks settle their differences.

The whole portico was filled with people, who complained about boundary lines that had been moved, about sheep which had been carried away from the flocks and branded with false marks, about debtors who wouldn't pay.

Among them came a rich man dressed in a trailing purple robe, who brought before the court a poor widow who was supposed to owe him a few silver shekels. The poor widow cried and said that the rich man dealt unjustly with her; she had already paid her debt to him once, and now he tried to force her to pay it again, but this she could not afford to do; she was so poor that should the judges condemn her to pay, she must give her daughters to the rich man as slaves.

Then he who sat in the place of honor on the judges' bench, turned to the rich man and said: "Do you dare to swear on oath that this poor woman has not already paid you?"

Then the rich man answered: "Lord, I am a rich man. Would I take the trouble to demand my money from this poor widow, if I did not have the right to it? I swear to you that as certain as that no one shall ever walk through Righteousness' Gate does this woman owe me the sum which I demand."

When the judges heard this oath they believed him, and doomed the poor widow to leave him her daughters as slaves.

But the little boy sat close by and heard all this. He

thought to himself: what a good thing it would be if some one could squeeze through Righteousness' Gate! That rich man certainly did not speak the truth. It is a great pity about the poor old woman, who will be compelled to send her daughters away to become slaves!

He jumped upon the platform where the two pillars towered into the heights, and looked through the crack.

"Ah, that it were not altogether impossible!" thought he.

He was deeply distressed because of the poor woman. Now he didn't think at all about the saying that he who could squeeze through Righteousness' Gate was holy, and without sin. He wanted to get through only for the sake of the poor woman.

He put his shoulder in the groove between the two pillars, as if to make a way.

That instant all the people who stood under the portico, looked over toward Righteousness' Gate. For it rumbled in the vaults, and it sang in the old pillars, and they glided apart—one to the right, and one to the left—and made a space wide enough for the boy's slender body to pass between them!

Then there arose the greatest wonder and excitement! At first no one knew what to say. The people stood and stared at the little boy who had worked so great a miracle.

The oldest among the judges was the first one who came to his senses. He called out that they should lay hold on the rich merchant, and bring him before the judgment seat. And he sentenced him to leave all his goods to the poor widow, because he had sworn falsely in God's Temple.

When this was settled, the judge asked after the boy who had passed through Righteousness' Gate; but when the people looked around for him, he had disappeared. For the very moment the pillars glided apart, he was awakened, as from a dream, and remembered the home journey and his parents. "Now I must hasten away from here, so that my parents will not have to wait for me," thought he.

He knew not that he had sat a whole hour before Righteousness' Gate, but believed he had lingered there only a few minutes; therefore, he thought that he would even have time to take a look at Paradise Bridge before he left the Temple.

And he slipped through the throng of people and came to Paradise Bridge, which was situated in another part of the big temple.

But when he saw the sharp steel sword which was drawn across the chasm, he thought how the person who could walk across that bridge was sure of reaching Paradise. He believed that this was the most marvelous thing he had ever beheld; and he seated himself on the edge of the chasm to look at the steel sword.

There he sat down and though how delightful it would be to reach Paradise, and how much he would like to walk across the bridge; but at the same time he saw that it would be simply impossible even to attempt it.

Thus he sat and mused for two hours, but he did not know how the time had flown. He sat there and thought only of Paradise.

But it seems that in the court where the deep chasm was, a large altar had been erected, and all around it walked white-robed priests, who tended the altar fire and received sacrifices. In the court there were many with offerings, and a big crowd who only watched the service.

Then there came a poor old man who brought a lamb which was very small and thin, and which had been bitten by a dog and had a large wound.

The man went up to the priests with the lamb and begged that he might offer it, but they refused to accept it. They told him that such a miserable gift he could not offer to our Lord. The old man implored them to accept the lamb out of compassion, for his son lay at the point of death, and he possessed nothing else that he could offer to God for his restoration. "You must let me offer it," said he, "else my prayers will not come before God's face, and my son will die!"

"You must not believe but that I have the greatest sympathy with you," said the priest, "but in the law it is forbidden to sacrifice a damaged animal. It is just as impossible to grant your prayers, as it is it cross Paradise Bridge."

The little boy did not sit very far away, so he heard all this. Instantly he thought what a pity it was that no one could cross the bridge. Perhaps the poor man might keep his son if the lamb were sacrificed.

The old man left the Temple Court disconsolate, but the boy got up, walked over to the trembling bridge, and put his foot on it.

He didn't think at all about wanting to cross it to be certain of Paradise. His thoughts were with the poor man, whom he desired to help.

But he drew back his foot, for he thought: "This is impossible. It is much too old and rusty, and would not hold even me!"

But once again his thoughts went out to the old man whose son lay at death's door. Again he put his foot down upon the blade.

Then he noticed that it ceased to tremble, and that beneath his foot it felt broad and secure.

And when he took the next step upon it, he felt that the air around him supported him, so that he could not fall. It bore him as though he were a bird, and had wings.

But from the suspended sword a sweet tone trembled when the boy walked upon it, and one of those who stood in the court turned around when he heard the tone. He gave a cry, and then the others turned and saw the little boy tripping across the sword.

There was great consternation among all who stood there. The first who came to their senses were the priests. They immediately sent a messenger after the poor man, and when he came back they said to him: "God has performed a miracle to show us that He will accept your offering. Give us your lamb and we will sacrifice it."

When this was done they asked for the little boy who had walked across the chasm; but when they looked around for him they could not find him.

For just after the boy had crossed the chasm, he happened to think of the journey home, and of his parents. He did not know that the morning and the whole forenoon were gone, but thought: "I must make haste and get back, so that they will not have to wait. But first I want to run over and take a look at the Voice of the Prince of this World."

And he stole away through the crowd and ran over to the damp pillar aisle where the copper trumpet stood leaning against the wall.

When he saw it, and thought about the prediction that

he who could coax a tone from it should one day gather all the peoples of earth under his dominion, he fancied that never had he seen anything so wonderful! and he sat down beside it and regarded it.

He thought how great it would be to win all the peoples of earth, and how much he wished that he could blow in the old trumpet. But he understood that it was impossible, so he didn't even dare try.

He sat like this for several hours, but he did not know how the time passed. He thought only how marvelous it would be to gather all the peoples of earth under his dominion.

But it happened that in this cool passageway sat a holy man who instructed his pupils, that sat at his feet.

And now this holy man turned towards one of his pupils and told him that he was an impostor. He said the spirit had revealed to him that this youth was a stranger, and not an Israelite. And he demanded why he had sneaked in among his pupils under a false name.

Then the strange youth rose and said that he had wandered through deserts and sailed over great seas that he might hear wisdom and the doctrine of the only true God expounded. "My soul was faint with longing," he said to the holy man. "But I knew that you would not teach me if I did not say that I was an Israelite. Therefore, I lied to you, that my longing should be satisfied. And I pray that you will let me remain here with you."

But the holy man stood up and raised his arms towards heaven. "It is just as impossible to let you remain here with me, as it is that someone shall arise and blow in the huge copper trumpet, which we call the Voice of the Prince of this World! You are not even permitted to enter this part of the Temple. Leave this place at once, or my pupils will throw themselves upon you and tear you in pieces, for your presence desecrates the Temple."

But the youth stood still, and said: "I do not wish to go elsewhere, where my soul can find no nourishment. I would rather die here at your feet."

Hardly was this said when the holy man's pupils jumped to their feet, to drive him away, and when he made resistance, they threw him down and wished to kill him.

But the boy sat very near, so he heard and saw all this, and he thought: "This is a great injustice. Oh! if I could only blow in the big copper trumpet, he would be helped."

He rose and laid his hand on the trumpet. At this moment he no longer wished that he could raise it to his lips because he who could do so should be a great ruler, but because he hoped that he might help one whose life was in danger.

And he grasped the copper trumpet with his tiny hands, to try and lift it.

Then he felt that the huge trumpet raised itself to his lips. And when he only breathed, a strong, resonant tone came forth from the trumpet, and reverberated all through the great Temple.

Then they all turned their eyes and saw that it was a little boy who stood with the trumpet to his lips and coaxed from it tones which made foundations and pillars tremble.

Instantly, all the hands which had been lifted to strike the strange youth fell, and the holy teacher said to him:

"Come and sit thee here at my feet, as thou didst sit before! God hath performed a miracle to show me that it is His wish that thou shouldst be consecrated to His service."

As it drew on towards the close of day, a man and a woman came hurrying toward Jerusalem. They looked frightened and anxious, and called out to each and everyone whom they met: "We have lost our son! We thought he had followed our relatives, but none of them have seen him. Has anyone of you passed a child alone?"

Those who came from Jerusalem answered them: "Indeed, we have not seen your son, but in the Temple we saw a most beautiful child! He was like an angel from heaven, and he has passed through Righteousness' Gate."

They would glady have related, very minutely, all about this, but the parents had no time to listen.

When they had walked on a little farther, they met other persons and questioned them.

But those who came from Jerusalem wished to talk only about a most beautiful child who looked as though he had come down from heaven, and who had crossed Paradise Bridge.

They would gladly have stopped and talked about this until late at night, but the man and woman had no time to listen to them, and hurried into the city.

They walked up one street and down another without finding the child. At last they reached the Temple. As they came up to it, the woman said: "Since we are here, let us go in and see what the child is like, which they say has come down from heaven!" They went in and asked where they should find the child.

"Go straight on to where the holy teachers sit with their students. There you will find the child. The old men have seated him in their midst. They question him and he questions them, and they are all amazed at him. But all the people stand below in the Temple court, to catch a glimpse of the one who has raised the Voice of the Prince of this World to his lips."

The man and the woman made their way through the throng of people, and saw that the child who sat among the wise teachers was their son.

But as soon as the woman recognized the child she began to weep.

And the boy who sat among the wise men heard that someone wept, and he knew that it was his mother. Then he rose and came over to her, and the father and mother took him between them and went from the Temple with him.

But as the mother continued to weep, the child asked: "Why weepest thou? I came to thee as soon as I heard thy voice."

"Should I not weep?" said the mother. "I believed that thou wert lost to me."

They went out from the city and darkness came on, and all the while the mother wept.

"Why weepest thou?" asked the child. "I did not know that the day was spent. I thought it was still morning, and I came to thee as soon as I heard thy voice."

"Should I not weep?" said the mother. "I have sought for thee all day long. I believed that thou wert lost to me."

They walked the whole night, and the mother wept all the while.

When day began to dawn, the child said: "Why dost thou weep? I have not sought mine own glory, but God has let me perform miracles because He wanted to help the three poor creatures. As soon as I heard thy voice, I came to thee."

"My son," replied the mother. "I weep because thou art none the less lost to me. Thou wilt never more belong to me. Henceforth thy life ambition shall be righteousness; thy longing, Paradise; and thy love shall embrace all the poor human beings who people this earth."

Karl Gustaf Verner von Heidenstam

(1859–1940)

"The leader of a new era in our literature"—so reads the Swedish citation that accompanied the Nobel Prize in literature awarded to Verner von Heidenstam in 1916. A brilliant poet and novelist who eloquently defended romanticism at a time when stark realism dominated Swedish letters, Heidenstam was indeed the leader of a new literary era. It was his exuberant lyrical poetry and persuasive critical essays that helped generate the literary renaissance that flourished at the turn of the century in Sweden.

Descended on both sides from families of the Swedish nobility, Heidenstam was born on July 6, 1859 in Olshammar Manor on Lake Wittern. It was in this picturesque region, rich in historical traditions, that he spent his childhood. While still a youth, Verner aspired to be a painter; thus he was sent to the Stockholm Art Academy. However, in 1875, at the age of sixteen, he left the private school because of poor health. For the next ten years or so he traveled abroad, with his tutor, seeking sunnier and more temperate climes. After his travels through southern Europe (primarily Italy and Greece) and the Near East, he returned to his homeland in March 1887.

During his travels Heidenstam had continued his studies in painting, but even while working under the celebrated Gérôme in Paris his interests had been shifting to more literary art forms. This change in direction was vividly manifested through the publication of *Pilgrimage and Wander-Years* (1888), his first collection of poetry. This volume received an enthusiastic critical response, and the young writer was immediately hailed as one of Sweden's most talented and promising poets. As a matter of fact, many felt that Heidenstam's colorful and joyously unrestrained verse marked the beginning of the Swedish literary

renaissance. Close on the heels of *Pilgrimage* came "Renascence" (1889), a brilliant treatise attacking the realism of the age. Almost overnight Heidenstam had become one of Sweden's most important literary spokesmen.

Even though Heidenstam published two more volumes of poetry a few years later (*Poems* in 1895, and *New Poems* in 1915), after 1890 most of his time and energy were devoted to prose works—especially historical fiction and works of literary theory and criticism. Some of his best-known historical pieces are *Hans Alienus* (1892), a lengthy poetic allegory; *The Charles Men* (1897–98), a cycle of tales that glorifies Sweden during the time of Charles XII; *St. Bridget's Pilgrimage* (1901), featuring one of Sweden's most popular saints; and *The Tree of the Folkungs* (1905–07), a two-volume work that chronicles the rise of the Folkung dynasty.

Heidenstam wrote little after 1915, but by that time he had established himself as one of Sweden's finest contemporary authors. Like Selma Lagerlöf, he is still regarded as one of the leading romanticists of the modern age, but he is also remembered as a classical humanist who possessed remarkably strong nationalistic feelings. Besides winning the Nobel Prize in literature, he was the recipient of the Henrik Steffens Prize in 1938. He died two years later, on May 20, 1940, in Övralid, Sweden.

"St. Erik and the Abducted Maiden" is taken from *The Swedes and Their Chieftains* (1909), a hefty two-volume compendium considered by many critics to be the richest repository of Heidenstam's prodigious historical knowledge. Through colorful stories of Sweden's greatest heroes, *Chieftains* traces the nation's history from prehistoric times to the beginning of the nineteenth century. It is not surprising that Heidenstam selected Erik the Devout (Erik Jedvardsson) as one of his principal subjects. Chosen king by the Svear in 1150, Erik's ten-year reign was distinguished by some rather remarkable achievements, including a victorious crusade to Finland that ultimately resulted in the forced baptism of all Finns. Unfortunately, shortly after his return to Sweden in 1160 he was attacked and killed by the Danish prince, Magnus Henriksen. It is St. Erik's tragic death and the strange events leading up to it that form the backbone of Heidenstam's narrative.

While it is certainly true that Erik was a brave and sagacious Swedish chieftain, he is best remembered for his extraordinary piety. It is this trait that Heidenstam makes central to his tale. "St. Erik" may have begun as an historical study, but it ended as an almost perfect example of the saint's legend, an ancient literary form with roots going back as far as the 1st century A.D.

It is as saint's legend that this story must be judged. To begin with, the reader of "St. Erik" should not expect to find deep psychological probing of character. The typical saint's legend is designed to emphasize the purity and devoutness of the Christian hero to the exclusion of any other traits he or she may possess: the result, as might be expected, is one-dimensional characterization. Nor should the reader expect thematic subtlety. Saint's legends are designed primarily to enlighten and instruct: most themes involve the conflict between good and evil, and are often rather embarrassingly blatant and overt. Heidenstam's story is typical in all these respects. Furthermore, like most other saint's legends, it does not always accurately reflect historical fact—or even reality. While it is true that Erik's violent death at Upsala is handled with reasonable historical accuracy, his relationship with the ages-old Abducted Maiden and her weird company of trolls, dwarfs, and brownies is obviously not historically authentic. It is, however, this extraordinary blending of history and myth, reality and fantasy, that makes the tale so distinctive and memorable. This is the primary source of the story's mysterious ambience, and it is through this blending that Heidenstam manages to emphasize the purity and strength of his protagonist. The stature of St. Erik increases considerably due to the fact that even grotesque supernatural creatures fail either to destroy his equanimity or to disturb his spiritual calm. Heidenstam's simply told tale may not be the most complex or sophisticated of the Christian fantasies contained in this volume, but it will not take a back seat to any of them in its sincere and enthusiastic depiction of Christian virtue.

ST. ERIK AND THE
ABDUCTED MAIDEN

by Verner von Heidenstam
(Translated by Charles Wharton Stork)

It was the night before Ascension Day, Holy Thursday,
and the dwarfs had opened the doors of the mountains.
Troll-wise fishermen swung their skiffs through the reeds in
the direction the sun turns and sat with a rod in either fist.
And crooked wizards searched about on the ground, where
on this night they might pick up gold and silver with their
bare hands.

Unheeding their conjurations, Erik the Devout rode
along the path with his warriors, who were singing psalms.
On his bright curled locks was a blue cap surmounted by a
golden diadem with flat jewels, and a blue mantle hung
down over his sword. Before him was carried a banner
with a cross, under which he had been fighting in Finland
and which he now wished to hang up in his church on the
hills of Upsala.

It was dusk in the woods, and he noted that a little
dwarf with a pointed red hood was going along beside him
leading his horse. But the pious king merely shut his eyes
so as not to be disturbed at his prayers and silently shifted
the beads on his rosary. Only with the last bead did he look
up.

The dwarf emitted an evil laugh, for he had led the king
into the mountain and was trying to shut the rocky door
behind him. But Erik made the sign of the cross. It was
then impossible to close the door. Cold drops fell from the
cavern ceiling, and a troop of small villainous-looking
smiths were hammering and clamoring about a green fire.
In the farthest corner of the cave lay something which at
first appeared to be a pile of dust and blackened wood. But
with that it stirred, and a young girl raised herself and
lifted her veil. She had a round dusky face, a stone ax in
her belt, and was clad in shaggy furs.

"Stranger," she whispered somnolently as in a dream. "You made just now the sign of the hammer as Ura-Kaipa, the great chieftain, used to do when he prayed to the Stone Gods. Lives Ura-Kaipa still? Has he grown old? I was one of his thrall women. Ah! now it grows clear in my memory. In the dark of night during a snowstorm I was led away into the mountains."

"Many thousand years may have passed since then," answered Erik, "for I never remember to have seen such a human being as you."

"To me it has been as a single night," she continued more rapidly. "But neither have I ever seen such a snorting monster as you are on. Get off and sit here on my down cushions!" It was a wretched bed of moss and earth, but the trolls had bewitched her sight so that everything looked unlike itself to her. "What a fine dwelling-place! Take a torch and light yourself about!" she bade, staring at the mouldering walls of the cavern. The light she gave him was but a bit of stone. "Little brownies, lay the festal board. Ura-Kaipa's thrall desires to have speech with the unknown one and to hear news of mankind." They brought lizards, toads, and decayed wood, taking a nibble themselves in the process. But they were light eaters and were satisfied with a single bite.

"Poor captive!" said Erik. "Races have died out, and here you have slept on in this cave. Come and see for yourself how things are going on the earth!" He lifted her before him in the saddle and rode out of the mountain hall. The dwarfs followed inquisitively in a long row, making the oddest leaps and stopping only at the edge of the woods. They had gradually come to be her friends, and she was glad to perceive their hoods among the juniper bushes.

But now her eyes began to grow wide. Out on the plain by the mouth of the river the town of East Aros lay in the dawn light. It is there that modern Upsala now stands. No tents or wattled huts were there as in the encampments of Ura-Kaipa, but entire trunks were laid one upon another to make a house. Most remarkable of all, however, was the reddish mountain in the middle. "That is the Church of the Holy Trinity," explained Erik. "Men can now build with stones so that they hang high in the air without falling. But

then every little stone must be laid with careful measurement."

Only now and then did she understand any words of his speech, for the language, too, had changed. She nestled nearer to him, and his hair shirt prickled her through his outer clothing, but she felt that he had already become as a kind of father to her. She asked in alarm what that was which boomed and sang.

"Those are the bells, which cleanse the air of trolls and witchcraft."

She turned and could not keep from laughing when she saw the terrified dwarfs run back into the woods at the sound of the bells. Some tumbled forward, some on their backs. They hardly knew how to get away fast enough. With that the sun rose.

"Oh, there is the sun!" she exulted, with throbbing heart. "Oh thou radiant as ever, art thou still living?"

"Yes, that is the sun," he nodded as he lifted her out of the saddle. "We will stop here for mass," he added to his men, who were already awaiting him at the church door. There he tarried a while and administered justice to both poor and rich who had gathered about him. He did this with such mild benevolence that the disputants became gradually appeased. After that all entered the church except the girl, who remained standing before the threshold, looking up mistrustfully at the roof.

"However much Ura-Kaipa offered to the Stone Gods, he could never get them to hang in the air," she thought. "He is a marvelous man, this new chieftain. He did not tremble before the dwarfs, and now he stands just as calmly under the hanging stones."

Innumerable candles burned in the church, and pungent incense was streaming up. As she stood there thinking how all things had changed, all but the sun and the forest, she caught sight of a glittering war host approaching. She then forgot her fear and ran in among the warriors under the dome to warn the kneeling king.

"I forebode that these are my enemies of Denmark and that they covet my crown and my life," he answered softly, without rising. "Sit down by the threshold, girl, and be patient. I must hear out this beautiful mass. We men have gradually won much that is dearer to us than life."

When the mass had been sung he went out. The fight was fierce but short. Erik, the Devout, overmatched, was thrown to earth. One of his foes raised a broadsword above his neck.

"Now I shall see if he is not afraid," sobbed the girl, as she stared wonderingly in the midst of her terror.

The king's face, which had before been pale, was suffused with bright red as if of the deepest joy. "More than the earth and sun, which has just arisen," he whispered, kissing the cross of his rosary, "I love something far off, which I have never yet seen with my eyes or touched with my hands. For the love of that it is a glory and a heavenly bliss to die."

The sword fell, and where his head rolled to the ground a bright fountain sprang up. Monks and other pious men raised up the body, and the blind who touched it received again their sight. His banner with the cross was thenceforward preserved as Sweden's holiest standard, and the day of his death in May, when the wheat is in the ear and the juniper blossoms, was celebrated in even the smallest church. His bones were carried about the fields to bring a good harvest, as formerly was done with the image of Freyr, and today they lie in a silver casket in Upsala Cathedral.

But on the evening of the day when he fell there was a knocking at the gate of the mountain. "Open, dwarfs!" commanded a trembling voice. "Everything outside is new and strange for the thrall woman of Ura-Kaipa. We go better together, ye and I. Dwarfs, dwarfs, things have come to such a pass that men let themselves be killed for something far off, which they can neither see nor touch with their hands. Where will it end? With you I will sit again in the mountain and dream."

Roots and bushes wound themselves over the gate of the mountain, and hundreds of years have since gone by like fleeting winter days. Awake! thrall woman of Ura-Kaipa; come out once again, behold and wonder. It will soon be time.

Walter de la Mare

(1873–1956)

"Only in men's imagination does every truth find an effective and undeniable existence. Imagination, not invention, is the supreme master of art as of life." Although written by Joseph Conrad in his *A Personal Record* (1912), these strong sentiments could have come as naturally from the pen of his contemporary Walter de la Mare. It is the imagination that reigns supreme in the art of de la Mare, and it is the imagination that makes his works so distinctive and memorable.

An Englishman of French Huguenot and Scottish ancestry who was related on his mother's side to Robert Browning, de la Mare was born at Charlton, Kent, on April 25, 1873. He received his formal education at St. Paul's Cathedral Choir School, London, where, at the age of sixteen, he founded, edited, and contributed to *The Choristers' Journal*, the school magazine. When he left St. Paul's in 1890, the young graduate immediately accepted a bookkeeper's position in the city office of the Anglo-American (Standard) Oil Company. Although not particularly happy with his rather bland employment, de la Mare remained with the firm for eighteen years, all the while writing stories, poems, and reviews for such periodicals as *The Pall Mall Gazette*, *The Cornhill Magazine*, *The Sketch*, and *The London Times Literary Supplement*. Finally, in 1908, at the age of thirty-six, he was granted a Civil List pension of a hundred pounds a year, which allowed him to retire to the country and devote all of his time to writing. For de la Mare this was indeed a consummation for which he had long, and devoutly, wished.

His life in the country seems to have been idyllic. De la Mare not only wrote what he wanted to when he wanted to, but he also received the recognition he so richly de-

served. Besides receiving honorary doctorates from Oxford, Cambridge, St. Andrews, and Bristol universities, he was made a Companion of Honour in 1948, and five years later, at the age of eighty, he was awarded the Order of Merit. In addition, he was offered a knighthood, but modestly declined the honor. Married to Constance Ingpen, and the father of four children, de la Mare died at Twickenham, Middlesex, June 22, 1956.

De la Mare's writing career was long and remarkably productive. His first professional work to see print was "Kismet," a short story accepted by *The Sketch* in 1895, while his first full-length work, *Songs of Childhood*, was published in 1902. During these early years de la Mare used the anagrammatic pseudonym "Walter Ramal." All told, de la Mare wrote and had published nearly fifty volumes of poetry, short stories, essays, and novels. Perhaps most notable is his novel *Memoirs of a Midget* (1921), which won the Tait Black Memorial Prize for 1922. This fascinating work is thought by many critics to be not only his finest achievement, but also to be one of the greatest British novels of our century. Although each of his collections of poetry has its own particular strengths, *The Listeners and Other Poems* (1912) is of especially high quality and helped establish de la Mare as one of the foremost poets of his day. His *Come Hither* (1923) is called by Martin Seymour-Smith (*Who's Who in Twentieth Century Literature*, 1976) ". . . the best English anthology [of poetry] for children of the century"—a bold pronouncement perhaps, but one that many critics, and most children, would enthusiastically endorse. Short-story and fantasy enthusiasts will find much to their liking in such delectable collections as *Broomsticks and Other Tales* (1925), *Collected Stories for Children* (1947), and *A Beginning and Other Stories* (1955). In brief, nearly every reader, no matter what his or her tastes may be, is likely to find something of interest in the de la Mare canon.

"The Giant" is one of Walter de la Mare's most moving Christian fantasies. Delicate and poignant, and resonating with profound spiritual and psychological implications, its canvas is dominated by pastels and soft brushstrokes rather than by the bold colors and strokes so often employed in works depicting the conflict between good and evil. De la

Mare treats Peter's obsessive fears with such subtlety, sensitivity, compassion, and authenticity that the reader cannot help but empathize with him. If the reader happens to be a child, there is of course an immedate recognition of, and identity with, Peter's plight; if an adult, there is the even more remarkable and rewarding experience of hearkening back to what it was like to be a child. Fear, suggests de la Mare, is perhaps the most insidious and devastating of Satan's many weapons. Happily, Peter is administered a spiritual antidote that quickly and effectively neutralizes the paralyzing fear from which he is suffering. The sensitive reader will also share in the catharsis Peter experiences as a result of the appearance of his heavenly visitant, convincing evidence indeed of de la Mare's considerable powers as an author of Christian fantasy.

THE GIANT

by Walter de la Mare

Peter lived with his aunt, and his sister Emma, in a small house near Romford. His aunt was a woman of very fair complexion, her heavy hair was golden brown, her eyes blue; on work days she wore a broad printed apron. His sister Emma helped her aunt in the housework as best she could, out of schooltime. She would sometimes play at games with Peter, but she cared for few in which her doll could take no part. Still, Peter knew games which he might play by himself; and although sometimes he played with Emma and her doll, yet generally they played apart, she alone with her doll, and he with the people of his own imagining.

The rose-papered room above the kitchen (being the largest room upstairs) was his aunt's bedroom. There Emma also slept, in a little bed near the window. For, although in the great double bed was room enough (her aunt being but a middle-sized woman,) yet the other pillow was always smooth and undinted, and that half of the bed was always undisturbed. On Mayday primroses were strewn there, and a sprig of mistletoe at Christmas.

On a bright morning in July (for not withstanding the sun shone fiercely in the sky, yet a random wind tempered his heat), Peter went out to sit under the shadow of the wall to read his book in the garden. But when he opened the door to go out, something seemed strange to him in the garden. Whether it was the garden itself that looked or sounded strange, or himself and his thoughts that were different from usual, he could not tell. He stood on the doorstep and looked out across the grass. He wrinkled up his eyes because of the fervid sunshine that glanced bright even upon the curved blades of grass. And, while he looked across towards the foot of the garden, almost without his

knowing it his eyes began to travel up along the trees, till he was looking into the cloudless skies. He quickly averted his eyes, with water brimming over, it was so bright above. But yet, again, as he looked across, slowly his gaze wandered up from the ground into the dark blue. He fumbled with the painted covers of his book and sat down on the doorstep. He could hear the neighboring chickens clucking and scratching in the dust, and sometimes a voice in one of the gardens spoke out in the heat. But he could not read his book for glancing out of his eye along the garden. And suddenly, with a frown, he opened the door and ran back into the kitchen.

Emma was in the bedroom making the great bed. Peter climbed upstairs and began to talk to her, and while he talked drew gradually nearer and nearer to the window. And then he walked quickly away, and took hold of the brass knob of the bedpost.

"Why don't you look out of the window, Emmie?" said he.

"I'm a-making the bed, Peter, don't you see?" said Emma.

"You can see Mrs. Watts feeding the chickens," said Peter.

Emma drew aside the windowblind and looked out. Peter stood still, watching her intently.

"She's gone in now, and they are all pecking in the dust," said Emma.

"Can you see the black-and-white pussycat on our fence, Emmie?" said Peter in a soft voice.

Emma looked down towards the poplar trees at the foot of the garden.

"No," she said, "and the sparrows are pecking up the crumbs I shook out of the tablecloth, so she can't be in our garden at all."

Emma turned away from the window, and set to dusting the looking glass, unheeding her grave reflection. Peter watched her in silence awhile.

"But, Emmie, didn't you see anything else in the bottom of the garden?" he said. But he said it in so small a voice that Emma, busy at her work, did not hear him.

In the evening of that day Peter and his aunt went out to water the mignonette and the sweet williams, and the nas-

turtiums in the garden. There were slipper sweetpeas there, also, and lad's love, and tall hollyhocks twice as high as himself swaying, indeed, their topmost flower cups above his aunt's brown head. And Peter carried down the pots of water to his aunt, and watered the garden, too, with his small rose pot. Yet he could not forbear glancing anxiously and timidly towards the poplars, and following up with his eye the gigantic shape of his fancy that he found there.

"Aren't the trees sprouting up tall, Auntie?" said he, standing close beside her.

"That they are, Peter," said his aunt. "Now some for the middle bed, my man, though I'm much afeard the rosebush is done for with blight: time it blossomed long since."

"How high are the trees, Auntie?" said Peter.

"Why, surely they're a good lump higher than the house; they do grow wonderful fast," said his aunt, stooping to pluck up a weed from the bed.

"How high is the house, Auntie?" said Peter, bending down beside her.

"Bless me! I can't tell you that," said she, glancing up; "ask Mr. Ash there in his garden. Good evening, Mr. Ash; here's my little boy asking me how high the house is,— they do ask questions, to be sure."

"Well," said Mr. Ash, narrowing his eye, over the fence, "I should think, Ma'am, it were about thirty foot high; say thirty-five foot to the rim of the chimney pot."

"Is that as high as the trees?" said Peter.

"Now, which trees might you be meaning, my friend?" said Mr. Ash.

"You mean those down by the fence yonder, don't you, Peter?" said his aunt. "Poplars, aren't they? That's what he means, Mr. Ash."

"Well," said Mr. Ash, pointing the stem of his pipe towards them, "if you ask me, the poplars must be a full forty foot high, and mighty well they've growed, too, seeing as how I saw 'em planted."

Peter watched Mr. Ash attentively, as he stood there looking over the fence towards the poplar trees. But his aunt began to talk of other matters, so that Mr. Ash said no more on the subject. Yet he did not appear to have descried anything out of the common there.

114

Now the evening was darkening; already a lamp was shining at an upper window, and the crescent moon had become bright in the west. Peter stayed close beside his aunt; sometimes peeping from behind her skirts towards the trees, glancing from root to foliage, to crown, and thence into the shadowy skies, whence the daylight was fast withdrawing. By-and-by his aunt began to feel the chill of the night air. She bade Mr. Ash goodnight, and went into the house with Peter. Soon Peter heard Mr. Ash scraping his boots upon the stones. Presently he also went in, and shut his door, leaving the gardens silent now.

At this time Peter was making a rabbit hutch out of a sugar box; but tonight he had no relish for the work, and sat down with a book, while Emma learned her spelling, repeating the words to herself.

"Auntie," said Peter, looking up when the clock had ceased striking, "If Satan was to come in our garden, would he be like a man, or is he little like a hunchback?"

"Dearie me! what'll these stories put into his head next? Why, Peter, God would not let him come up into the world like that, not to hurt His dear children. But if they are bad, wicked children, and grown-up folks too for that matter, then God goes away angry, and the Spirit is grieved too. Why, my pretty, in pictures he has great dark wings, just as the angels' are beautiful and bright; but the good angels watch and guard little children and all good people."

"Then he's just as big as a man in the pictures, like Mr. Ash, not a—"

"Aunt Elizabeth has heaps of pictures of him in a book, Auntie, with all the wicked angels crowding round," said Emma; "but he's much taller than Mr. Ash, like a giant, and they are all standing up in the sky, and—"

"Yes, Emmie, that's in the book, I daresay," said her aunt, frowning at Emma, and nodding her head. "But come and sit on auntie's lap, dearie; why he looks quite scared, poor pigeon, with his stories. Auntie will tell you about little Snowwhite, shall she?—about little Snowwhite and the dwarfs?"

Peter said nothing, though his lip trembled; and albeit he asked no more questions, yet he did not attend to the story of Snowwhite.

At the beginning of the next day, Peter woke soon after

the dawning, and getting out of bed peered through the glass of his window, down the garden. The flowers were not yet unfolded in the misty air. There was no movement nor sound anywhere. The trees leaned motionless in the early morning. But towering implacable against the rosy east stood that gigantic specter of his imagination, secret and terrific there. And Peter with a sob ran back quickly to bed.

However, he mentioned nothing of his thoughts during the day, eating his breakfast, and going to school as usual. But when he reached school he had forgotten his lessons, and was kept in. Even there, alone in the vacant schoolroom, he could not learn his returned lessons because of all his vivid fears passing to and fro in his mind. As the afternoon decreased, hour by hour, towards evening, he began to hate the memory of night and bedtime. He lingered on, seeking any excuse for light and company, until Emma spoke roughly to him. "Leave off worrying, Peter, do! How you do worry!"

At last, when even his aunt grew vexed at his disobedience, Peter begged her for a light to go to bed by. At first she refused, laughing at his timidity. But, in the end, with importunities he persuaded her; and she gave him a piece of candle in his room, to be burned in a little water, in order that when he was asleep, and the burning wick should fall low, then the water would rush in and extinguish it.

It was far in the night, just when the flame of the candle leapt out into darkness with a hiss, that Peter woke from a dream, and sat up trembling in his bed. He had dreamed of a street in the distance, whither a giant became a speck, and the eye was strained in vain. Even yet he saw its undimmed length retreating back unimaginably. And, as if impelled by an influence inscrutable, he got out silently and drew back the muslin window blind. In the clear, dark air he saw the row of poplar trees; he saw that gigantic shade of fear abiding there, uplifted as with a threat, and the trembling stars of the heavens about him for a headdress.

Peter cried out in terror at the sight, hiding his eyes in his hands. And while he stood sobbing bitterly, scarcely able to take breath, his ear caught a sound in the room like the wintry shaking of dry reeds at the brink of a pool. At this new sound he caught back his sobs; his scalp seemed

to creep upon his head. He looked out between his fingers towards the bed; and he saw there an Angel standing, whose face was white and steadfast as silver, and whose eyes were pure as the white flame of the Holy Ones. His wings were to him as a covering of perfect brightness, his feet hovering in the silentness of the little room. Peter, his tears dried upon his face, could not bear to gaze long upon that steadfast figure angelical; yet it seemed as if he was now indeed come out of a dreadful vision into the pure and safe light of day; and when presently the visitant was vanished away, he went back into his still warm bed, his fear more than half abated, and fell asleep.

In the morning, when he looked out of the window, a gentle rustling rain was falling, clear in the reflected cloud light of the sun. He could hear the waterdrops running together and dripping down from leaf to leaf. He heard the sparrows chirping upon the housetop, the remote crowing of a cock. And the poplar trees were swaying their leafy tops in the cool air, as if they also had awakened refreshed from the evil perils of a dream.

Maurice Baring

(1874–1945)

Maurice Baring came from the same mold that produced John Buchan, Eric Linklater, H. Ryder Haggard, and Lord Dunsany: the cultivated Englishman who combined a love of travel and adventure with the taste for and skill in writing. A member of the foreign service, a war correspondent, and a major in the air force, Baring still found time to write approximately fifty substantive volumes of various types of literature. Included among his works, as was the case with the other distinguished gentlemen just listed, were a number of fantasies.

Baring was born into a distinguished family. His father, Edward Charles Baring, was the First Baron Revelstoke and his uncle, Evelyn Baring, was the First Earl of Cromer. After attending Eton, Baring spent two years in Germany and Italy studying languages. He then went to Trinity College, Cambridge, for one year (in 1893) but left, without taking a degree, to return to the continent and the pursuit of language studies. His genius for languages led him in 1898 to join the diplomatic service. He became an attaché in Paris and later in Copenhagen and finally in Rome before taking a post in the Foreign Office in London. He had learned Russian, so he became a foreign correspondent for the *Morning Post* in Manchuria, covering the Russo-Japanese War until it ended in 1905. From 1905 to 1912 he lived primarily in Russia but left to report on Turkey in 1909 and the Balkans in 1912. He had by this time developed a love of Russia and even wrote an outline of Russian literature, *Landmarks in Russian Literature* (1910). From 1914 to 1918 he served in the Royal Flying Corps, atttaining the rank of major and becoming a staff officer by 1918. By the age of forty-eight he had led such a full life that he

was justified in writing his autobiography, *The Puppet Show of Memory* (1922).

In the following years he produced the bulk of his writings, including faery tales, poetry, essays, biography, novels, and even a popular anthology of quotations in different languages, with his own notes and translations, called *Have You Anything to Declare?* (1936). His most popular writings were his novels of manners, among these *C* (1924), *Cat's Cradle* (1925), and *Daphne and Adeane* (1926). This last-mentioned work was translated into nearly every European language. In 1936 he suffered the first of a series of strokes that eventually brought about his death. Baring was a devout convert to Roman Catholicism and a friend of two other prominent Roman Catholic writers, G. K. Chesterton and Hilaire Belloc. A James Gunn painting of this trio hangs in the National Portrait Gallery.

"Dr. Faust's Last Day," Baring's contribution to the Faust legend, presents an interesting reversal of Goethe's *Faust*. Two points from Goethe's work provide the backdrop for Baring's story. In Goethe's version, Faust brings ruin upon a young girl and then ignobly abandons her. Also in this version, Faust comes to the brink of damnation but is finally saved, despite his ignoble behavior and his pact with the devil (knowledge in return for his soul). Baring's version indicates his disagreement with Goethe's view of Faust's just desserts. Original to Baring is his removal of "The Doctor" to sunny Naples, where, with his rationalist skepticism, he puts his bargain with the devil out of his mind completely. He thus represents, for Baring, the twentieth-century rationalist, agnostic position. Baring's simplicity of style focuses our attention on the plot, which draws us on to the memorable ending through a series of foreshadowings, beginning with the mysterious note left by the signore.

DR. FAUST'S LAST DAY

by Maurice Baring

The doctor got up at dawn, as was his wont, and as soon as
he was dressed he sat down at his desk in his library
overlooking the sea, and immersed himself in the studies
which were the lodestar of his existence. His hours were
mapped out with rigid regularity like those of a schoolboy,
and his methodical life worked as though by clockwork.
He rose at dawn and read without interruption until eight
o'clock. He then partook of some light food (he was a
strict vegetarian), after which he walked in the garden of
his house, overlooking the Bay of Naples, until ten. From
ten to twelve he received sick people, peasants from the
village, or any visitors that needed his advice or his com-
pany. At twelve he ate a frugal meal. From one o'clock
until three he enjoyed a siesta. At three he resumed his
studies, which continued without interruption until six,
when he partook of a second meal. At seven he took an-
other stroll in the village or by the seashore and remained
out of doors until nine. He then withdrew into his study,
and at midnight went to bed.

It was, perhaps, the extreme regularity of his life, com-
bined with the strict diet which he observed, that ac-
counted for his good health. This day was his seventieth
birthday, and his body was as vigorous and his mind as
alert as they had been in his fortieth year. His thick hair
and beard were scarcely gray, and the wrinkles on his
white, thoughtful face were rare. Yet the Doctor, when
questioned as to the secret of his youthfulness, being like
many learned men fond of a paradox, used to reply that
diet and regularity had nothing to do with it, and that the
Southern sun and the climate of the Neapolitan coast,
which he had chosen among all places to be the abode of

120

his old age, were in reality responsible for his excellent health.

"I lead a regular life," he used to say, "not in order to keep well, but in order to get through my work. Unless my hours were mapped out regularly I should be the prey of every idler in the place, and I should never get any work done at all."

On this day, as it was his seventieth birthday, the Doctor had asked a few friends to share his midday meal, and when he returned from his morning stroll he sent for his housekeeper to give her a few final instructions. The housekeeper, who was a voluble Italian peasant woman, after receiving his orders, handed him a piece of paper on which a few words were scrawled in reddish-brown ink, saying it had been left by a Signore.

"What Signore?" asked the Doctor, as he perused the document, which consisted of words in the German tongue to the effect that the writer regretted his absence from the Doctor's feast, but would call at midnight. It was not signed.

"He was a Signore, like all Signores," said the housekeeper; "he just left the letter and went away."

The Doctor was puzzled, and in spite of much cross-examination he was unable to extract anything more beyond the fact that he was a "Signore."

"Shall I lay one place less?" asked the housekeeper.

"Certainly not," said the Doctor. "All my guests will be present." And he threw the piece of paper on the table.

The housekeeper left the room, but she had not been gone many minutes before she returned and said that Maria, the wife of the late Giovanni, the baker, wished to speak to him. The Doctor nodded, and Maria burst into the room, sobbing.

When her tears had somewhat subsided she told her story in broken sentences. Her daughter, Margherita, who was seventeen years old, had been allowed to spend the summer at Sorrento with her late father's sister. There, it appeared, she had met a "Signore," who had given her jewels, made love to her, promised her marriage, and held clandestine meetings with her. Her aunt professed now to have been unaware of this, but Maria assured the Doctor

that her sister-in-law, who had the evil eye and had more than once trafficked with Satan, must have had knowledge of the business, even if she were not directly responsible, which was highly probable. In the meantime, Margherita's brother Anselmo had returned from the wars in the North, and, discovering the truth, had sworn to kill the Signore unless he married Margherita.

"And what do you wish me to do?" asked the Doctor, after he had listened to the story.

"Anything, anything," she answered, "only calm my son Anselmo, or else there will be a disaster."

"Who is the Signore?" asked the Doctor.

"The Conte Guido da Siena," she answered.

The Doctor reflected a moment, and then said, "I will see what can be done. The matter can be arranged. Send your son to me later." And then, after scolding Maria for not having taken proper care of her daughter, he sent her away.

As he did so he caught sight of the dirty piece of paper on his table. For one second he had the impression that the letters on it were written in blood, and he shivered, but the momentary hallucination and sense of discomfort passed immediately.

At midday the guests arrived. They consisted of Dr. Cornelius, Vienna's most learned scholar; Taddeo Mainardi, the painter; a Danish student from the University of Wittenberg; a young English nobleman, who was traveling in Italy; and Guido da Siena, philosopher and poet, who was said to be the handsomest man in Italy. The Doctor set before his guests a precious wine from Cyprus, in which he toasted them, although as a rule he drank only water. The meal was served in the cool loggia overlooking the bay, and the talk, which was of the men and books of many climes, flowed like a rippling stream on which the sunshine of laughter lightly played.

The student asked the Doctor whether in Italy men of taste took any interest in the recent experiments of a French Huguenot, who professed to be able to send people into a trance. Moreover, the patient when in the trance, so it was alleged, was able to act as a bridge between the material and the spiritual worlds, and the dead could be

summoned and made to speak through the unconscious patient.

"We take no thought of such things here," said the Doctor. "In my youth, when I studied in the North, experiments of that nature exercised a powerful sway over my mind. I dabbled in alchemy; I tried and indeed considered that I succeeded in raising spirits and visions; but two things are necessary for such a study: youth, and the mists of the Northern country. Here the generous sun kills such fantasies. There are no phantoms here. Moreover, I am convinced that in all such experiments success depends on the state of mind of the inquirer, which not only persuades, but indeed compels itself by a strange magnetic quality to see the vision it desires. In my youth I considered that I had evoked visions of Satan and Helen of Troy, and whatnot—such things are fit for the young. We graybeards have more serious things to occupy us, and when a man has one foot in the grave, he has no time to waste."

"To my mind," said the painter, "this world has sufficient beauty and mystery to satisfy the most ardent inquirer."

"But," said the Englishman, "is not this world a phantom and a dream as insubstantial as the visions of the ardent mind?"

"Men and women are the only study fit for a man," interrupted Guido; "and as for the philosopher's stone, I have found it. I found it some months ago in a garden at Sorrento. It is a pearl radiant with all the hues of the rainbow."

"With regard to that matter," said the Doctor, "we will have some talk later. The wench's brother has returned from the war. We must find her a husband."

"You misunderstand me," said Guido. "You do not think I am going to throw my precious pearl to the swine? I have sworn to wed Margherita, and wed her I shall, and that swiftly."

"Such an act of folly would only lead," said the doctor, "to your unhappiness and to hers. It is the selfish act of a fool. You must not think of it."

"Ah!" said Guido, "you are young at seventy, Doctor, but you were old at twenty-five, and you cannot know what these things mean."

"I was young in my day," said the Doctor, "and I found many such pearls; believe me, they are all very well in their native shell. To move them is to destroy their beauty."

"You do not understand," said Guido. "I have loved countless times; but she is different. You never felt the revelation of the real, true thing that is different from all the rest and transforms a man's life."

"No," said the Doctor, "I confess that to me it was always the same thing." And for the second time that day the Doctor shivered, he knew not why.

Soon after the meal was over the guests departed, and although the Doctor detained Guido and endeavored to persuade him to listen to the voice of reason and common sense, his efforts were in vain. Guido had determined to wed Margherita.

"Besides which, if I left her now, I should bring shame and ruin on her," he said.

The Doctor started—a familiar voice seemed to whisper in his ear, "She is not the first one." A strange shudder passed through him, and he distinctly heard a mocking voice laughing. "Go your way," he said, "but do not come and complain to me if you bring unhappiness on yourself and her."

Guido departed and the Doctor retired to enjoy his siesta.

For the first time during all the years he had lived at Naples the Doctor was not able to sleep. "This and the hallucinations I have suffered from today come from drinking that Cyprus wine," he said to himself.

He lay in the darkened room tossing uneasily on his bed, and sleep would not come to him. Stranger still, before his eyes fiery letters seemed to dance before him in the air. At seven o'clock he went out into the garden. Never had he beheld a more glorious evening. He strolled down towards the seashore and watched the sunset. Mount Vesuvius seemed to have dissolved into a rosy haze; the waves of the sea were phosphorescent. A fisherman was singing in his boat. The sky was an apocalypse of glory and peace.

The Doctor sighed and watched the pageant of light until it faded and the stars lit up the magical blue darkness. Then out of the night came another song—a song which seemed familiar to the doctor, although for the moment he could not place it, about a King in the Northern Country

who was faithful to the grave and to whom his dying mistress a golden beaker gave.

"Strange," thought the Doctor; "it must come from some Northern fishing smack," and he went home.

He sat reading in his study until midnight, and for the first time in thirty years he could not fix his mind on his book. For the vision of the sunset and the song of the Northern fisherman, which in some unaccountable way brought back to him the days of his youth, kept on surging up in his mind.

Twelve o'clock struck. He rose to go to bed, and as he did so he heard a loud knock at the door.

"Come in," said the Doctor, but his voice faltered ("The Cyprus wine again!" he thought), and his heart beat loudly.

The door opened and an icy draft blew into the room. The visitor beckoned, but spoke no word, and Dr. Faust rose and followed him into the outer darkness.

John Buchan

(1875–1940)

John Buchan's biography reads like one of the adventure stories for which he became so well known. He was born in Perth, Scotland, the son of a Free Church Minister. As a young man he attended Glasgow University and there took his degree in the classics. He earned a scholarship to Brasenose College, Oxford, where he excelled, taking a first-class degree in literature and winning both the Stanhope Prize for an essay and the Newdigate Prize for poetry. He went to London in 1900 to study law and was called to the Bar in 1901. In the same year he joined the staff of Lord Milner's mission to South Africa. Returning in 1903, he became a partner in a publishing firm and later a director of the Reuter Press Agency. With this background Buchan went to France as a war correspondent in 1915, returning in 1917, with the rank of colonel, as director of information. In 1927 he became a Conservative Member of Parliament. In 1935 Buchan was appointed governor-general of Canada, a position that brought him a peerage and the title of Lord Tweedsmuir. He took a leave from this position in 1938 to become chancellor of Edinburgh University. He died of a head injury from an unfortunate accident in 1940. Buchan had married in 1907 and had three sons and one daughter.

While devoting so much time to business and to the service of his country, Buchan took time to serve as an elder of the Church of Scotland in London for thirty years. He also found time, astonishingly, to produce at least sixty-eight books of history, biography, essays, short stories, and novels. For his contributions in his many areas of endeavor, Buchan received honors from numerous prestigious universities, including Oxford and Edinburgh, McGill and Toronto, Harvard and Yale. He is now best

remembered for his tales of adventure, works such as the novels *Prester John* (1910) and *The Thirty-Nine Steps* (1915), and collections of short stories such as *The Moon Endureth* (1912), which includes the present work.

Fans of C. S. Lewis who are familiar with *That Hideous Strength* will probably recall Lewis's comment about one of the characters, Mark Studdock, a modern, literal-minded rationalist; Studdock, according to Lewis, had missed reading Buchan—along with MacDonald—and as a consequence he lacked an appreciation for mystery. Lewis's appreciation for Buchan's sense of mystery, or awareness of phenomena that lay beyond the reach of rational analysis, would undoubtedly hold true for "The Rime of True Thomas." Simon Etterick, who is disturbed because he cannot remember the "fifteen heads and three parentheses" of his minister's discourse, clearly holds no appreciation for mystery. He has his eyes opened, however, through the unusual ministrations of a curlew, a coastal bird familiar in Scotland. In one sense, Simon's conflict is one familiar in literature since the Middle Ages—of Christianity opposed to the powers of faerie in a struggle for a human's soul (see also the story by Oscar Wilde in this anthology). Elements of this conflict can be found in "Thomas of Erceldoune," a medieval poem by the revered Scottish bard, Thomas the Rimer (thirteenth century), which is probably the source for Buchan's title. In another, related sense, the conflict in Buchan's story is the more universal one between the conservativeness of religion and the desire of the individual for the freedom to gain experience directly, personally. In both cases the conflict involves the spiritual welfare of the individual. The question of religion and personal freedom invites comparison between the stories of the two Scotsmen represented in this volume, Buchan and MacDonald. Dwelling too much on this conflict, however, does something of a disservice to Buchan, whose forte is the fast-moving narrative. Indeed, the entertaining plot is here, as are other Buchan attractions: humor, vivid imagery, and a delightful Scottish dialect.

THE RIME OF TRUE THOMAS

The Tale of the Respectable Whaup
and the Great Godly Man

by John Buchan

This is a story that I heard from the King of the Numidi-
ans, who with his tattered retinue encamps behind the peat
ricks. If you ask me where and when it happened I fear
that I am scarce ready with an answer. But I will vouch my
honor for its truth; and if any one seek further proof, let
him go east the town and west the town and over the fields
of Nomansland to the Long Muir, and if he find not the
King there among the peat ricks, and get not a courteous
answer to his question, then times have changed in that
part of the country, and he must continue the quest to his
Majesty's castle in Spain.

Once upon a time, says the tale, there was a Great
Godly Man, a shepherd to trade, who lived in a cottage
among heather. If you looked east in the morning, you saw
miles of moor running wide to the flames of sunrise and if
you turned your eyes west in the evening, you saw a great
confusion of dim peaks with the dying eye of the sun set in
a crevice. If you looked north, too, in the afternoon, when
the life of the day is near its end and the world grows wise,
you might have seen a country of low hills and haugh-
lands with many waters running sweet among meadows.
But if you looked south in the dusty forenoon or at hot
midday, you saw the far-off glimmer of a white road, the
roofs of the ugly little clachan of Kilmaclavers, and the
rigging of the fine new kirk of Threepdaidle.

It was a Sabbath afternoon in the hot weather, and the
man had been to kirk all the morning. He had heard a
grand sermon from the minister (or it may have been the
priest, for I am not sure of the date and the King told the
story quickly)—a fine discourse with fifteen heads and
three parentheses. He held all the parentheses and fourteen
of the heads in his memory, but he had forgotten the

fifteenth; so for the purpose of recollecting it, and also for the sake of a walk, he went forth in the afternoon into the open heather.

The whaups were crying everywhere, making the air hum like the twanging of a bow. *Poo-eelie, Poo-eelie,* they cried, *Kirlew, Kirlew, Whaup, Wha- -up.* Sometimes they came low, all but brushing him, till they drove settled thoughts from his head. Often had he been on the moors, but never had he seen such a stramash among the feathered clan. The wailing iteration vexed him, and he *shoo'd* the birds away with his arms. But they seemed to mock him and whistle in his very face, and at the flaff of their wings his heart grew sore. He waved his great stick; he picked up bits of loose moor rock and flung them wildly; but the godless crew paid never a grain of heed. The morning's sermon was still in his head, and the grave words of the minister still rattled in his ear, but he could get no comfort for this intolerable piping. At last his patience failed him and he swore unchristian words. "Deil rax the birds' thrapples," he cried.

At this all the noise was hushed and in a twinkling the moor was empty. Only one bird was left, standing on tall legs before him with its head bowed upon its breast, and its beak touching the heather.

Then the man repented his words and stared at the thing in the moss. "What bird are ye?" he asked thrawnly.

"I am a Respectable Whaup," said the bird, "and I kenna why ye have broken in on our family gathering. Once in a hundred years we foregather for decent conversation, and here we are interrupted by a muckle, sweerin' man."

Now the shepherd was a fellow of great sagacity, yet he never thought it a queer thing that he should be having talk in the mid-moss with a bird.

"What for were ye making siccan a din, then?" he asked. "D'ye no ken ye were disturbing the afternoon of the holy Sabbath?"

The bird lifted its eyes and regarded him solemnly. "The Sabbath is a day of rest and gladness," it said, "and is it no reasonable that we should enjoy the like?"

The shepherd shook his head, for the presumption staggered him. "Ye little ken what ye speak of," he said. "The

Sabbath is for them that have the chance of salvation, and it has been decreed that salvation is for Adam's race and no for the beasts that perish."

The whaup gave a whistle of scorn. "I have heard all that long ago. In my great-grandmother's time, which 'ill be a thousand years and mair syne, there came a people from the south with bright brass things on their heads and breasts and terrible swords at their thighs. And with them were some lang-gowned men who kenned the stars and would come out o' nights to talk to the deer and the corbies in their ain tongue. And one, I mind, foregathered with my great-grandmother and told her that the souls o' men flitted in the end to braw meadows where the gods bide or gaed down to the black pit which they ca'·Hell. But the souls o' birds, he said, die wi' their bodies, and that's the end o' them. Likewise in my mother's time, when there was a great abbey down yonder by the Threepdaidle Burn which they called the House of Kilmaclavers, the auld monks would walk out in the evening to pick herbs for their distillings, and some were wise and kenned the ways of bird and beast. They would crack often o' nights with my ain family, and tell them that Christ had saved the souls o' men, but that birds and beasts were perishable as the dew o' heaven. And now ye have a black-gowned man in Threepdaidle who threeps on the same overcome. Ye may a' ken something o' your ain kitchen-midden, but certes! ye ken little o' the warld beyond it."

Now this angered the man, and he rebuked the bird. "These are great mysteries," he said, "which are no to be mentioned in the ears of an unsanctified creature. What can a thing like you wi' a lang neb and twae legs like stilts ken about the next warld?"

"Weel, weel," said the whaup, "we'll let the matter be. Everything to its ain trade, and I will not dispute with ye on Metapheesics. But if ye ken something about the next warld, ye ken terrible little about this."

Now this angered the man still more, for he was a shepherd reputed to have great skill in sheep and esteemed the nicest judge of hogg and wether in all the countryside. "What ken ye about that?" he asked. "Ye may gang east to Yetholm and west to Kells, and no find a better herd."

"If sheep were a'," said the bird, "ye micht be right; but what o' the wide warld and the folk in it? Ye are Simon Etterick o' the Lowe Moss. Do ye ken aucht o' your forebears?"

"My father was a God-fearing man at the Kennelhead, and my grandfather and great-grandfather afore him. One o' our name, folk say, was shot at a dykeback by the Black Westeraw."

"If that's a'," said the bird, "ye ken little. Have ye never heard o' the little man, the fourth back from yoursel', who killed the Miller o' Bewcastle at the Lammas Fair? That was in my ain time, and from my mother I have heard o' the Covenanter who got a bullet in his wame hunkering behind the divot-dyke and praying to his Maker. There were others o' your name rode in the Hermitage forays and turned Naworth and Warkworth and Castle Gay. I have heard o' an Etterick, Sim o' the Redcleuch, who cut the throat o' Jock Johnstone in his ain house by the Annan side. And my grandmother had tales o' auld Ettericks who rade wi' Douglas and the Bruce and the ancient Kings o' Scots; and she used to tell o' others in her mother's time, terrible shock-headed men hunting the deer and rinnin' on the high moors, and bidin' in the broken stane biggings on the hill-taps."

The shepherd stared, and he, too, saw the picture. He smelled the air of battle and lust and foray, and forgot the Sabbath.

"And you yoursel'," said the bird, "are sair fallen off from the auld stock. Now ye sit and spell in books, and talk about what ye little understand, when your fathers were roaming the warld. But little cause have I to speak, for I too am a downcome. My bill is two inches shorter than my mother's, and my grandmother was taller on her feet. The warld is getting weaklier things to dwell in it, even since I mind mysel'."

"Ye have the gift o' speech, bird," said the man, "and I would hear mair." You will perceive that he had no mind of the Sabbath day or the fifteenth head of the forenoon's discourse.

"What things have I to tell ye when ye dinna ken the very hornbook o' knowledge? Besides, I am no clatter-

vengeance to tell stories in the middle o' the muir, where there are ears open high and low. There's others than me wi' mair experience and a better skill at the telling. Our clan was well acquaint wi' the reivers and lifters o' the muirs, and could crack fine o' wars and the takin of cattle. But the blue hawk that lives in the corrie o' the Dreichil can speak o' kelpies and the dwarfs that bide in the hill. The heron, the lang solemn fellow, kens o' the greenwood fairies and the wood elfins, and the wild geese that squatter on the tap o' the Muneraw will croak to ye of the merrymaidens and the girls o' the pool. The wren—him that hops in the grass below the birks—has the story of the *Lost Ladies of the Land*, which is ower ald and sad for any but the wisest to hear; and there is a wee bird bides in the heather—hill lintie men call him—who sings the 'Lay of the West Wind,' and the 'Glee of the Rowan Berries.' But what am I talking of? What are these things to you, if ye have not first heard True Thomas's Rime, which is the beginning and end o' all things?"

"I have heard no rime," said the man, "save the sacred psalms o' God's Kirk."

"Bonny rimes," said the bird. "Once I flew by the hinder end o' the Kirk and I keekit in. A wheen auld wives wi' mutches and a wheen solemn men wi' hoasts! Be sure the Rime is no like yon."

"Can ye sing it, bird?" said the man, "for I am keen to hear it."

"Me sing?" cried the bird, "me that has a voice like a craw! Na, na, I canna sing it, but maybe I can tak ye where ye may hear it. When I was young an auld bogblitter did the same to me, and sae began my education. But are ye willing and brawly willing?—for if ye get but a sough of it ye will never mair have an ear for other music."

"I am willing and brawly willing," said the man.

"Then meet me at the Gled's Cleuch Head at the sun's setting," said the bird, and it flew away.

Now it seemed to the man that in a twinkling it was sunset, and he found himself at the Gled's Cleuch Head with the bird flapping in the heather before him. The place was a long rift in the hill, made green with juniper and

hazel, where it was said True Thomas came to drink the water.

"Turn ye to the west," said the whaup, "and let the sun fall on your face; then turn ye five times round about and say after me the Rune of the Heather and the Dew." And before he knew, the man did as he was told, and found himself speaking strange words, while his head hummed and danced as if in a fever."

"Now lay ye down and put your ear to the earth," said the bird; and the man did so. Instantly a cloud came over his brain, and he did not feel the ground on which he lay or the keen hill air which blew about him. He felt himself falling deep into an abysm of space, then suddenly caught up and set among the stars of heaven. Then slowly from the stillness there welled forth music, drop by drop like the clear falling of rain, and the man shuddered for he knew that he heard the beginning of the Rime.

High rose the air, and trembled among the tallest pines and the summits of great hills. And in it were the sting of rain and the blatter of hail, the soft crush of snow and the rattle of thunder among crags. Then it quieted to the low sultry croon which told of blazing midday when the streams are parched and the bent crackles like dry tinder. Anon it was evening, and the melody dwelled among the high soft notes which mean the coming of dark and the green light of sunset. Then the whole changed to a great paean which rang like an organ through the earth. There were trumpet notes in it and flute notes and the plaint of pipes. "Come forth," it cried; "the sky is wide and it is a far cry to the world's end. The fire crackles fine o' nights below the firs, and the smell of roasting meat and wood smoke is dear to the heart of man. Fine, too, is the sting of salt and the risp of the north wind in the sheets. Come forth, one and all, to the great lands oversea, and the strange tongues and the hermit peoples. Learn before you die to follow the Piper's Son, and though your old bones bleach among gray rocks, what matter if you have had your bellyful of life and come to your heart's desire?" And the tune fell low and witching, bringing tears to the eyes and joy to the heart; and the man knew (though no one told him) that this was the first part of the Rime, the

"Song of the Open Road," the "Lilt of the Adventurer," which shall be now and ever and to the end of days.

Then the melody changed to a fiercer and sadder note. He saw his forefathers, gaunt men and terrible, run stark among woody hills. He heard the talk of the bronze-clad invader, and the jar and clangor as stone met steel. Then rose the last coronach of his own people, hiding in wild glens, starving in corries, or going hopelessly to the death. He heard the cry of the Border foray, the shouts of the famished Scots as they harried Cumberland, and he himself rode in the midst of them. Then the tune fell more mournful and slow, and Flodden lay before him. He saw the flower of the Scots gentry around their King, gashed to the breastbone, still fronting the lines of the south, though the paleness of death sat on each forehead. "The flowers of the Forest are gone," cried the lilt, and through the long years he heard the cry of the lost, the desperate, fighting for kings over the water and princes in the heather. "Who cares?" cried the air. "Man must die, and how can he die better than in the stress of fight with his heart high and alien blood on his sword? Heigh-Ho! One against twenty, a child against a host, this is the romance of life." And the man's heart swelled, for he knew (though no one told him) that this was the "Song of Lost Battles" which only the great can sing before they die.

But the tune was changing, and at the change the man shivered, for the air ran up to the high notes and then down to the deeps with an eldrich cry, like a hawk's scream at night, or a witch's song in the gloaming. It told of those who seek and never find, the quest that knows no fulfilment. "There is a road," it cried, "which leads to the Moon and the Great Waters. No changehouse cheers it, and it has no end; but it is a fine road, a braw road—who will follow it?" And the man knew, (though no one told him) that this was the "Ballad of Gray Weather," which makes him who hears it sick all the days of his life for something which he cannot name. It is the song which the birds sing on the moor in the autumn nights, and the old crow on the treetop hears and flaps his wing. It is the lilt which men and women hear in the darkening of their days, and sigh for the unforgetable; and love-sick girls get

catches of it and play pranks with their lovers. It is a song so old that Adam heard it in the Garden before Eve came to comfort him, so young that from it still flows the whole joy and sorrow of earth.

Then it ceased, and all of a sudden the man was rubbing his eyes on the hillside, and watching the falling dusk. "I have heard the Rime," he said to himself, and he walked home in a daze. The whaups were crying but none came near him, though he looked hard for the bird that had spoken with him. It may be that it was there and he did not know it, or it may be that the whole thing was only a dream; but of this I cannot say.

The next morning the man rose and went to the manse.

"I am glad to see you, Simon," said the minister, "for it will soon be the Communion Season, and it is your duty to go round with the tokens."

"True," said the man, "but it was another thing I came to talk about," and he told him the whole tale.

"There are but two ways of it, Simon," said the minister. "Either ye are the victim of witchcraft, or ye are a self-deluded man. If the former (whilk I am loth to believe), then it behoves ye to watch and pray lest ye enter into temptation. If the latter, then ye maun put a strict watch over a vagrom fancy, and ye'll be quit o' siccan whig-maleeries."

Now Simon was not listening, but staring out of the window. "There was another thing I had it in my mind to say," said he. "I have come to lift my lines, for I am thinking of leaving the place."

"And where would ye go?" asked the minister, aghast.

"I was thinking of going to Carlisle and trying my luck as a dealer, or maybe pushing on with droves to the South."

"But that's a cauld country where there are no faithfu' ministrations," said the minister.

"Maybe so, but I am not caring very muckle about ministrations," said the man, and the other looked after him in horror.

When he left the manse he went to a Wise Woman, who lived on the left side of the kirkyard above Threepdaidle burn-foot. She was very old, and sat by the ingle day and night, waiting upon death. To her he told the same tale.

135

She listened gravely, nodding with her head. "Ach," she said, "I have heard a like story before. And where will you be going?"

"I am going south to Carlisle to try the dealing and droving," said the man, "for I have some skill of sheep."

"And will ye bide there?" she asked.

"Maybe aye, and maybe no," he said. "I had half a mind to push on to the big toun or even to the abroad. A man must try his fortune."

"That's the way of men," said the old wife. "I, too, have heard the Rime, and many women who now sit decently spinning in Kilmaclavers have heard it. But a woman may hear it and lay it up in her soul and bide at hame, while a man, if he get but a glisk of it in his fool's heart, must needs up and awa' to the warld's end on some daft-like ploy. But gang your ways and fare-ye-weel. My cousin Francie heard it, and he went north wi' a white cockade in his bonnet and a sword at his side, singing 'Charlie's come hame.' And Tam Crichtoun o' the Bourhopehead got a cough o' it one simmer's morning, and the last we heard o' Tam he was fetching like a deil among the Frenchmen. Once I heard a tinkler play a sprig of it on the pipes, and a' the lads were wud to follow him. Gang your ways for I am near the end o' mine." And the old wife shook with her coughing.

So the man put up his belongings in a pack on his back and went whistling down the Great South Road.

Whether or not this tale have a moral it is not for me to say. The King (who told it me) said that it had, and quoted a scrap of Latin, for he had been at Oxford in his youth before he fell heir to his kingdom. One may hear tunes from the Rime, said he, in the thick of a storm on the scarp of a rough hill, in the soft June weather, or in the sunset silence of a winter's night. But let none, he added, pray to have the full music; for it will make him who hears it a footsore traveler in the ways o' the world and a masterless man till death.

A(lfred) E(dgar) Coppard

(1878–1957)

Ford Madox Ford once said of A. E. Coppard: "He is almost the first English prose writer to get into English prose the peculiar quality of English lyric poetry. I do not mean that he is metrical; I mean that hitherto no English prose writer has had the fancy, the turn of imagination, the wisdom, the as it were piety, and the beauty of the great seventeenth-century lyricists like Donne or Herbert—or even Herrick. And that peculiar quality is the best thing that England has to show" (*Twentieth-Century Authors*, p. 313). This is high praise, indeed, but it is praise fully earned by a remarkable English poet and short-story writer whose highly imaginative plots and poetic prose make his works so distinguished and unique.

The hallmark of Coppard's life, especially the first forty years of it, was hardship. The son of a poor tailor and a housemaid, he was born on January 4, 1878, at Folkestone, Kent. He began his formal education at the Lewes Hill Board School, Brighton, but at the age of nine, one year after his father's death from tuberculosis, he was taken out of school so that he could help support his destitute family. After working two years in London, first as a shop boy to a trousers maker and then as a messenger boy at Reuter's Telegraph Agency, the young Coppard returned to Brighton, but not to resume his education. Unfortunately, the continued poverty of his family made it imperative for him to remain a wage earner. For the next twenty years Coppard moved from one unsatisfying occupation to another, all the while pursuing his own program of self-education. During this time he became an avid reader of poetry, and even began writing some of his own verse.

A turning point in Coppard's life came in 1907 when, at

the age of twenty-nine, he moved to Oxford and began working as an accountant in an engineering firm. Although his position wasn't much more satisfying than those he had previously held, the cultural and intellectual environment of this great university city certainly was. The budding writer took full advantage of the new and exciting learning opportunities that were so readily available. He frequented the many fine bookstores and libraries; he attended public lectures offered by literary giants like W. B. Yeats and Bertrand Russell; and he discussed literature with a number of important writers, including Robert Graves and Aldous Huxley. Perhaps most importantly, it was during his Oxford sojourn that he decided to make writing his career.

In 1919, Coppard left the security of his job to devote himself entirely to writing. Financially, he had a very difficult time of it at first. However, despite the all too familiar pinch of poverty, he persisted in his literary endeavors, finally publishing, in 1921, *Adam and Eve and Pinch Me*, his first collection of short stories and the work that established his literary reputation. A year later his first collection of verse, *Hips and Haws* (1922), saw print. Now somewhat better off financially, and with his writing career safely launched, Coppard began producing a steady stream of critically acclaimed, and fairly popular, works.

Although a few other volumes of his poetry were published after 1922, Coppard was most prolific in the genre of the short story, writing enough tales to fill more than a dozen volumes, including such fine collections as *The Black Dog* (1923), *Fishmonger's Fiddle* (1925), *The Field of Mustard* (1926), *Silver Circus* (1928), *The Gollan* (1929), *Dunky Fitlow* (1933), *Ninepenny Flute* (1937), *Tapster's Tapestry* (1939), *Ugly Anna and Other Tales* (1944), *Fearful Pleasures* (1946), *The Dark-Eyed Lady: Fourteen Stories* (1947), and *Collected Tales* (1948). At least one of his books, *Pink Furniture* (1930), was written specifically for children.

Coppard lived a rather quiet and reserved life. He didn't travel much, probably because he never had much money, but he did thoroughly enjoy the inexpensive recreation of hiking, and in that mode he managed to explore most of England. He married twice, and had a son and daughter by

his second wife, Winifred May de Kok, originally a resident of the Orange Free State in South Africa. Before his death on January 18, 1957, at his home in Dunmow, Essex, he managed to complete *It's Me, Oh Lord!*, the first part of an autobiography. Its fanciful title accurately reflects the wonderfully wry sense of humor that characterized both his life and his work.

"Some books are to be tasted," said Francis Bacon, "others to be swallowed, and some few to be chewed and digested." "Simple Simon" is the kind of story that deserves to be chewed and digested at a leisurely pace. To begin with, Coppard's handling of character is both subtle and ingenious. In some ways his treatment is reminiscent of Chaucer's: both writers are remarkably economical in their character portrayals, and both create characters who represent easily recognizable human types but who still retain their individuality. Like Chaucer, too, Coppard delights in the use of irony and satire. It is a delicious irony, for example, that the title character should be named "Simple Simon," since it is he who possesses the deep and quiet wisdom so obviously lacking in most of the other characters, and that the Godly Man is distinctly devoid of Christian compassion and concern, although full enough of high-sounding platitudes. Coppard's inspired use of the language also deserves careful attention. There is certainly the touch of the poet here. Note, for example, his opening description of the protagonist:

Lonely was Simon, for he had given up all the sweet of the world and had received none of the sweet of heaven. Old now, and his house falling to ruin, he said he would go seek the sweet of heaven, for what was there in the mortal world to detain him? Not peace, certainly, for time growled and scratched at him like a mangy dog, and there were no memories to cherish; he had a heavy father, a mother who was light, and never a lay-by who had not deceived him.

We stand indebted to A. E. Coppard for leaving us "Simple Simon"—not only because we can learn a great deal from this poignant Christian parable, but also because we are so delightfully entertained while learning.

SIMPLE SIMON

by A. E. Coppard

This simple man lived lonely in a hut in the depths of a forest, just underneath three hovering trees, a pine tree and two beeches. The sun never was clear in the forest, but the fogs that rose in its unshaken shade were neither sweet nor sour. Lonely was Simon, for he had given up all the sweet of the world and had received none of the sweet of heaven. Old now, and his house falling to ruin, he said he would go seek the sweet of heaven, for what was there in the mortal world to detain him? Not peace, certainly, for time growled and scratched at him like a mangy dog, and there were no memories to cherish; he had had a heavy father, a mother who was light, and never a lay-by who had not deceived him. So he went in his tatters and his simplicity to the lord of the manor.

"I'm bound for heaven, sir," says Simon, "will you give me an old coat, or an odd rag or so? There's a hole in my shoe, sir, and good fortune slips out of it."

No—the lord of the manor said—he could not give him a decent suit, nor a shoe, nor the rags neither. Had he not let him dwell all life long in his forest? With not a finger of rent coming? Snaring the conies—(May your tongue never vex you, sir!)—and devouring the birds—(May God see me, sir!)—and cutting the fuel, snug as a bee in a big white hive. (Never a snooze of sleep, with the wind howling in the latch of it and the cracks gaping, sir!) What with the taxes and the ways of women—said the lord—he had but a scrimping time of it himself, so he had. There was neither malt in the kiln nor meal in the hopper, and there were thieves in the parish. Indeed, he would as lief go with Simon, but it was such a diggins of a way off.

So Simon went walking on until he came to the godly

140

man who lived in a blessed mansion, full of delights for the mind and eye as well as a deal of comfort for his belly.

No—the godly man said—he would not give him anything, for the Lord took no shame of a man's covering.

"Ah, but your holiness," said Simon, "I've a care to look decent when I go to the King of All."

"My poor man, how will you get there, my poor man?" he said.

"Maybe," says Simon, "I'll get a lift on my way."

"You'll get no lift," the godly man said, "for it's a hard and lonely road to travel."

"My sorrow! And I heard it was a good place to go to!"

"It is a good place, my simple man, but the road to it is difficult and empty and hard. You will get no lift, you will lose your way, you will be taken with a sickness."

"Ah, and I heard it was a good kind road, and help in the end of it and warmth and a snap of victuals."

"No doubt, no doubt, but I tell you, don't be setting yourself up for to judge of it. Go back to your home and be at peace with the world."

"Mine's all walk-on," said Simon, and turning away he looked towards his home. Distant or near there was nothing he could see but trees, not a glint of sea, and little of sky, and nothing of a hill or the roof of a friendly house— just a trap of trees as close as a large hand held before a large face, beeches and beeches, pines and pines. And buried in the middle of it was a tiny hut, sour and broken; in the time of storms the downpour would try to dash it into the ground, and the wind would try to tear it out. Well, he had had his enough of it, so he went to another man, a scholar for learning, and told him his intentions and his wishes.

"To heaven!" said the scholar. "Well, it's a fair day for that good-looking journey."

"It is indeed a fine day," said Simon. As clear as crystal it was, yet soft and mellow as snuff.

"Then content you, man Simon, and stay in it."

"Ah, sir," he says, "I've a mind and a will that makes me serve them."

"Cats will mouse and larks will sing," the scholar said,

"but you are neither the one nor the other. What you seek is hidden, perhaps hidden for ever; God remove discontent and greed from the world: why should you look on the other side of a wall—what is a wall for?"

The old man was silent.

"How long has this notion possessed you?"

The old man quavered "Since . . . since . . ." but he could say no more. A green bird flew laughing above them.

"What bird is that—what is it making that noise for?"

"It is a woodpecker, sir; he knows he can sing a song for sixpence."

The scholar stood looking up into the sky. His boots were old—well, that is the doom of all boots, just as it is of man. His clothes were out of fashion, so was his knowledge; stripped of his gentle dignity he was but dust and ashes.

"To travel from the world?" he was saying. "That is not wise."

"Ah, sir, wisdom was ever. deluding me, for I'm not more than half done—like a poor potato. First, of course, there's the things you don't know; then there's the things you do know but can't understand; then there's the things you do understand but which don't matter. Saving your presence, sir, there's a heap of understanding to be done before you're anything but a fool."

"He is not a fool who is happy; mortal pleasures decline as the bubble of knowledge grows; that's the long of it, and it's the short of it too."

Simon was silent, adding up the buttons on the scholar's tidy coat. He counted five of them, they shone like gold and looked—oh, very well they looked.

"I was happy once," then he said. "Ah, and I remember I was happy twice, yes, and three times I was happy in this world. I was not happy since . . ."

"Yes, since what?" the scholar asked him: but the old man was dumb.

"Tell me, Simon, what made you happy."

"I was happy, sir, when I first dwelled in the wood and made with my own hands a house of boards. Why—you'd not believe—but it had a chimney then, and was no ways drafty then, and was not creaky then, nor damp then; a good fine house with a door and a half door, birds about it,

142

magpies and tits and fine boy blackbirds! A lake with a score of mallards on it! And for conies and cushats you could take your oath of a meal any day in the week, and twice a day, any day. But 'tis falling with age and weather now, I see it go; the rain wears it, the moss rots it, the wind shatters it. The lake's as dry as a hen's foot, and the forest changes. What was bushes is timber now, and what was timber is ashes; the forest has spread around me and the birds have left me and gone to the border. As for conies, there's no contriving with those foxes and weasels so cunning at them; not the trace of a tail, sir, nothing but snakes and snails now. I was happy when I built that house; that's what I was; I was then."

"Ah, so, indeed. And the other times—the second time?"

"Why, that was the time I washed my feet in the lake and I saw . . ."

"What, man Simon, what did you see?"

Simon passed his hand across his brow. "I see . . . ah, well, I saw it. I saw something . . . but I forget."

"Ah, you have forgotten your happiness," said the scholar in a soft voice: "Yes, yes." He went on speaking to himself: "Death is a naked Ethiope with flaming hair. I don't want to live forever, but I want to live."

He took off his coat and gave it to Simon, who thanked him and put it on. It seemed a very heavy coat.

"Maybe," the old man mumbled, "I'll get a lift on the way?"

"May it be so. And good-bye to you," said the scholar, " 'Tis as fine a day as ever came out of Eden."

They parted so, and old Simon had not been gone an hour when the scholar gave a great shout and followed after him frantic, but he could not come up with him, for Simon had gone up in a lift to heaven—a lift with cushions in it, and a bright young girl guiding the lift, dressed like a lad, but with a sad stern voice.

Several people got into the lift, the most of them old ladies, but no children, so Simon got in too and sat on a cushion of yellow velvet. And he was near sleeping when the lift stopped of a sudden and a lady who was taken sick got out. "Drugs and lounge!" the girl called out, "Second to the right and keep straight on. Going up?"

But though there was a crowd of young people waiting

nobody else got in. They slid on again, higher and much higher. Simon dropped into sleep until the girl stopped at the fourth floor: "Refreshments," she said, "and Ladies' Cloak Room!" All the passengers got out except Simon: he sat still until they came to the floor of heaven. There he got out, and the girl waved her hand to him and said "Good-bye." A few people got in the lift. "Going down?" she cried. Then she slammed the door and it sank into a hole and Simon never laid an eye on it or her from that day for ever.

Now it was very pleasant where he found himself, very pleasant indeed and in no ways different from the fine parts of the earth. He went onwards and the first place he did come to was a farmhouse with a kitchen door. He knocked and it was opened. It was a large kitchen; it had a cracked stone floor and white rafters above it with hooks on them and shearing irons and a saddle. And there was a smoking hearth and an open oven with bright charred wood burning in it, a dairy shelf beyond with pans of cream, a bed of bracken for a dog in the corner by the pump, and a pet sheep wandering about. It had the number 100 painted on its fleece and a loud bell was tinkling round its neck. There was a fine young girl stood smiling at him; the plait of her hair was thick as a rope of onions and as shining with the glint in it. Simon said to her: "I've been a-walking, and I seem to have got a bit dampified like, just a touch o' damp in the knees of my breeches, that's all."

The girl pointed to the fire and he went and dried himself. Then he asked the girl if she would give him a true direction, and so she gave him a true direction and on he went. And he had not gone far when he saw a place just like the old forest he had come from, but all was delightful and sunny, and there was the house he had once built, as beautiful and new, with the shining varnish on the door, a pool beyond, faggots and logs in the yard, and inside the white shelves were loaded with good food, the fire burning with a sweet smell, and a bed of rest in the ingle. Soon he was slaking his hunger; then he hung up his coat on a peg of iron, and creeping into the bed he went into the long sleep in his old happy way of sleeping.

But all this time the scholar was following after him, searching under the sun, and from here to there, calling

out high and low, and questioning the traveling people: had they seen a simple man, an old man who had been but three times happy?—but not a one had seen him. He was cut to the heart with anxiety, with remorse, and with sorrow, for in a secret pocket of the coat he had given to Simon he had left—unbeknown, but he remembered it now —a wallet of sowskin, full of his own black sins, and nothing to distinguish them in any way from any other man's. It was a dark load upon his soul that the poor man might be punished with an everlasting punishment for having such a tangle of wickedness on him and he unable to explain it. An old man like that, who had been happy but the three times! He enquired upon his right hand, and upon his left hand he enquired, but not a walking creature had seen him and the scholar was mad vexed with shame. Well, he went on, and on he went, but he did not get a lift on the way. He went howling and whistling like a man who would frighten all the wild creatures down into the earth, and at last he came by a back way to the borders of heaven. There he was, all of a day behind the man he was pursuing, in a great wilderness of trees. It began to rain, a soft meandering fall that you would hardly notice for rain, but the birds gave over their whistling and a strong silence grew everywhere, hushing things. His footfall as he stumbled through briars and the wild gardens of the wood seemed to thump the whole earth, and he could hear all the small noises like the tick of a beetle and the gasping of worms. In a grove of raspberry canes he stood like a stock with the wonder of that stillness. Clouds did not move, he could but feel the rain that he could not see. Each leaf hung stiff as if it was frozen, though it was summer. Not a living thing was to be seen, and the things that were not living were not more dead than those that lived but were so secret still. He picked a few berries from the canes, and from every bush as he pulled and shook it a butterfly or a moth dropped or fluttered away, quiet and most ghostly. "An old bit of a man"—he kept repeating in his mind— "with three bits of joy, an old bit of a man."

Suddenly a turtle dove with clatter enough for a goose came to a tree beside him and spoke to him! A young dove, and it crooed on the tree branch, croo, croo, croo, and after each cadence it heaved the air into its lungs again

with a tiny sob. Well, it would be no good telling what the bird said to the scholar, for none would believe it, they could not; but speak it did. After that the scholar tramped on, and on again, until he heard voices close ahead from a group of frisky boys who were chasing a small bird that could hardly fly. As the scholar came up with them one of the boys dashed out with his cap and fell upon the fledgling and thrust it in his pocket.

Now, by God, that scholar was angry, for a thing he liked was the notes of birds tossed from bush to bush like aery bubbles, and he wrangled with the boy until the little lad took the crumpled bird out of his pocket and flung it saucily in the air as you would fling a stone. Down dropped the bird into a gulley as if it was shot, and the boys fled off. The scholar peered into the gulley, but he could not see the young finch, not a feather of it. Then he jumped into the gulley and stood quiet, listening to hear it cheep, for sure a wing would be broken, or a foot. But nothing could he see, nothing, though he could hear hundreds of grasshoppers leaping among dead leaves with a noise like pattering rain. So he turned away, but as he shifted his foot he saw beneath it the shattered bird: he had jumped upon it himself and destroyed it. He could not pick it up, it was bloody; he leaned over it, sighing: "Poor bird, poor bird, and is this your road to heaven? Or do you never share the heaven that you make?" There was a little noise then added to the leaping of the grasshoppers—it was the patter of tears he was shedding from himself. Well, when the scholar heard that he gave a good shout of laughter, and he was soon contented, forgetting the bird. He was for sitting down awhile but the thought of the old man Simon, with that sinful wallet—a rare budget of his own mad joys—urged him on till he came by the end of the wood, the rain ceasing, and beyond him the harmony of a flock roaming and bleating. Every ewe of the flock had numbers painted on it, that ran all the way up to ninety and nine.

Soon he came to the farmhouse and the kitchen and the odd sheep and a kind girl with a knot of hair as thick as a twist of bread. He told her the thing that was upon his conscience.

146

"Help me to come up with him, for I'm a day to the bad, and what shall I do? I gave him a coat, an old coat, and all my sins were hidden in it, but I'd forgotten them. He was an old quavering man with but three spells of happiness in the earthly world." He begged her to direct him to the man Simon. The smiling girl gave him a good direction, the joyful scholar hurried out and on, and in a score of minutes he was peeping in the fine hut, with his hand on the latch of the half door, and Simon snoring in bed, a quiet decent snore.

"Simon!" he calls, but he didn't wake. He shook him, but he didn't budge. There was the coat hanging down from the iron peg, so he went to it and searched it and took out the wallet. But when he opened it—a black sow-skin wallet it was, very strong with good straps—his sins were all escaped from it, not one little sin left in the least chink of the wallet, it was empty as a drum. The scholar knew something was wrong, for it was full once, and quite full.

"Well, now," thought he, scratching his head and searching his mind, "did I make a mistake of it? Would they be by chance in the very coat that is on me now, for I've not another coat to my name?" He gave it a good strong search in the patch pockets and the inside pockets and in the purse on his belt, but there was not the scrap of a tail of a sin of any sort, good or bad, in that coat, and all he found was a few cachous against the roughening of his voice.

"Did I make another mistake of it," he says again, "and put those solemn sins in the fob of my fancy waistcoat? Where are they?" he shouts out.

Simon lifted his head out of sleeping for a moment. "It was that girl with the hair," Simon said. "She took them from the wallet—they are not allowed in this place—and threw them in the pigwash."

With that he was asleep again, snoring his decent snore.

"Glory be to God," said the scholar, "am I not a great fool to have come to heaven looking for my sins!"

He took the empty wallet and tiptoed back to the world, and if he is not with the saints yet, it is with the saints he will be one day—barring he gets another budget of sins in his eager joy. And *that* I wouldn't deny him.

Kenneth Vennor Morris

(1879–1937)

It is Ursula K. Le Guin to whom fantasy enthusiasts are primarily indebted for the current renaissance of interest in the works of Kenneth Morris. In her fine essay on style, "From Elfland to Poughkeepsie" (Portland, Oregon: Pendragon Press, 1973), Le Guin includes Morris as one of three "master stylists" of modern fantasy, along with E. R. Eddison and J. R. R. Tolkien, and her claim is not exaggerated. She refers to Morris's *Book of the Three Dragons* (1930) as "a singularly fine example of the recreation of a work magnificent in its own right (the *Mabinogion*)—a literary event rather rare except in fantasy, where its frequency is perhaps proof, if one were needed, of the ever-renewed vitality of myth" (pp. 18–19).

At the time Le Guin made these remarks she also warned that the reader would have some difficulty finding Morris's works, all of which were out of print at the time. Fortunately, that situation has seen considerable improvement. In 1978, for example, Newcastle published a reprint edition of *The Fates of the Princes of Dyfed* (1913), and Arno did the same for *Book of the Three Dragons*. While most of Morris's short stories are still unavailable, at least three have been recently reprinted: "Red-Peach-Blossom Inlet" in *The Fantastic Imagination: An Anthology of High Fantasy II* (1978); "The Last Adventure of Don Quixote" in *Dreamer of Dreams: An Anthology of Fantasy* (1978); and "The Rose and the Cup" in *The Phoenix Tree: An Anthology of Myth Fantasy* (1980). Furthermore, we believe that we have helped remedy the dearth of biographical-bibliographical material available on Morris through our detailed study of the Welsh writer in *Lloyd Alexander, Evangeline Walton Ensley, Kenneth Morris: A Primary and Secondary Bibliography* (G. K. Hall, 1981).

The son of Alfred Arthur Vennor Morris, a chemical manufacturer, and Rosa Morris, née Leach, Kenneth Vennor Morris was born on July 31, 1879, at Wernoleu Bettws, District of Llanedebie, Carmarthenshire, South Wales. The Morris family was modestly wealthy, thanks to Kenneth's grandfather, William, a well-to-do tinplate manufacturer who had large holdings in the Amman Valley. In the mid-1880s, however, the family suffered a series of profound misfortunes: Kenneth's father died in 1884, his grandfather in 1885, and shortly afterwards the family tinplate business was ruined by the American Tariff Law.

As a result of all this, Kenneth and his mother moved to London in very reduced circumstances. Shortly after their arrival, in 1887, he was enrolled in Christ's Hospital, a famous school that had been attended by such luminaries as Samuel Taylor Coleridge, Charles Lamb, and Leigh Hunt. He was graduated from Christ's Hospital in 1895 with a strong background in classics, and, in 1896, he spent some time with a group of writers in Dublin. Here he formed close ties with the poet and short-story writer George Russell ("A.E."). He also joined the Theosophical Society, an organization that profoundly influenced his subsequent life and writings. By 1889 he was back in Wales (Cardiff), contributing prose and poetry to various Theosophical magazines. In 1908, at the age of twenty-nine, he came to the United States, where he became professor of history and literature at the Theosophical University in Point Loma, California. He remained in this position, teaching and writing, until he returned to Wales in 1930. He published the monthly magazine, *Y Fforum Theosophaid*, from 1930 until his death in Llandough Hospital, Cardiff, on April 21, 1937.

From a literary perspective, the twenty-two years that Morris spent in the United States were by far his most productive. History, literary criticism, poetry, fiction—Professor Morris excelled in all of these areas. It was during this period, too, that he produced his masterpieces of fantasy: *The Fates of the Princes of Dyfed* and *Book of the Three Dragons* (both retellings of the Welsh *Mabinogion*), and *The Secret Mountain and Other Stories* (1926), a splendid collection of marvelously inventive short stories.

Most of Morris's short fiction was initially published in

theosophical periodicals such as *The Raja Yoga Messenger, The Century Path,* and its successor *The Theosophical Path.* It was in *The Theosophical Path* that "The Night of Al Kadr" first saw print in July 1915, under the pseudonym (Morris used several) C. ApArthur. It is an early Morris story, but it exhibits a literary craftsmanship equal to that found in any of his later works: his descriptions are concrete and evocative; his characterizations are colorful and believable; and his narrative moves with a sinuous grace.

The metaphysical thrust of the story is also characteristic of the author. "Al Kadr," like many of Morris's fantasies, explores the relationship between human and supernatural, and between one religious belief and another. In this case, the Christian, Don Jesús, through the mystical experience he undergoes in the castle of his Moslem enemy, al-Moghrebbi, learns that true religious belief transcends all denominations. What is important, ultimately, is the individual's insight into the nature of God, his communion with the Spirit, and his ability to embrace all other human beings in a spirit of brotherly love, no matter what their particular religious creeds. Sectarian beliefs, as a matter of fact, can come to be serious obstacles to these devoutly wished-for consummations. All this, Don Jesús realizes after experiencing the mystical wonder of the Night of Al Kadr, the holiest of Muslim holidays, and he is a better Christian—and human being—for it. It is this transcending of sectarianism that is at the heart of Morris's story and that is also at the heart of his own theosophical beliefs.

THE NIGHT OF AL KADR

by C. ApArthur (Kenneth Morris)

On Jesús María Guzmán de Altanera y Palafox would go crusading; not to the Holy Land, since opportunity was lacking, but into infidel territories that lay more conveniently at hand. A day's ride from his castle of Altanera de la Cruz lay the stronghold of that stubborn pagan Ali Mumenin al-Moghrebbi; which now it seemed was likely to be lost to pagandom. A third of the spoils to Santiago de Compostella, if Aljamid should be surprised; and this even before the king's fifth had been deducted. Don Jesús was a generous and religious man.

Of the *sangre azul* was this Don Jesús: a Goth, inheriting the ruthless lordliness of the northern hordes that poured into Spain under Adolf and Walia, a thousand years before, and set up turbulent kingdoms on the ruins of the Roman province. His were still the blue eyes and flaxen hair of the north; though Spanish skies and centuries, and a few Celtic mothers perhaps, had wrought in the temper that lay beneath them a certain change for better or worse. Had made subtle and dangerous the old Teutonic bull-at-a-gate impetuosity; had turned half leopard—smooth, graceful, but clawed fearfully—what of old had been all lion and largeness. Such a transmutation may make of brutality a reasoned cruelness; but also kindles a gleam of idealism in the spaces of the soul. The wild warrior of huge feastings and potations becomes the knight much given to prayer; the old thirst for mere big deeds and adventures, a longing after warfares with some glimmer of the spiritual about them. You shall fight, now, for God, the Faith, the Saints, and the Virgin; your cause shall be sanctified; your sword drawn against something you may dub evil; behind your rape and plunder, even, there shall be a kind of vision. Herein lay the difference between Don Jesús and his

151

ancestor, the big-limbed Goth who fought under Walia. The end of the affair, he had every hope, would be indiscriminate slaughter and all the worser horrors of war: hell let loose, after the fashion of the age, on the household of al-Moghrebbi, and no restraint imposed upon its beastly gluttony. None the less, he had taken Mass with his men before ever the portcullis was raised for them to pass, and went forth in exaltation of spirit, as one commissioned of heaven. As he rode down the hill from Altanera de la Cruz in the early morning, you should see in the keen eyes of him, in the spare, aquiline face and firm jaw, possibilities of cruelty and rapacity no doubt, but also the eagle's far glance sunward and beyond, as into things unseen. —The Grand Alchemist, Nature, forever dabbles in humanity: taking these elements and those, mixing them in such and such proportions and at such and such a temperature, and experimenting always after a spiritual type. In old Spain she came very near triumph and crying *Eureka!* —alas, her miss was as bad as many a mile. A little would make Don Jesús a demon; but then, a little might make him something very like a God.

All day they rode, but for a halt at noon; by the time the sun was nearing the snow peaks westward, they had crested the last ridge of the foothills: had passed the debatable land, and were on the border, you might say, of Infidelity. Here, amid the pines they halted, and looked out towards their prey. From their feet the woods swept down steeply into the valley; beyond, in the shadow of the mountains already, or gilded with slant rays, lay the cornfields and orchards of the pagans; there wound the river, pale under the liquid blue of late afternoon; yonder, bounding the landscape, the majesty of the Sierra, deep purple in shadow, and the purple suffused with a glow of rich silver or faint gold. Far off were the peaks piled up skyward, white against a heaven in which soon the sunset roses would begin to bloom. And gaunt against the glow and gloom of the mountain, something westward of opposite, rose the crag outstanding into the valley, the hither face of it a precipice of four hundred sheer feet; and its crown the castle of Aljamid which Saint James that night should deliver into Catholic hands.

They were to wait where they were for the present, not invading the Moorish lands until after nightfall; and then with muffled hoofs, lest a hornet's nest of heathen should be roused against them before ever they came to their goal.—Of course there was no thought of ascending yonder precipice; for goats and monkeys it might serve, not for Christians. The stormable road ran up from the mountainside beyond; it was steep and easily defended, they knew; but given a surprise and a guide, not impossible, they hoped, by moonlight. And a guide Don Jesús had brought with him: one Francisco Rondón, who had been a slave in Aljamid for years, until a certain lightness of the fingers, discovered, brought him into trouble. After that he had achieved escaping; with ideas of avenging, not so much his long durance, as the stripes that had been meted out to him in punishment by the master of the slaves. It was he who had inspired Don Jesús with the design, having convinced him of its feasibility and profitable nature. Al-Moghrebbi, he knew, was likely to be in Granada that day with the bulk of his men; in any case, it was the holiest night of their Ramadan with the pagans, and there would be much feasting and little watching, after sunset, within the walls.—Of the sanctity of the enterprise Don Jesús needed no convincing.

There then they lay, chatting beneath the pines, till a call from the sentinel brought them to their feet and to the lookout. The garrison was sallying, it appeared; and somewhat late in the day to be destined for Granada. The question was: Had Ali Mumenin heard of their coming, and determined to give them battle in the valley? Unlikely, considering the strength of his walls, impregnable except to surprise (and treachery). But if so, they would take him in the ford; let the Moors be involved in the water; then would the Christians swoop. . . . So they stood by their saddles, ready to mount and thunder down at an instant; the *Cierra España!* you may say, formed in their throats for the shouting.

Dimly the Moslem warriors could be seen emerging from the castle, and for awhile, passing in full view along the road. Then they were hidden, as though the way they took were walled or ran through a ravine; presently they

153

came out on to the mountainside, leading their horses. In single file they came; in groups, in no order, straggling down into the valley; then, at the call of a silver fife or pipe, they began to assemble, and mounted.

Five hundred of them, at the least; instead of the mere fifty of the regular garrison; they would, then, be five to one against the Christians, should it come to fighting. But there were the saints of heaven also to be considered; which put the odds, to Christian thinking, very much on their own side. However, fighting there would be none, it seemed. The Moors had gathered at the foot of the crag, were a-saddle; and now, at another scream of the fife, started: not southward and east, towards the ford and the Spaniards, but northwestward and on the road to Granada. Not yet was the light so dim that one could not see the round shields, the lances, the turbaned helmets; the flutter of white robes over the coats of mail: the prancing and caracoling and beautiful steps of the horses, mostly gray or white, and all with sweeping manes and tails. White-robed horsemen and white beasts, pearl-gray all through the dusk: one could see, even at that distance, the lovely grace of the horsemanship; every ripple of motion expending itself through horse and rider, as if they were one. . . . Away they rode and out into the dimness of distance; on and up along the river bank, towards the head of the valley, the pass, and Granada. Certainly martial Santiago of Spain was with his Spaniards, who might count their victory won already. . . .

They rode down the hill before the light was quite gone; and waited, not long, for the moon to rise before fording the river. A quarter of a mile, then, along the bank, and they turned, and struck up hill under the castle rock; a watch having been posted in the valley. Thence on they led their horses, until a cork grove half way up the slope offered concealment in which these might be left; having tied them, and posted a guard, they went forward in silence. The path was easy enough, until one turned, and faced outward towards the crag of Aljamid. A neck of land, rising steeply towards the fortress, and falling away on either side in sheer cliffs, lay between the mountainside and the stronghold: a way that only goats could have traveled before patient Berber toil of old, cutting steps and

passages, made a winding, much-ramparted path, to be traveled hardly anywhere by more than one abreast, and guarded by gates at a dozen places. Aljamid was deemed impregnable; it had never changed hands by force of arms since Musa built and garrisoned it.

To one after another of these gates our Christians came, and found all guardless and wide open. They might have suspected a trap, you will say; but Rondón had confidence in his plans, and Don Jesús in him; if a trap were set, it would go hard but they would trap the trappers. So up and down, to left and right, with sudden turns the way led; only now and again one caught glimpses of the grim moon-lit towers beyond. Presently, in a sort of wide well or rampart deep bastioned, Rondón halted them. "Señor," said he, "from the top of yonder stairs, the road is straight and open; at the end of it, and before the gate, is a chasm a hundred feet deep; while the rest remain here hidden, I must have ten lithe climbers to descend and ascend that, overcome what guard may be beyond, and let down the drawbridge."

Don Jesús whispered his orders. He himself, he considered, with Saint James to aid him, would be more than equal to ten. He picked two men for sentries: one for the top of the stairs, one for the hither brink of the chasm; then, with Rondón, stole forward.

The descent, when they came to it, was no easy work for an armed man; but the Spanish moon is bright, and Don Jesús was all leopard, sound and clean of limb, and un-weakened by sinister living. Also the guide had learnt well every possible foothold. A narrow place of boulders, scorpions and sharp moon-shadows at the bottom; then the ascent, less difficult, on the other side. At half way up they came to a narrow ledge; above which the rock wall rose sheer and unbroken. But the Arabs were masters of engineering, and there was a way for one who knew the secret. Stamped upon the memory of Randón was the exact spot where you should press upon the cliff face; and now, at his touch, the rock gave, and a panel was to be shoved along its groove; which passing, they found themselves in a little chamber. Through the open door in the wall opposite came the light of a distant lantern; no one was there, and no sound was to be heard. They took that passage, and

ascended many steps; lanterns set on the floor at long intervals lighting them. Presently they came out into a little room: a place for the gate-keeper, to judge by the bunches of keys on the walls. No guard was there.

"Here, Señor, I let down the bridge and raise the port-cullis," said Rondón; and took hold upon certain cranks to begin. But the silence and the peril had been working on the nerves of his master. At each step forward the tension had grown greater; but it was the tension of a sublime exaltation. Now all the Quixote flamed up in him: pride of race and pride of faith and pride of personality. He would have no aid in his work but from the Blessed on high. Having mastered the castle, overcome the infidels and slain without sparing, he would himself raise the cross on the highest tower before ever another Spaniard should enter there to help him. "No," he said; "we shall need no aid from without. Leave it, and lead forward into Aljamid."

Rondón stared; realized the position after a moment, and then fell to entreaties; but who is to argue with a madman with drawn sword? It was death immediate, he saw, under that Christian blade; or death deferred, but devised by the devil-cunning of black Abu'l Haidara, the slave-master. . . . Well, give the saints the time implied in that deferment, and they might do something—in consideration of all he had done for them. There might be a chance to slip behind and run for it; thank heaven, he knew the way. He cried inwardly to his churchly deities, and obeyed—just in time.

Through several halls they passed, all lovely with arches and lattice tracery; and dimly lighted with lanterns set lonely here and there on great stretches of tesselated floor. Stronghold and palace in one was this Aljamid; whence Ali Mumenin, paying slight attention to his sultan at Granada, kinged it in state over his own frontier valleys; in turn harrying and harried by the Christians. (True, a little of Don Jesús' confidence was drawn from the fact that he was breaking a long truce.)

Out they came, presently, into a patio filled with moon-light and the music of a fountain, and set round with orange trees planted in huge vases. Here at last a tinkling and a thrumming came blown to them, betokening human presence not far off; and the need to find someone to fight,

to compel to surrender, was growing imperative on Don Jesús. He strode across the patio quickly, all his attention flowing towards what he should find beyond; and forbode to note the chance he was giving to Rondón. So it happened that a tale reached the waiting Spaniards, a little later, that their lord was taken and slain; that the garrison within numbered thousands, and were expecting them: were indeed on the point of sallying in force; and so it happened that by dawn these same Spaniards were well on their way to Altanera de la Cruz. Meanwhile Don Jesús, all unaware of his aloneness, had crossed the patio, passed through a doorless arch beyond, and come upon humanity at last.

A lamp, quite priceless, you would say, with its rubies, stood in the middle of the floor; beside it sat the lutanist, an African boy, not uncomely; and on a divan beyond was an old Arab, white-bearded, handsome with the beauty of wise old age, and of a gravity and dignity altogether new to this grave and dignified Spaniard. He rose and came forward as our hidalgo entered, approaching him with a mien all courtesy and kindliness. "Welcome to Aljamid, Don Jesús de Palafox," said he; and, "your grace is in his own house."

The hall was full of the scent of musk and sandalwood, and of some wonderful thing else, perceivable by a sense more intimate even than that of smell. Don Jesús' sword had sought its scabbard before the Moor had begun to speak. He had met pagans of rank before, both at war and in peace, and knew them for

> *caballeros de Granada,*
> *hijosdalgo, aunque moros;*

—to be respected, indeed, on all points save that of creed. But here there was something that roused reverence and wonder, and was not to be accounted for by anything visible. The moods that but now had been burning so bright in the Spaniard's soul, vanished: race and creed were forgotten: he felt no enmity towards this august pagan: indeed the terms *pagan* and *Christian*, had they been brought before his mind now, would have carried little meaning. Instead, there was a sense of intense ex-

pectancy: as if a curtain should be drawn back now, before which all his life he had been waiting; a feeling that the occasion was, for him, momentous, and predestined from times beyond his memory.

The Arab led him to the divan, and ordered that food should be served. "You would prefer to remain armed, Señor, or is the weight of the steel perchance an encumbrance?" Santiago of Spain, where were you now, to raise no raucous war-cry of the spirit that might save your champion from perdition? Belike the presence of sainthood in the flesh had shriveled and banished your sainthood of dream and dogma! . . . Don Jesús paused not before answering, "Señor, of your infinite courtesy—" unbuckling his sword belt, and handing the weapon to his host. A slave came, and relieved him of his armor; another with water in a golden basin, for the washing of his hands. Then they brought in a low table and dishes, from which a savory scent arose; and Don Jesús remembered that he was hungry. While he ate, the old man talked to him.

As for the substance of the talk, you may imagine it. Whoever has been the guest of a Moslem aristocrat, a descendant of the Companions of Mohammed, knows what hostly courtesy means with these people: perfect breeding, kingly manners, and above all a capacity to make one feel oneself the supreme object of the care and personal interest of his host. All this the Moor displayed, and very much more. No matter what he said, it rang with an inner importance and vitality. Could he look at will into the past life of his guest; or had he secret information as to its details and intricacies? With the infinite tact of impersonality, he shed light upon the heights and depths of it, revealing the man to himself. All this in sentences that seemed casual; that were strewn here and there, and lifted themselves afterwards, and shone out strangely, from the current of his talk. Don Jesús listened and marveled; ideals long cherished came to seem to him base or too restricted; his old spiritual exaltation grew, but had shed all credal bonds. . . . The words of his host came, luminous of the dusk within his soul; in surprise at which light, he took little note as yet of the objects illumined. But there was, it seemed, a vast, an astounding world within there; in which one might find, presently—

Mutes came in, obeying a handclap of the Moor, and removed the dishes; then brought in a board and chessmen. Don Jesús played?—Was, in fact, not inexpert; so the game began. "But first, music," said the old man. Considering the matter in after years, this was the beginning, thought Don Jesús, of what might be called supernatural: no one entered in obedience to the handclap, that time; and it was certain that they were alone. Yet the music was there; it stole into being close at hand and all about them, out of the soft lamplight and out of the musk odor: faint at first, as a mere accompaniment to thought, a grouping and melodizing of the silence. . . . The game proceeded; the chessmen were of ivory, exquisitely carven; red was the Spaniard, white the Moor. The red king's pawn was well advanced; and the Don's game all to make a queen of it. A white knight moves and threatens; the threat is countered, and the pawn goes forward;—so the game goes, a stern struggle. What?—the white pieces move in their turn, without ever the Moor stretching out a hand to move them. . . . And how is this—that Don Jesús is watching the white queen, the knight that threatened, the rook, not from his place on the divan, but from that very sixth square where his pawn—no, he himself—is standing? The board has become the world in which he lives; he is there; he is the pawn: is menaced, plans, is trepidant, is rescued, moves forward and breathes freely; one more move and the goal is reached. . . . The music grows, becomes loud and triumphant; a shout rings over the battlefield; he turns; there is one riding down upon him: a great white figure of mien relentlessly compassionate; and he is taken.

He was, as it were, wakened out of sleep by a wondrous chanting; wakened into a light, shining in the night, clearly, but supernatural, and excelling the sun at noon. He woke with the sense of having passed through fasting and spiritual search; of having long contemplated the world and man with an agony of compassionate question; which agony, as he sensed the splendor of his vision, found itself appeased.

Out of the radiant infinity he heard the boom and resonance of a voice grander than music, that shaped itself for his hearing into this:—

The Night of Al Kadr is better than a thousand months. Therein do the angels descend, and the Spirit Gabriel also, with the decrees of their Lord concerning every matter. It is Peace, until the Rosy Dawn.
—But it was as if some one of God's ultimate secrets, some revelation supernal, had been translated and retranslated *downwards* a thousand times, until reaching a plane where it might be spoken in words at all. . . . To him, listening, the verse spoke all the systole and diastole of things that be or seem; he felt within it and within himself, the Universes roll, and the Secret Spirit, the Master of the Universes, contain itself in everlasting radiant quiescence and activity. He looked out on the world and men, that before had presented themselves with such insistent incomprehensible demands to his heart; and saw them spun out from and embodying the Light of Lights. "From IT do we proceed, and unto IT shall we return," he cried; and went forth, clothed in the Peace of Al Kadr, sensible of divinity "nearer to him than his jugular vein."

The light faded, the music died into confusion; and from the confusion was born again, now martial, wild, and fierce. He rode in reckless battle, exulting in the slaying of men; was in cities besieged, and fell in the slaughter that followed their capture. Now it was one body he wore, now another: Arab, Berber, Greek, Frank, German, Spaniard. Now in war, now in trade; now crowned and acclaimed king, now sold and fettered for a slave: he flung himself into this or that business or adventure, questing a light and knowledge, forgotten indeed, but whose afterglow would not wane out of his soul. One of a host of mobile horsemen, he scoured war-smitten fields raising the *tekbir* of the Moslem; in the name of the Most Merciful slaying and slain;—yet slain or slaying, found not that for which his soul thirsted. Clad in steel, he rode a knight of the Cross; slew mightily to the warshout of *Cierra España!* But the vision of those saints on whom he called, faded always or ever his eyes closed in death: he went hungering always into the silence; burned still for desire of the flame; was disappointed of the inwardness of the faith; called in vain for a supreme shining in the dusk within. . . . And always,

it seemed, a voice from afar, from long ago, cried out to him, and might not intelligently be heard; and riding, fighting, trading, slaying, and sinning, he was without content, for longing to know what was being called. That would be the Secret, that the Glory; it was to hear and understand that, it seemed, he was thus plunging into life after life.

Night, night, night; and afar off, and obsessing his spirit with longings, dawn bloomed in the sky: dawn, all-knowledge, all-beauty: the satisfaction of the unrest and aspirations of his heart. On and on with him over the desert; dimly glittering under the glittering stars were the bones of them that had fallen in the way before him. Would there never be an end to this interminable riding? . . . Ah, here was the light; here was the splendor; here was the voice out of the sunburst: *The Night of Al Kadr is better than a thousand months . . . It is Peace until the Rosy Dawn.*

The old Moor was sitting opposite him on the divan, intoning words in an incomprehensible tongue—yet it had not been incomprehensible to Don Jesús a moment before, when he was out in the desert, and the great light shone. "Master, I know!" said he, very humbly. "It is peace. . . . it shall be peace . . . until—"

The old man rose up; beautiful his eyes with strange compassion, triumph, understanding. "Your grace will be weary after long riding," said he. "Sleep now, and peace let it be with you."

Don Jesús leaned back on the cushions and slept. Was it in dream, or was it through half-closed eyes that sleep had not quite captured, that he saw his host, luminously transfigured for a moment, then disappear?

He awoke; broad daylight shone in through the arches from the patio. Standing before him, watching him intently, was a Moorish lord whom he recognized for the redoubtable al-Moghrebbi: black-bearded, well-knit, eyed and browed like a warrior and a despot.

"A strange guest I find in my castle, Señor," said the Moor.

Don Jesús rose and bowed. What he saw before him was not a pagan, not an enemy of Christian Spain; but a fellow man: a fellow—what shall I say?—casket of the Gem of Gems, lantern of the Light of Lights, seeker in the desert after the Dawn. "I am at your disposal, Señor," said he.

"You have eaten my salt, it appears; even though unknown to me it was offered to you. I give you safe-conduct to your own borders; thereafter, knowing the strength of Aljamid, you may make choice between peace and war."

"Señor Moro," said Don Jesús—and wondered whence the words came to him—"it is Peace, until the Rosy Dawn."

"The dawn is passed, Señor. You choose war?"

"I do not choose war, Señor; either now, or at any future time. If your grace will remember that I have eaten your salt, I—I shall remember that I have passed in your stronghold a night that was—*better than a thousand months*."

Ali Mumenin eyed him curiously. "Strange words these, to come from a Christian to a Moor."

Again the Spaniard bowed. "Might we not say, Caballero, *from a man to a brother man?*"

Don Jesús meditated as he rode through the cork forest; his Moorish escort, headed by the now all-cordial al-Moghrebbi, having left him at the border. A tenth of his possessions, in commemoration of certain victories, ought certainly to be devoted to—Santiago de Compostella? Then in fairness another tenth ought to go to some Moorish shrine. On consideration, he decided that better uses might be found for both.

He lived to win the trust of Ferdinand the Catholic, and to receive from that politic, but not unkindly monarch, the Castle of Aljamid and the government of the surrounding district. Isabella removed him when she began her policy of persecution, and he retired to Altanera de la Cruz. Torquemada sent emissaries through his late government, inquiring into certain rumors anent his faith; who, sheep's-clothinged in apparent sympathy, learnt that he was certainly at heart with the conquered pagans; and probably, as

these held, an agent of the Brothers of Sincerity* himself. But crossing into the Christian territories of Altanera de la Cruz, they found an orthodox peasantry equally assured that he was, if not a Catholic saint, only waiting death and the Pope to make him one.

But a legend remained among the slaves at Aljamid until the Conquest of Granada, how that on the holiest night of Ramadan, the Night of Al Kadr, in such a year, when their lord had ridden away with the garrison in the evening, only to return at dawn unexpectedly, having heard of the presence of Christians in his valley—Aljamid had been full of the music of Paradise, the scent of musk and sandalwood, the aroma of holiness; and the Spirit Gabriel had descended, and saved them from the sword of the Spaniard. Gabriel, or as some more thoughtful held, one of the great Brothers of Sincerity, the servants of that everliving Man who is the Pillar and Axis of the World.

* According to Islamic doctrine, a secret Lodge or Brotherhood of Adepts, whose members live throughout the ages, are the Guardians of the Esoteric Wisdom, and Incarnate from time to time among men for the sake of humanity.

Charles Williams

(1886–1945)

The adage that people can know a good deal about you by the company you keep is particularly apt in the case of Charles Williams, especially if we add to that adage the clause "and by the company that seeks and admires you." In the case of Charles Williams, this company included W. H. Auden, J. R. R. Tolkien, T. S. Eliot, Dorothy Sayers, Owen Barfield, and C. S. Lewis. Williams felt quite comfortable with his more famous colleagues with whom he shared intense and active interests in literature and religion. For their part, his colleagues felt drawn to Williams as a man at once warmly human and deeply spiritual.

Unlike most of the notables mentioned above, all of whom were Oxford-educated, Williams was largely self-educated. He was born in London and attended the University of London for two years, but had to quit for financial reasons and go to work. He joined a small publisher, married a woman named Florence Conway, with whom he had one son, and settled down. He continued his schooling at night at the Workingmen's College, read widely on his own, and began writing. In 1912 he had a volume of poetry published, the first of an impressive list of publications that numbers nearly three hundred items in Lois Glenn's *Charles W. S. Williams: A Checklist*. It took the Luftwaffe to uproot him from London, and even then he would probably have stayed in London had not the Oxford University Press moved him, along with the rest of their operation, to Oxford. In later years this man, who never took a university degree, became an editor of the Oxford University Press and lectured at Oxford University, where he was awarded an honorary Master of Arts degree.

Although he had from the outset a small but select and highly appreciative audience, recognition for Williams's

writings has been slow in coming. The reason for this is that he wrote with a great deal of originality about some highly complex subjects, most of which dealt with some aspect of mysticism or theology. Nonetheless, he was not an elitist and certainly took pains to attract a general audience. Happily, the demand for his works, particularly the novels, has increased, with the result that all seven novels are now available in paperback.

Williams wrote two narrative Arthurian poems of note, *Taliessen Through Logres* (1938) and *The Region of the Summer Stars* (1944). He also wrote a number of historical plays as well as works of biography and history, including *Bacon* (1934), about the noted jurist and essayist, who also appears in the short story below. Important, too, in terms of this story are Williams's critical works on Dante, *Love in Dante* (1941) and *The Figure of Beatrice* (1943). Dorothy Sayers refers frequently to the latter work in her notes to her translation of Dante's *Divine Comedy*. Williams also has several works of philosophy and theology to his credit, but by far his most popular writings, and consequently the source by which most of us become familiar with Williams's ideas, are his seven novels: *War in Heaven* (1930), *Many Dimensions* (1931), *The Place of the Lion* (1932), *The Greater Trumps* (1932), *Shadows of Ecstasy* (1933), *Descent into Hell* (1937), and *All Hallows Eve* (1945). All seven of the novels deal with the reality of the supernatural—diabolic as well as divine and benevolent. To emphasize such realities, Williams superimposes the supernatural world, as a sort of fifth dimension, upon the natural world. Another theological tenet central to Williams's novels is the proposition that we be brave enough to take literally the scriptural injunction to bear one another's burdens—physical and nonphysical alike. Williams's application of this tenet—he calls it substitution—provides for some fascinating supernatural plot lines.

"Et in Sempiternum Pereant" ("and may they be forever damned") is apparently Williams's only short story. Appearing in 1935, it uses Lord Arglay, the central character in the 1931 novel, *Many Dimensions*. More importantly, however, the story uses—indeed interprets fictionally—Canto 34, the conclusion of Dante's *Inferno*. The last line of the story borrows the last line of this Canto: "and

thence we issued forth to see again the stars." One could profitably make a close comparison between Canto 34 and the short story; for our purposes, it is important simply to know that in Canto 34, Dante discovers the very pit of hell, where Satan is devouring Judas, Brutus, and Cassius, the three most notorious traitors of history. Dorothy Sayers quotes Williams concerning the nature of this deepest point in the *Inferno*. According to Williams, it is a place of dreadful monotony and despair and one of "infinite cannibalism," and one that is "willed" by those who suffer there—otherwise it couldn't possibly exist. In his short story Williams embodies these beliefs about hell.

The fact that this is Williams's only short story testifies that he did not find the brevity of the form congenial to the complexity of his ideas. In addition to retelling the conclusion to the *Inferno*, Williams undertakes the difficult task of locating the temporal within the eternal to prepare his readers to find hell in an isolated country house. His style, reflecting his struggle to express this difficult concept in a short space, is in places awkwardly convoluted. On the other hand, the emaciated, self-consuming grotesque in the cottage and such images as the road "coiling spirally into the darkness" and the shrill insect sound of the "multitude of the lost" create a vivid hell in the recesses of the farmhouse, the secondary world of the story.

As far as we know, this is the first appearance of this story since 1935, when *The London Mercury* printed it. It is a story we would not willingly be without and one that, despite its flaws, shows us what to expect in the longer religious fantasies of Charles Williams.

ET IN SEMPITERNUM PEREANT

by Charles Williams

Lord Arglay came easily down the road. About him the spring was as gaudy as the restraint imposed by English geography ever lets it be. The last village lay a couple of miles behind him; as far in front, he had been told, was a main road on which he could meet a motor bus to carry him near his destination. A casual conversation in a club had revealed to him, some months before, that in a country house of England there were supposed to lie a few yet unpublished legal opinions of the Lord Chancellor Bacon. Lord Arglay, being no longer Chief Justice, and having finished and published his *History of Organic Law*, had conceived that the editing of these papers might provide a pleasant variation upon his present business of studying the more complex parts of the Christian Schoolmen. He had taken advantage of a weekend spent in the neighborhood to arrange, by the good will of the owner, a visit of inspection; since, as the owner had remarked, with a bitterness due to his financial problems, "everything that is smoked isn't Bacon." Lord Arglay had smiled—it hurt him a little to think that he had smiled—and said, which was true enough, that Bacon himself would not have made a better joke.

It was a very deserted part of the country through which he was walking. He had been careful to follow the directions given him, and in fact there were only two places where he could possibly have gone wrong, and at both of them Lord Arglay was certain he had not gone wrong. But he seemed to be taking a long time—a longer time than he had expected. He looked at his watch again, and noted with sharp disapproval of his own judgment that it was only six minutes since he had looked at it last. It had seemed more like sixteen. Lord Arglay frowned. He was

167

usually a good walker, and on that morning he was not conscious of any unusual weariness. His host had offered to send him in a car, but he had declined. For a moment, as he put his watch back, he was almost sorry he had declined. A car would have made short time of this road, and at present his legs seemed to be making rather long time of it. "Or," Lord Arglay said aloud, "making time rather long." He played a little, as he went on, with the fancy that every road in space had a corresponding measure in time; that it tended, merely of itself, to hasten or delay all those that drove or walked upon it. The nature of some roads, quite apart from their material effectiveness, might urge men to speed, and of others to delay. So that the intentions of all travelers were counterpointed continually by the media they used. The courts, he thought, might reasonably take that into consideration in case of offenses against right speed, and a man who accelerated upon one road would be held to have acted under the improper influence of the way, whereas one who did the same on another would be known to have defied and conquered the way.

Lord Arglay just stopped himself looking at his watch again. It was impossible that it should be more than five minutes since he had last done so. He looked back to observe, if possible, how far he had since come. It was not possible; the road narrowed and curved too much. There was a cloud of trees high up behind him; it must have been half an hour ago that he passed through it, yet it was not merely still in sight, but the trees themselves were in sight. He could remark them as trees; he could almost, if he were a little careful, count them. He thought, with some irritation, that he must be getting old more quickly, and more unnoticeably, than he had supposed. He did not much mind about the quickness, but he did mind about the unnoticeableness. It had given him pleasure to watch the various changes which age tended to bring; to be as stealthy and as quick to observe those changes as they were to come upon him—the slower pace, the more meditative voice, the greater reluctance to decide, the inclination to fall back on habit, the desire for the familiar which is the first skirmishing approach of unfamiliar death. He neither welcomed nor grudged such changes; he only observed

them with a perpetual interest in the curious nature of the creation. The fantasy of growing old, like the fantasy of growing up, was part of the ineffable sweetness, touched with horror, of existence, itself the lordliest fantasy of all. But now, as he stood looking back over and across the hidden curves of the road, he felt suddenly that time had outmarched and out-twisted him, that it was spreading along the countryside and doubling back on him, so that it troubled and deceived his judgment. In an unexpected and unusual spasm of irritation he put his hand to his watch again. He felt as if it were a quarter of an hour since he had looked at it; very well, making just allowance for his state of impatience, he would expect the actual time to be five minutes. He looked; it was only two.

Lord Arglay made a small mental effort, and almost immediately recognized the effort. He said to himself: "This is another mark of age. I am losing my sense of duration." He said also: "It is becoming an effort to recognize these changes." Age was certainly quickening its work in him. It approached him now doubly; not only his method of experience, but his awareness of experience was attacked. His knowledge of it comforted him—perhaps, he thought, for the last time. The knowedge would go. He would savor it then while he could. Still looking back at the trees, "It seems I'm decaying," Lord Arglay said aloud. "And that anyhow is one up against decay. Am I procrastinating? I am, and in the circumstances procrastination is a proper and pretty game. It is the thief of time, and quite right too! Why should time have it all its own way?"

He turned to the road again, and went on. It passed now between open fields; in all those fields he could see no one. It was pasture, but there were no beasts. There was about him a kind of void, in which he moved, hampered by this growing oppression of duration. Things *lasted*. He had exclaimed, in his time, against the too swift passage of the world. This was a new experience; it was lastingness— almost, he could have believed, everlastingness. The measure of it was but his breathing, and his breathing, as it grew slower and heavier, would become the measure of everlasting labor—the labor of Sisyphus, who pushed his own slow heart through each infinite moment, and relaxed but to let it beat back and so again begin. It was the first

touch of something Arglay had never yet known, of simple and perfect despair.

At that moment he saw the house. The road before him curved sharply, and as he looked he wondered at the sweep of the curve; it seemed to make a full half-circle and so turn back in the direction that he had come. At the farthest point there lay before him, tangentially, another path. The sparse hedge was broken by an opening which was more than footpath and less than road. It was narrow, even when compared with the narrowing way by which he had come, yet hard and beaten as if by the passage of many feet. There had been innumerable travelers, and all solitary, all on foot. No cars or carts could have taken that path; if there had been burdens, they had been carried on the shoulders of their owners. It ran for no long distance, no more than in happier surroundings might have been a garden path from gate to door. There, at the end, was the door.

Arglay, at the time, took all this in but half-consciously. His attention was not on the door but on the chimney. The chimney, in the ordinary phrase, was smoking. It was smoking effectively and continuously. A narrow and dense pillar of dusk poured up from it, through which there glowed, every now and then, a deeper undershade of crimson, as if some trapped genius almost thrust itself out of the moving prison that held it. The house itself was not much more than a cottage. There was a door, shut; on the left of it a window, also shut; above, two little attic windows, shut, and covered within by some sort of dark hanging, or perhaps made opaque by smoke that filled the room. There was no sign of life anywhere, and the smoke continued to mount to the lifeless sky. It seemed to Arglay curious that he had not noticed this gray pillar in his approach, that only now when he stood almost in the straight and narrow path leading to the house did it become visible, an exposition of tall darkness reserved to the solitary walkers upon that wearying road.

Lord Arglay was the last person in the world to look for responsibilities. He shunned them by a courteous habit; a responsibility had to present itself with a delicate emphasis before he acceded to it. But when any so impressed itself he was courteous in accepting as in declining; he sought

friendship with necessity, and as young lovers call their love fatal, so he turned fatality of life into his love. It seemed to him, as he stood and gazed at the path, the shut door, the smoking chimney, that here perhaps was a responsibility being delicately emphatic. If everyone was out —if the cottage had been left for an hour—ought he to do something? Of course, they might be busy about it within; in which case a thrusting stranger would be inopportune. Another glow of crimson in the pillar of cloud decided him. He went up the path.

As he went he glanced at the little window, but it was blurred by dirt; he could not very well see whether the panes did or did not hide smoke within. When he was so near the threshold that the window had almost passed out of his vision, he thought he saw a face looking out of it—at the extreme edge, nearest the door—and he checked himself, and went back a step to look again. It had been only along the side of his glance that the face, if face it were, had appeared, a kind of sudden white scrawl against the blur, as if it were a mask hung by the window rather than any living person, or as if the glass of the window itself had looked sideways at him, and he had caught the look without understanding its cause. When he stepped back, he could see no face. Had there been a sun in the sky he would have attributed the apparition to a trick of the light, but in the sky over this smoking house there was no sun. It had shone brightly that morning when he started; it had paled and faded and finally been lost to him as he had passed along his road. There was neither sun nor peering face. He stepped back to the threshold, and knocked with his knuckles on the door.

There was no answer. He knocked again and again waited, and as he stood there he began to feel annoyed. The balance of Lord Arglay's mind had not been achieved without the creation of a considerable counter energy to the violence of Lord Arglay's natural temper. There had been people whom he had once come very near hating, hating with a fury of selfish rage and detestation; for instance, his brother-in-law. His brother-in-law had not been a nice man; Lord Arglay, as he stood by the door and for no earthly reason, remembered him, admitted it. He admitted, at the same moment, that no lack of niceness on that

other's part could excuse any indulgence of vindictive hate on his own, nor could he think why, then and there, he wanted him, wanted to have him merely to hate. His brother-in-law was dead. Lord Arglay almost regretted it. Almost he desired to follow, to be with him, to provoke and torment him, to. . . .

Lord Arglay struck the door again. "There is," he said to himself, "entire clarity in the Omnipotence." It was his habit of devotion, his means of recalling himself into peace out of the angers, greeds, sloths and perversities that still too often possessed him. It operated; the temptation passed into the benediction of the Omnipotence and disappeared. But there was still no answer from within. Lord Arglay laid his hand on the latch. He swung the door, and, lifting his hat with his other hand, looked into the room—a room empty of smoke as of fire, and of all as of both.

Its size and appearance were those of a rather poor cottage, rather indeed a large brick hut than a cottage. It seemed much smaller within than without. There was a fireplace—at least, there was a place for a fire—on his left. Opposite the door, against the right-hand wall, there was a ramshackle flight of wooden steps, going up to the attics, and at its foot, swinging on a broken hinge, a door which gave a way presumably to a cellar. Vaguely, Arglay found himself surprised; he had not supposed that a dwelling of this sort would have a cellar. Indeed, from where he stood, he could not be certain. It might only be a cupboard. But, unwarrantably, it seemed more, a hinted unseen depth, as if the slow slight movement of the broken wooden door measured that labor of Sisyphus, as if the road ran past him and went coiling spirally into the darkness of the cellar. In the room there was no furniture, neither fragment of paper nor broken bit of wood; there was no sign of life, no flame in the grate nor drift of smoke in the air. It was completely and utterly void.

Lord Arglay looked at it. He went back a few steps and looked up again at the chimney. Undoubtedly the chimney was smoking. It was received into a pillar of smoke; there was no clear point where the dark chimney ended and the dark smoke began. House leaned to roof, roof to chimney, chimney to smoke, and smoke went up for ever and ever over those roads where men crawled infinitely through the

smallest measurements of time. Arglay returned to the door, crossed the threshold, and stood in the room. Empty of flame, empty of flame's material, holding within its dank air the very opposite of flame, the chill of ancient years, the room lay round him. Lord Arglay contemplated it. "There's no smoke without fire," he said aloud. "Only apparently there is. Thus one lives and learns. Unless indeed this is the place where one lives without learning."

The phrase, leaving his lips, sounded oddly about the walls and in the corners of the room. He was suddenly revolted by his own chance words—"a place where one lives without learning," where no courtesy or integrity could any more be fined or clarified. The echo daunted him; he made a sharp movement, he took a step aside towards the stairs, and before the movement was complete, was aware of a change. The dank chill became a concentration of dank and deadly heat, pricking at him, entering his nostrils and his mouth. The fantasy of life without knowledge materialized, inimical, in the air, life without knowledge, corrupting life without knowledge, jungle and less than jungle, and though still the walls of the bleak chamber met his eyes, a shell of existence, it seemed that life, withdrawn from all those normal habits of which the useless memory was still drearily sustained by the thin phenomenal fabric, was collecting and corrupting in the atmosphere behind the door he had so rashly passed—outside the other door which swung crookedly at the head of the darker hole within.

He had recoiled from the heat, but not so as to escape it. He had even taken a step or two up the stairs, when he heard from without a soft approach. Light feet were coming up the beaten path to the house. Some other Good Samaritan, Arglay thought, who would be able to keep his twopence in his pocket. For certainly, whatever was the explanation of all this and wherever it lay, in the attics above or in the pit of the cellar below, responsibility was gone. Lord Arglay did not conceive that either he or anyone else need rush about the country in an anxious effort to preserve a house which no one wanted and no one used. Prematurely enjoying the discussion, he waited. Through the doorway someone came in.

It was, or seemed to be, a man of ordinary height,

wearing some kind of loose dark overcoat that flapped
about him. His head was bare; so, astonishingly, were his
legs and feet. At first, as he stood just inside the door,
leaning greedily forward, his face was invisible, and for a
moment Arglay hesitated to speak. Then the stranger lifted
his face and Arglay uttered a sound. It was emaciated
beyond imagination; it was astonishing, at the appalling
degree of hunger revealed, that the man could walk or
move at all, or even stand as he was now doing, and turn
that dreadful skull from side to side. Arglay came down the
steps of the stair in one jump; he cried out again, he ran
forward, and as he did so the deep burning eyes in the
turning face of bone met his full and halted him. They
did not see him, or if they saw did not notice; they gazed at
him and moved on. Once only in his life had Arglay seen
eyes remotely like those; once, when he had pronounced
the death sentence upon a wretched man who had broken
under the long strain of his trial and filled the court with
shrieks. Madness had glared at Lord Arglay from that
dock, but at least it had looked at him and seen him; these
eyes did not. They sought something—food, life, or per-
haps only a form and something to hate, and in that energy
the stranger moved. He began to run round the room. The
bones that were his legs and feet jerked up and down. The
head turned from side to side. He ran circularly, round and
again round, crossing and recrossing, looking up, down,
around, and at last, right in the center of the room, coming
to a halt, where, as if some terrible pain of starvation
gripped him, he bent and twisted downward until he
squatted grotesquely on the floor. There, squatting and
bending, he lowered his head and raised his arm, and as
the fantastic black coat slipped back, Arglay saw a wrist,
saw it marked with scars. He did not at first think what
they were; only when the face and wrist of the figure
swaying in its pain came together did he suddenly know.
They were teeth marks; they were bites; the mouth closed
on the wrist and gnawed. Arglay cried out and sprang
forward, catching the arm, trying to press it down, catch-
ing the other shoulder, trying to press it back. He achieved
nothing. He held, he felt, he grasped; he could not control.
The long limb remained raised, the fierce teeth gnawed.
But as Arglay bent, he was aware once more of that efflu-

via of heat risen round him, and breaking out with the more violence when suddenly the man, if it were a man, cast his arm away, and with a jerk of movement rose once more to his feet. His eyes, as the head went back, burned close into Arglay's, who, what with the heat, the eyes, and his sickness at the horror, shut his own against them, and was at the same moment thrown from his balance by the rising form, and sent staggering a step or two away, with upon his face the sensation of a light hot breath, so light that only in the utter stillness of time could it be felt, so hot that it might have been the inner fire from which the pillar of smoke poured outward to the world.

He recovered his balance; he opened his eyes; both motions brought him into a new corner of that world. The odd black coat the thing had worn had disappeared, as if it had been a covering imagined by a habit of mind. The thing itself, a wasted flicker of pallid movement, danced and gyrated in white flame before him. Arglay saw it still, but only now as a dreamer may hear, half-asleep and half-awake, the sound of dogs barking or the crackling of fire in his very room. For he opened his eyes not to such things, but to the thing that on the threshold of this place, some seconds earlier or some years, he had felt and been pleased to feel, to the reality of his hate. It came in a rush within him, a fountain of fire, and without and about him images of the man he hated swept in a thick cloud of burning smoke. The smoke burned his eyes and choked his mouth; he clutched at it, at images within it—at his greedy loves and greedy hates—at the cloud of the sin of his life, yearning to catch but one image and renew again the concentration for which he yearned. He could not. The smoke blinded and stifled him, yet more than stifling or blinding was the hunger for one true thing to lust or hate. He was starving in the smoke, and all the hut was full of smoke, for the hut and the world were smoke, pouring up round him, from him and all like him—a thing once wholly, and still a little, made visible to his corporeal eyes in forms which they recognized, but in itself of another nature. He swung and twisted and crouched. His limbs ached from long wrestling with the smoke, for as the journey to this place had prolonged itself infinitely, so now, though he had no thought of measurements, the clutch of his hands and the

growing sickness that invaded him struck through him the sensation of the passage of years and the knowledge of the passage of moments. The fire sank within him, and the sickness grew, but the change could not bring him nearer to any end. The end here was not at the end, but in the beginning. There was no end to this smoke, to this fever and this chill, to crouching and rising and searching, unless the end was now. *Now—now* was the only possible other fact, chance, act. He cried out, defying infinity, *"Now!"*

Before his voice the smoke of his prison yielded, and yielded two ways at once. From where he stood he could see in one place an alteration in that perpetual gray, an alternate darkening and lightening as if two ways, of descent and ascent, met. There was, he remembered, a way in, therefore a path out; he had only to walk along it. But also there was a way still farther in, and he could walk along that. Two doors had swung, to his outer senses, in that small room. From every gate of hell there was a way to heaven, yes, and in every way to heaven there was a gate to deeper hell.

Yet for a moment he hesitated. There was no sign of the phenomenon by which he had discerned the passage of that other spirit. He desired—very strongly he desired—to be of use to it. He desired to offer himself to it, to make a ladder of himself, if that should be desired, by which it might perhaps mount from the nature of the lost, from the dereliction of all minds that refuse living and learning, postponement and irony, whose dwelling is necessarily in their undying and perishing selves. Slowly, unconsciously, he moved his head as if to seek his neighbor.

He saw, at first he felt, nothing. His eyes returned to that vibrating oblong of an imagined door, the heart of the smoke beating in the smoke. He looked at it; he remembered the way; he was on the point of movement, when the stinging heat struck him again, but this time from behind. It leapt through him; he was seized in it and loosed from it; its rush abandoned him. The torrent of its fiery passage struck the darkening hollow in the walls. At the instant that it struck, there came a small sound; there floated up a thin shrill pipe, too short to hear, too certain to miss, faint and quick as from some single insect in the hedgerow or the field, and yet more than single—a weak wail of multitudes

of the lost. The shrill lament struck his ears, and he ran. He cried as he sprang: "Now is God: now is glory in God," and as the dark door swung before him it was the threshold of the house that received his flying feet. As he passed, another form slipped by him, slinking hastily into the house, another of the hordes going so swiftly up that straight way, hard with everlasting time; each driven by his own hunger, and each alone. The vision, a face looking in as a face had looked out, was gone. Running still; but more lightly now, and with some communion of peace at heart, Arglay came into the curving road. The trees were all about him; the house was at their heart. He ran on through them beyond, he saw, he reached, the spring day and the sun. At a little distance a motor bus, gaudy within and without, was coming down the road. The driver saw him. Lord Arglay instinctively made a sign, ran, mounted. As he sat down, breathless and shaken, *"E quindi uscimmo,"* his mind said, *"a riveder le stelle."*

Pär Lagerkvist

(1891–1974)

When Pär Lagerkvist received his Nobel Prize for literature on December 10, 1951, he heard the following words read, as part of his citation: "For the artistic power and deep-rooted independence he demonstrates in his writings in seeking an answer to the eternal questions of humanity." The citation is a perceptive one even though it has the ring of a familiar generalization. In one of his early stories, "The Eternal Smile," a group of the dead, upset over their treatment during life, seek for a thousand years to find God. When they do, they confront him with the question "Why?" and God can only shrug and reply: "I have done the best I could." Critics are fond of quoting Lagerkvist's self-bestowed title of "religious atheist." This was early in his career, and critics disagree about whether or not he ever found belief. Whether he did or not, he spent his life seeking for it for himself and for others.

Lagerkvist was born in a small town named Växjö in southern Sweden on May 23, 1891, to a family that traditionally produced farmers. His father broke that tradition by working for the railroad, and Pär departed even further. He studied humanities from 1911 to 1912 at the University of Upsala, from which his fellow writer Selma Lagerlöf had graduated in 1904. His first publication, a poem, appeared in 1912. The same year saw publication of his first prose work, a novella, and five years later his first play appeared. Lagerkvist continued to write in all three genres throughout the rest of his career. He was elected as one of the eighteen Immortals of the Swedish Academy in 1940, taking the place of the recently deceased Verner von Heidenstam. He was nominated for the 1949 Nobel Prize but was runner-up to William Faulkner, for whom Lagerkvist cast his own vote. He has been described as an ex-

178

tremely shy person, shunning any kind of notoriety and refusing to give interviews. When asked to make a statement upon winning the Nobel Prize, he politely referred the questioners to his books. Lagerkvist was twice married and had one son, who has become a film maker.

Lagerkvist's best known works are his short stories and novels, although the *New York Times* obituary referred to him as the successor to the Swedish dramatist Strindberg. His most famous short prose work is "The Eternal Smile" (1920). *Evil Tales* (1924) contains other fine short stories, including the one that follows. His three great novels are *The Dwarf* (1944), *Barabbas* (1950), and *The Sibyl* (1956). *Barabbas*, an immediate and enormous success, was translated into nine languages and adapted for a film version, all within a year of its publication.

"The Lift That Went Down into Hell" may perhaps be best described as a satire of a popular portrayal of the devil, in literature and other media, as a sophisticated and dashing good fellow. Lagerkvist portrays the devil, not so much as a monster, but as a pathetic figure and hell as a run-down, squalid place rather than a terrible one. Ironically, the devil fancies himself a dandy. As in all of his writing, Lagerkvist uses a simple, almost folktale type of narrative structure and relies on vivid imagery to convey the subtle overtones of meaning. Thus, hell is a place of murky side streets, corrosive yellow light, and filthy, grease-stained doorways. Thematically, the story may be viewed as a parallel parable to the story that Luke tells of the rich man and Lazarus (Luke 16:19–31). Luke describes the rich man, having gone to hell, pleading with Abraham to let Lazarus warn the rich man's five brothers, "lest they too come into this place of torment." Abraham replies that if they wouldn't listen to Moses and the prophets, "they would not believe even if someone rises from the dead."

THE LIFT THAT WENT DOWN
INTO HELL
(1924)

by Pär Lagerkvist
(Translated by Alan Blair)

Mr. Smith, a prosperous businessman, opened the elegant
hotel lift and amorously handed in a gracile creature smell-
ing of furs and powder. They nestled together on the soft
seat and the lift started downward. The little lady extended
her half-open mouth, which was moist with wine, and they
kissed. They had dined up on the terrace, under the stars;
now they were going out to amuse themselves.

"Darling, how divine it was up there," she whispered.
"So poetic sitting there with you, like being up among the
stars. That's when you really know what love is. You do
love me, don't you?"

Mr. Smith answered with a kiss that lasted still longer;
the lift went down.

"A good thing you came, my darling," he said; "other-
wise I'd have been in an awful state."

"Yes, but you can just imagine how insufferable he was.
The second I started getting ready he asked where I was
going. 'I'll go where I please,' I said. 'I'm no prisoner.'
Then he deliberately sat and stared at me the whole time I
was changing, putting on my new beige—do you think it's
becoming? What do you think looks best, by the way,
perhaps pink after all?"

"Everything becomes you, darling," the man said, "but
I've never seen you so lovely as this evening."

She opened her fur coat with a gratified smile, they
kissed for a long time, the lift went down.

"Then when I was ready to go he took my hand and
squeezed it so that it still hurts, and didn't say a word. He's
so brutal, you've no idea! 'Well, good-bye,' I said. But not
a word from him. He's so unreasonable, so frightfully, I
can't stand it."

"Poor little thing," said Mr. Smith.

"As though I can't go out for a bit and enjoy myself. But then he's so deadly serious, you've no idea. He can't take anything simply and naturally. It's as though it were a matter of life and death the whole time."

"Poor pet, what you must have gone through."

"Oh, I've suffered terribly. Terribly. No one has suffered as I have. Not until I met you did I know what love is."

"Sweetheart," Smith said, hugging her; the lift went down.

"Fancy," she said, when she had got her breath after the embrace, "sitting with you up there gazing at the stars and dreaming—oh, I'll never forget it. You see, the thing is— Arvid is impossible, he's so everlastingly solemn, he hasn't a scrap of poetry in him, he has no feeling for it."

"Darling, it's intolerable."

"Yes, isn't it—intolerable. But," she went on, giving him her hand with a smile, "let's not sit thinking of all that. We're out to enjoy ourselves. You do really love me?"

"Do I!" he said, bending her back so that she gasped; the lift went down. Leaning over her he fondled her; she blushed.

"Let us make love tonight—as never before. Hm?" he whispered.

She pressed him to her and closed her eyes; the lift went down.

Down and down it went.

At last Smith got to his feet, his face flushed.

"But what's the matter with the lift?" he exclaimed. "Why doesn't it stop? We've been sitting here for ever so long talking, haven't we?"

"Yes, darling, I suppose we have, time goes so quickly."

"Good Heavens, we've been sitting here for ages! What's the idea?"

He glanced out through the grill. Nothing but pitch darkness. And the lift went on and on at a good, even pace, deeper and deeper down.

"Heavens alive, what's the idea? It's like dropping down into an empty pit. And we've been doing this for God knows how long."

They tried to peep down into the abyss. It was pitch dark. They just sank and sank down into it.

"This is all going to hell," Smith said.

"Oh dear," the woman wailed, clinging to his arm, "I'm so nervous. You'll have to pull the emergency brake."

Smith pulled for all he was worth. It was no good. The lift merely plunged down and down interminably.

"It's frightful," she cried. "What are we going to do!"

"Yes, what the devil is one to do?" Smith said. "This is crazy."

The little lady was in despair and burst into tears.

"There, there, my sweet, don't cry, we must be sensible. There's nothing we can do. There now, sit down. That's right, now we'll sit here quietly both of us, close together, and see what happens. It must stop some time or there'll be the devil to pay."

They sat and waited.

"Just think of something like this happening," the woman said. "And we were going out to have fun."

"Yes, it's the very devil," Smith said.

"You do love me, don't you?"

"Darling," Smith said, putting his arms around her; the lift went down.

At last it stopped abruptly. There was such a bright light all around that it hurt the eyes. They were in hell. The Devil slid the grill aside politely.

"Good evening," he said with a deep bow. He was stylishly dressed in tails that hung on the hairy top vertebra as on a rusty nail.

Smith and the woman tottered out in a daze. "Where in God's name are we?" they exclaimed, terrified by the weird apparition. The Devil, a shade embarrassed, enlightened them.

"But it's not as bad as it sounds," he hastened to add. "I hope you will have quite a pleasant time. I gather it's just for the night?"

"Yes, yes!" Smith assented eagerly, "it's just for the night. We're not going to stay, oh no!"

The little lady clung tremblingly to his arm. The light was so corrosive and yellowy green that they could hardly see, and there was a hot smell, they thought. When they had grown a little more used to it they discovered they

were standing as it were in a square, around which houses with glowing doorways towered up in the darkness; the curtains were drawn but they could see through the chinks that something was burning inside.

"You are the two who love each other?" the Devil inquired.

"Yes, madly," the lady answered, giving him a look with her lovely eyes.

"Then this is the way," he said, and asked them to follow please. They slunk into a murky side street leading out of the square. An old cracked lantern was hanging outside a filthy, grease-stained doorway.

"Here it is." He opened the door and retired discreetly. They went in. A new devil, fat, fawning, with large breasts and purple powder caked on the moustache around her mouth, received them. She smiled wheezily, a good-natured, knowing look in her beady eyes; around the horns in her forehead she had twined tufts of hair and fastened them with small blue silk ribbons.

"Oh, is it Mr. Smith and the little lady?" she said. "It's in number eight then." And she gave them a large key.

They climbed the dim, greasy staircase. The stairs were slippery with fat; it was two flights up. Smith found number eight and went in. It was a fairly large, musty room. In the middle was a table with a grubby cloth; by the wall a bed with smoothed-down sheets. They thought it all very nice. They took off their coats and kissed for a long time.

A man came in unobtrusively from another door. He was dressed like a waiter but his dinner jacket was well cut and his shirtfront so clean that it gleamed ghostlike in the semidarkness. He walked silently, his feet making no sound, and his movements were mechanical, unconscious almost. His features were stern, the eyes looking fixedly straight ahead. He was deathly pale; in one temple he had a bullet wound. He got the room ready, wiped the dressing table, brought in a chamberpot and a slop pail.

They didn't take much notice of him, but as he was about to go Smith said, "I think we'll have some wine. Bring us half a bottle of Madeira." The man bowed and disappeared.

Smith started getting undressed. The woman hesitated. "He's coming back," she said.

"Pshaw, in a place like this you needn't mind. Just take your things off." She got out of her dress, pulled up her panties coquettishly and sat on his knee. It was lovely.

"Just think," she whispered, "sitting here together, you and I, alone, in such a queer, romantic place. So poetic, I'll never forget it." "Sweetheart," he said. They kissed for a long time.

The man came in again, soundlessly. Softly, mechanically, he put down the glasses, poured out the wine. The light from the table lamp fell on his face. There was nothing special about him except that he was deathly pale and had a bullet wound in his temple.

The woman leaped up with a scream.

"Oh my God! Arvid! Is it you? Is it you? Oh God in Heaven, he's dead! He's shot himself!"

The man stood motionless, just staring in front of him. His face showed no suffering; it was merely stern, very grave.

"But Arvid, what have you done, what have you done! How could you! My dear, if I'd suspected anything like that, you know I'd have stayed at home. But you never tell me anything. You never said anything about it, not a word! How was I to know when you never told me! Oh my God . . ."

Her whole body was shaking. The man looked at her as at a stranger; his gaze was icy and gray, just went straight through everything. The sallow face gleamed, no blood came from the wound, there was just a hole there.

"Oh, it's ghastly, ghastly!" she cried. "I won't stay here! Let's go at once. I can't stand it."

She grabbed her dress, hat and fur coat and rushed out, followed by Smith. They slipped going down the stairs, she sat down, got spittle and cigarette ash on her behind. Downstairs the woman with the moustache was standing, smiling good-naturedly and knowingly and nodding her horns.

Out in the street they calmed down a little. The woman put on her clothes, straightened herself, powdered her nose. Smith put his arm protectingly round her waist, kissed away the tears that were on the point of falling—he was so good. They walked up into the square.

The head devil was walking about there, they ran into him again. "You *have* been quick," he said. "I hope you've been comfortable."

"Oh, it was dreadful," the lady said.

"No, don't say that, you can't think that. You should have been here in the old days, it was different then. Hell is nothing to complain of now. We do all we can not to make it too obvious, on the contrary to make it enjoyable."

"Yes," Mr. Smith said, "I must say it's a little more humane anyway, that's true."

"Oh," the Devil said, "we've had everything modernized, completely rearranged, as it should be."

"Yes, of course, you must keep up with the times."

"Yes, it's only the soul that suffers nowadays."

"Thank God for that," said the lady.

The Devil conducted them politely to the lift. "Good evening," he said with a deep bow, "welcome back." He shut the grill after them, the lift went up.

"Thank God that's over," they both said, relieved, and nestled up to one another on the seat.

"I should never have got through it without you," she whispered. He drew her to him, they kissed for a long time. "Fancy," she said, when she had got her breath after the embrace, "his doing such a thing! But he's always had such queer notions. He's never been able to take things simply and naturally, as they are. It's as though it were a matter of life and death the whole time."

"It's absurd," Smith said.

"He might have *told* me! Then I'd have stayed. We could have gone out another evening instead."

"Yes, of course," Smith said, "of course we could."

"But, darling, let's not sit thinking of that," she whispered, putting her arms around his neck. "It's over now."

"Yes, little darling, it's over now." He clasped her in his arms; the lift went up.

Felix Marti-Ibañez

(1912–1972)

Felix Marti-Ibañez deserves inclusion in a somewhat exclusive group: medical doctors who have become prominent literary figures, such as Anton Chekhov, the Russian playwright, William Carlos Williams, the American poet, and W. Somerset Maugham, the English novelist. Marti-Ibañez differs from those others to the extent that he achieved widespread recognition for his contributions to medicine, while his more literary endeavors have passed relatively unnoticed. These latter, particularly his short stories, deserve better.

Felix Marti-Ibañez was born in Cartagena, Spain. His father, a teacher and prolific essayist, evidently instilled his love of lecturing and writing in his son. Marti-Ibañez earned his degree in medicine from the University of Madrid and practiced medicine and psychiatry until the outbreak of the Spanish Civil War in 1936, when he became a public health official for the Republican (the anti-Franco) government. Consequently, he had to leave the country when Franco triumphed. He came to the United States and became a citizen in 1939. Only years later, in an autobiographical essay, "Interview with Myself," in *The Mirror of Souls and Other Essays* (1972), did he refer to the trauma of being uprooted from his native country. He spoke, in the same essay of a second trauma, the death of his wife from cancer.

He continued to be as active in the United States as he had been in Spain. He wrote and lectured extensively (he once said "I am a lover of the spoken word") throughout his busy career. Several of his books are still in print, twenty or more years after their appearance, and their titles testify to the man's diversity of interests: for example, *Ariel: Essays on the Arts and the History and Philoso-*

phy of Medicine (1962) or *Psychiatry and Religion*, which he edited in 1956. He founded MD Publications, Inc., which publishes several important medical magazines, including *MD*. For several years Marti-Ibañez held the chair of history and medicine at the New York Medical College.

While he acquired a reputation for his works related to medicine, he noted in his autobiographical essay that his volume of short stories, *All the Wonders We Seek: Thirteen Tales of Surprise and Prodigy* (1963), was among his favorites. The stories, all written in English (he wrote some essays in Spanish), were composed between 1954 and 1963. Two had been published separately in *Weird Tales*. "Amigo Heliotropo" is one of the finest of the thirteen tales of fantasy.

"Amigo Heliotropo" belongs to the venerable tradition of the saint's legend, a form closely related to and at least as old as its cousins, the local legend and the faery tale. The core of the saint's legend, unlike its cousins, is the miracle that bears witness to some truth or teaching. The friendly hermit who explains the legend of San Miguel to the two women explains to them a miraculous experience that, unknown to him, they have just lived through but could not comprehend. Aside from the central miraculous event, the saint's legend is much more realistic than the faery tale, and we have a better chance to get to know the characters more personally. This happens in the present story, in which the main character, named Amigo Heliotropo, is a combination of lover and clown. His name— *Heliotropo* means "turning toward the sun"—is significant, as will be seen. It is also worthy of note that the heliotrope is a flower native to Peru, where in earlier times, the sun god was the chief deity.

Marti-Ibañez in his "Interview With Myself" commented that in good writing an author adds color through images and metaphors. Figurative language and imagery abound in "Amigo Heliotropo," especially images of golden brightness; this is indeed fitting for a story with such a title and in which the theme is that love is a gift.

AMIGO HELIOTROPO

by Felix Marti-Ibañez

At noon the circus wagons came to a halt. The countryside was not very impressive. The sky was lofty and a radiant blue, but the land was dry and bare except for a few stunted poplars which stood there meekly announcing that, all things considered, this was the best that could be done. A few rocky hills, covered with lime dust, looked like buns sprinkled with sugar in the great oven of the desert. At the foot of the hills there circled a veinlet of faded green water. The huge sun was like a bell hanging from the blue, ringing out light instead of sound. And that was all, that and houses, white with rust-colored roofs, of the town of Santa Ana, which in the distance looked like a group of small girls playing at Little Red Riding Hood.

The Great Floriani, owner of the circus and magician, raised his muscular arm and cried, "Halt!" and then jumped down from the box of the first wagon.

"Rest!" joyfully shouted Mama Floriani, whose two hundred pounds in weight and half a century in years seemed in no way to impair her tightrope act.

"Lunch!" exclaimed Pipo and Rico, the clowns, who by force of habit always spoke in a duet.

"Nap!" said Samson (according to his billing, the strongest man in the world), who had clandestinely devoured a loaf of bread and a can of sardines on the road.

And Colombina, the bareback rider, always romantic, opened wide her eyes, the color of forget-me-nots, and sighed, "A river!"

The rest of the caravan—Filipon, juggler *extraordinaire*; the Rossoffs, animal trainers; Cascabel, the snake man; the twin sisters, Dora and Rita; the Condor trio, "human eagles"; the trained dogs, cats, monkeys and birds—said nothing but their thoughts ran along identical lines. The

similarity in ideas of a circus troupe at lunch time after a foodless morning is astonishing.

Ten minutes later the four wagons were arranged in a semicircle; the horses—when traveling, beasts of burden, when performing, Arab mounts for Colombina—were grazing on a spare plot of grass; and the animals in their cages were having an extra ration of water to compensate for the shortchanging in food. Mama Floriani and the twin sisters, Dora and Rita, spread a red and white oilcloth on the ground; the Great Floriani made a fire with some dry branches; and the rest of the performers lent a hand here and there in the preparation of the customary meager repast.

After a most unrewarding tour through Honduras, the Great Floriani Circus had arrived, weary yet hopeful, to give their first performance in El Salvador. This was, they had been told, a great country, inhabited by people made bold and brave by their constant struggle with a hostile nature. The art of the Floriani Circus would, no doubt, meet with great critical and box office success. And they needed it badly. Otherwise, in a few weeks even the monkeys would disappear, as had Antonini's trained hens. Poor Antonini! After many years of hard labor he had worked out quite an effective act. Then came lean days for the circus. At each performance Antonini exhibited one hen less. At night he would weep tears of remorse over the smooth bones, ending up by gnawing at them, tears streaming down his cheeks. One day Antonini stepped out on the arena without hens and tried to fill in with a stupendous vocal imitation. But even before he had finished he stepped out again—right out of the circus.

Mama Floriani was losing weight fast, "which is good for your act," commented the Great Floriani; Colombina's horses were so famished that they could hardly lift their hoofs from the ground, much less prance smartly; the snake man was growing so alarmingly thin that he feared that one day he would tie his body into a knot which he would never be able to untie; Samson had to stuff the sleeves of his tights with burlap to compensate for his lost biceps; and the great ferocious bear "brought from the Russian steppes," supposed to be the *pièce de résistance* in the animal trainer's act, would lumber over to the children

in the audience like a meek beggar as soon as he detected the odor of bread and sausage. But in the face of hunger they were all closely united, tightening their individual belts in collective hope.

The scanty meal was soon ready. At the height of noon the sky was all sun. The thin vein of water had turned into a shimmering ribbon of silver. The aroma of roast corn scented the air. The monkeys beatifically picked their fleas in the sun, and the horses in their lassitude abandoned their backs to the flies. In the blue distance, the little white town held out a happy promise, like a white dove.

The Great Floriani wound up the phonograph and soon the hushed warm air woke to the tender notes of the melody that for years had been the trademark and theme song of the circus; "In a Little Spanish Town." On the red and white oilcloth the ears of corn glistened like bars of baked gold. Mama Floriani artfully decorated a wooden platter with tomatoes and onions. Samson approached carrying a head of lettuce in his powerful hands as if it were a bouquet of gardenias. From the oil bottle there flowed a shimmering blond liquid. The vinegar drops were amethyst tears in the sun. The salad began to smell heavenly.

It was at that moment that the stranger appeared. No one saw him come. The Great Floriani was the first to notice his long shadow and then his tall, emaciated body.

He had a gaunt dark face, and the long hair that tumbled wildly around his brow was the color of ashes and chestnuts. But his smile was as crisp and fresh as the lettuce leaves in the salad, and his limpid blue eyes were in keeping with his smile.

"Hello," he greeted them in a sweet liquid voice. And pointing to the corn, "It looks tender and the salad very appetizing."

Mama Floriani buried her wooden fork deep in the salad bowl and a delicious aroma accompanied the spatter of oil and vinegar.

"Corn," she explained, "should be well roasted outside but tender inside, and nothing could be better than salad in this heat."

"Who are you?" interrupted the Great Floriani, pouring water for the coffee.

The newcomer gallantly relieved Mama Floriani of a pile of wood she had picked up.

"My name is Miguel and I come from Cojutepeque. Where shall I put the wood?"

"There, next to the fire," replied Cascabel, the snake man, approaching with the plates.

The stranger set down his load together with an orange-colored pouch that he had been carrying on his shoulder.

"May I offer the group something?" he asked.

Samson burst into laughter. "A ham," he suggested mordantly, looking at the flaccid pouch and dusty sandals of the stranger.

"And a couple of bottles of red wine," shouted one of the twins who approached with tin cups for the coffee.

The stranger smiled and, without saying a word, disappeared behind the wagons.

"Where did that hobo come from?" Pipo asked gruffly, for hunger always soured his temper.

But the next moment a great clamor from his companions brought him quickly to the side of the Great Floriani, who with eyes wide with amazement was brandishing a huge ham and a jug of wine.

Mama Floriani snatched the ham from her husband and gave it a resounding kiss.

"I won't believe it until I dig my teeth into it," she cried.

They all agreed with her, and a minute later, at a signal from the Great Floriani, the performers were devouring the ham, letting the corn get cold. The stranger, seated in their midst, pecked at the salad like a bird. Suddenly his fork, a piece of tomato on it, stopped midway between the plate and his mouth. From behind the cage, where the "wild" animals shared hunger and fleas, a resounding slap rang out and then Colombina emerged. Not far behind her, one side of his face afire, Filipon, the juggler, tried unsuccessfully to hide the mark from the blow. Neither paid any attention to the visitor as they sat down as far apart as possible. But for the remainder of the feast the stranger could no longer eat. Colombina's face, white and pure as milk, with lips like dark red berries, fascinated him.

When the meal was finished, the Great Floriani exam-

ined his happy surfeited troupe through the smoke of his cigar. On the oilcloth there remained some purple wine stains, a few grains of corn, bread crumbs, and, like the skeleton of a prehistoric monster, the polished bone of the ham. From the cage came a mew of protest.

"Give the bones to the animals," said Samson generously. And with a nostalgic sigh, "How fortunate they are to be hungry!"

While the women went to the brook to wash the dishes, the others picked up scattered utensils. The Great Floriani, beaming beatifically at his spouse, turned to the stranger.

"Thanks for your gifts, my friend. I had forgotten what ham tasted like."

The stranger, seated with his legs crossed under him, deprecatingly raised a long pale hand with a wrist so thin that it looked like the ivory back-scratchers used by wealthy Mandarins.

"No thanks are due. I shared your salad."

This was far from true, for his plate lay untouched on the oilcloth and myriads of sun-spangled flies were feasting on it.

Only when she heard his velvety voice did Colombina, languid and detached throughout the entire meal, take note of the stranger's presence.

"You ate nothing," she said to him in a tone of friendly reproach. "Have an almond," she added with the air of one saving a poor hungry soul from starvation.

The stranger took the peeled almond but did not eat it. His radiant eyes sprinkled the round pale face of Colombina with the essence of lilies.

"Where are you going?" she asked him.

"I don't know. Nowhere. Wherever you go."

"We are going to Santa Ana," Mama Floriani explained. "Tomorrow is May first, the Tree Festival in this country, and we shall make our debut in the city."

"I shall go there with you," the stranger said smiling.

"Will you come to see the circus?" Colombina asked, delicately picking the golden crumbs from her white skirt and placing them within reach of the ants.

"I shall go *with* the circus," he corrected, looking at her with dazzled eyes.

"But we have room for no one but the performers," protested the Great Floriani.

"I shall work with you."

Samson looked at him with the contempt of a strong man.

"What can you do?"

"Nothing, I'm afraid," was the sad answer.

"Where did you work before?"

"Nowhere," the stranger declared. "In Cojutepeque I tried to make cigars but I was no good at it. In Llobasco I tried to make pots but they all broke. In Ahuachapán I worked in the mines but I missed the fresh air and I left. I'm afraid I don't know how to do anything," he repeated sadly.

"Only a great man would make such an admission," Colombina remarked, and he thought that all the light of the heavens had gathered on her fair brow.

"We all do something here," said the Great Floriani. "Almost all," he corrected severely, looking at Pipo snoring under a wagon.

"I could learn," the stranger implored.

"Why do you want to join the circus?" asked Mama Floriani, her maternal instinct sharpened by the ham and the wine.

"Because it fascinates me. It's a perpetual holiday. The gaiety . . . the color . . . the music . . . the slow processions on country roads . . . the arrivals in villages at sundown when the cows on the roadway fill the air with golden dust . . . the nights outdoors, watching the stars bathing in the ponds . . ."

"The poor man is mad," Dora whispered to her sister.

If the stranger heard her, he paid no attention.

"To sleep in a wagon," he continued, "listening to the crystal drumsticks of the rain on the roof above . . . to watch the sun light up the eyes of every child during the performance . . ."

"He is crazier than I thought," Dora insisted to her sister. But the latter stared at him with languid calf's eyes.

"Either crazy," she granted, "or a poet."

The Great Floriani studied the stranger in perplexity.

"If you were bigger you might fight Samson, if you were

193

skinnier you might work with Cascabel as snake man number two, if you knew sleight of hand you might help me...."

"It would be a great honor," the stranger interrupted him humbly.

"It's very difficult, young man, very difficult. Look!" His hand moved quickly in the air and out of nowhere it suddenly pulled three colored ribbons. "Just this little trick took me three years of practice. To be a magician takes a lifetime."

"I should think so!" the stranger said with admiration.

"Very well. Since you are so eager, you may help me. Pity you have no specialty."

"I never learned anything, except a little trick," said the stranger.

He stepped forward quickly, passed his hand over Colombina's hair and pulled out a sprig of heliotrope.

"*¡Qué diablos!*" cried the Great Floriani, who forgot his language when he was excited.

"*¡Ostras!*" echoed his wife, who ran him a close second.

"Magnificent!" said Colombina, standing on tiptoe just as she did when greeting her audience.

"Where did you learn that?" Dora asked, while her sister's mouth formed a capital O.

"It's nothing, really." The stranger's eyes had turned the color of dry leaves. "I learned it when I was a child."

"Do it again. And the flowers are real! Where do you hide them?" the Great Floriani roared.

The stranger's pale hands fluttered like butterfly wings and little sprigs of the heliotrope sprouted everywhere—from Mama Floriani's double chin, from Cascabel's mustache, from the wheel of a wagon and even from the tail of Leal, the Rossoffs' dog.

"This must be hypnotism," declared Filipon scornfully, for he was an educated man.

"You're coming with us, my friend," the Great Floriani declared firmly. "This trick—you'll explain it to me when we're alone—can be added to my act. You'll be my assistant. But first we must give you a name."

"Let's call him Amigo Heliotropo," Colombina suggested.

"That will be my name," said the stranger, smiling his sweet smile.

The next night Heliotropo made his debut with the Floriani Circus at the Tree Festival in Santa Ana. In the morning the circus had made a triumphal entrance into the town to the strains of the perennial "In a Little Spanish Town." Santa Ana's narrow streets were blindingly white with lime dust and sun. The washed blue of the sky formed a lofty arch above the red-roofed houses. The children astride the green fences cheered as the cage of wild animals rolled by, and the roosters in the barns provided a counterpoint. Samson, in his burlap-stuffed violet tights, lavished his most ravishing smiles upon the dark-eyed señoritas on the balconies. The air smelled of soap and lavender.

It was indeed a glorious spectacle the circus afforded, its bright red tent unfurled in the public square, its multicolored banners waving gaily in the soft May breeze. It was like a ship with sails ready to soar through the blue.

The show was a great success, such as the troupe had never witnessed before. The tent was filled for every one of the three performances. Cascabel twisted his body into figures of eight; the Rossoffs drew roars—of boredom, no doubt—from their wild animals; the twin sisters used a chair for everything except what it was intended for; the clowns' wintry jokes sparkled with the freshness of spring. Everyone performed as though burning with the fire of creation.

Heliotropo, dressed in gold tights, looked like a golden stalk of wheat. Indefatigable, he was everywhere, helping everyone. He was usher, groom, maid and announcer. He served as foil for the clowns and he stood up against the board to be outlined by Filipon's knives. He even found time to laugh with the children and, from a distance, to admire Colombina in her white tulle costume and wig of silver braids. Finally, he assisted the Great Floriani.

The old maestro was superb that day. Such feats of magic had never been seen in Santa Ana. He made coins vanish into thin air, guessed cards by the dozens, produced one rabbit after another out of a hat, drew multicolored ribbons from the bald head of a man in the first row, and

had Colombina step into a box and sawed her in two. For the finale, he pointed to different places in the audience from which Heliotropo promptly plucked sprigs of heliotrope, which he then presented to the señoritas in the audience.

As they were going to bed that night, Mama Floriani asked the Great Floriani, "How does he do it?"

"Damned if I know!" retorted the great magician, slapping down mosquitoes as noisy as jet planes. "He won't tell me his secret, but he gives me all the credit. That's all that matters. Among magicians secrets are respected."

The days that followed were the fulfillment of a glorious dream for Heliotropo. The whole fascinating country rolled under the slow wheels of the circus wagons. The circus traversed the vast, undulating indigo plantations of La Libertad and unfurled its huge tent overlooking the glittering Bay of Fonseca, where Heliotropo made Colombina a present of a lovely seashell box—one of the port's typical arts—for her combs; and in Santa Tecla, at the foot of the Volcano San Salvador, which made Pipo shut his mouth in sheer amazement; and in the village of San Miguel, where the splendor of the silver lodged in the entrails of the earth was reflected in the sky on moonlit nights; and in Santa Rosa and San Vicente, where Colombina bought herself a hat of gold-colored straw. In Sonsonate, Heliotropo shared with his adored *écuyère* one of the locality's famous cream cheeses and their faces were anointed with snowy goat's milk.

"To share this cheese between us," whispered Heliotropo, "is to take communion from the same Eucharist." And she, more orthodox, pretended to be frightened by his profanity.

Heliotropo earned no money with the Great Floriani. They offered him no remuneration and he asked for none. With the coins the people tossed him for pulling sprigs of heliotrope out of nowhere he bought little gifts for Colombina, and this was all that mattered to him. She, like the Great Floriani and the others, tired of asking him to explain his trick and finally came to regard it as just another act. Just the same, Colombina, a child who had never quite become a woman or a woman who had never ceased being a child, never stopped being thrilled at her friend's ability

196

to offer her at any hour of the day or night a sprig of the tiny fragrant blue flower.

And soon the emaciated young man with dreamy eyes and the courageous girl with supple ankles began to exchange tender glances above the tiny bouquets. While their traveling companions watched them with wise smiles and friendly whispers and the Florianis dreamed of another bond within the circus family, Filipon raged in silence. Even before Heliotropo's arrival he had sought Colombina's favor in vain. His carefully trimmed moustache, his man of the world manners, his brilliantined hair and his spectacular knife-throwing act, though now he outlined Heliotropo instead of a dummy, had failed completely. His attentions had elicited no more response from Colombina than stones tossed into an empty well. And now the simple, meek Heliotropo was eliciting from her the same exalted response as a great artist achieves with his violin. Things went on in this way while the circus wheels rolled past the shadows of the volcanoes San Miguel and San Vicente, Izalco and Santa Ana, past the trembling mirror of the thousand rivers of the Lempa and the Paz, the painted lakes, the Guija and the Llopango, the plantations of wheat and rice, the woods of Peru balsam and the indigo, the fields of pochote and frijoles, the biblical flocks of sheep and goats. The circus, and with it Colombina and Heliotropo, marched on with the inexorability of an astronomic phenomenon. Until one night they came to a village on the Guatemalan frontier.

It was a hamlet with a few houses huddled together at the foot of a towering green mountain. The wagons stopped at the edge of a lyre-shaped lake with quiet gray waters. In the trees that solemnly watched over the sleeping lake, invisible birds sang as though enchanted. A hawk fluttered in the twilight blue, like an evil omen in a witches' tale. The bells of a white hermitage, which hung like a nest on the side of the mountain, underscored the peace of the evening.

The Great Floriani, feverish from a cold, soon took to his bed, but the others were having a fine dinner, old wine, songs and dancing by a crackling fire. The night slowly reclined upon the treetops, sultry and voluptuous like an amorous odalisque. With the last carmine rays of the set-

ting sun, the underbrush yielded its wild aromas and the crickets burst into their staccato singsong.

When they went to bed—all except Filipon, who devoured by jealousy and mosquitoes lingered on to spy in the shadows—Colombina and Heliotropo were alone by the dying fire. The glowing embers tinted the round little face of the girl rose. The lake, invisible in the darkness, lapped gently against the shore. The moon was hidden but a thousand yellow stars blinked brightly, though not as brightly as the stars that leaped from the fire. It was the languid hour of midnight.

Colombina and Heliotropo, holding hands, silently gazed at each other. From their lips hung a kiss that like a timid little bird dared not assert itself. The romantic message that had grown through long hot days, moonlit nights and hours of work, insomnia and hope, struggled silently to make itself known.

Finally Colombina rose. He followed her silently. She climbed into the wagon where she slept alone among many a prop and bale. From the top step she looked down at him, her lips shimmering with scarlet tremors.

"Come," she said to him, and entering the wagon she closed the door.

Heliotropo did not move. Filipon, who had witnessed the scene from the shadows, went to his own wagon blind with pain and rage. Heliotropo, standing still, was like a statue burnished in silver by a curious moon.

Sleepless, trembling, Colombina waited in vain. Her door never opened again that night.

"In a Little Spanish Town" . . . The melody announced the opening number. The circus was giving a gala performance in the mountain village of Cojutepeque. Colombina, her eyes red and swollen, passed Heliotropo without even glancing at him and went through her act with waxen face and pale lips.

Unfortunately the Great Floriani was too sick to perform. After a feverish night, visited by severe fits of coughing, he lay exhausted on his cot under the hot poultices the inexorable Mama Floriani applied to his vast chest every few minutes. A short consultation had taken place at his bedside. It was agreed that Heliotropo would do all he

could to entertain the public, and then as a finale they would put on Filipon's invariably spectacular knife act.

The Great Floriani gave final instructions to a shaking Heliotropo.

"Do all you can," he implored him. "At least make a coin vanish or change the color of a ribbon or two."

The roll of drums, which usually heralded the entrance of the Great Floriani and was now announcing Heliotropo, sounded to him like the prelude to his execution. The dais he had to mount in the center of the ring was the guillotine, the sand reminded him of the cemetery, and the audience was the Roman mob that with a turn of their thumbs brought death upon the victim's head.

He bowed clumsily and became even more flustered when he noticed Colombina staring at him with eyes of steel and a mocking smile. The anxious faces of the children in the first row made his fright mount to new heights. He tried the trick with the coin but it fell to the ground. Just as he was beginning the ribbon trick, the blue banners of the next trick dropped out from under his cape. He tried to draw flame out of a hat and almost started a fire.

Filipon's resounding guffaws mixed with the shouts of protest from the audience. Heliotropo, completely disconcerted, looked around for some means of escape. But something in Colombina's eyes stopped him.

Suddenly, without hesitating, Heliotropo approached a little boy and no sooner did he make him put out his hands than they held a nest of quivering white doves. Then he picked up a handful of sand and tossed it in the air, and instead of sand a cloud of gold spangles drifted down to the ground. The audience began to applaud. Heliotropo, pale but smiling, next changed the rope round the ring into a garland of flowers, the old tired horses into multicolored zebras, and the wrinkled, paper peanut bags into canaries of yellow flight and golden song. Never before had an audience seen such skill. The performers, standing together, stared at Heliotropo in stupefaction. Heliotropo raised a pale hand and there fell from the canvas roof a shower of colored confetti, streamers and balloons. From between the knees of a young man he produced a white pony bedizened in gorgeous velvet and silver mail. In the center of the ring he called forth a fountain of feathers and

pearls, and from a paper envelope he drew a twenty-foot-high palm tree with coconuts and monkeys high up in the branches. The audience went completely mad. It was then that Heliotropo, as his finale, signaled to Colombina to lie in the box in which she was sawed in two by the Great Floriani. At that moment, the Great Floriani, who had been kept apprised of the extraordinary happenings by an astonished and stammering Cascabel, uttered a blood-curdling scream.

"Look!" he cried to Mama Floriani. "There is the painted rubber saw with which I cut Colombina in two, and yet I saw Filipon take out a saw for the act. He must have taken the one used for cutting wood."

He had to say no more. Mama Floriani executed a truly astonishing leap, considering her weight, and darted out of the wagon toward the circus. The Great Floriani, bathed in a cold sweat of terror, at any minute expected Mama Floriani to walk in with a bloody Colombina under her arm. What a monstrous revenge! The jealousy-crazed Filipon had arranged for Heliotropo to cut his beloved in half. The Great Floriani thought he could hear Colombina's screams, which Heliotropo would mistake for the false cries she lavished on the audience every time Floriani pretended to cut her in two with the imitation saw. And this time the legs held up to the public would be real and not artificial ones dripping with red paint.

The wagon door was suddenly pushed open. The Great Floriani clenched his fists. But his wife was alone.

"I can't believe it," she panted, sitting down on a mustard plaster in her confusion. "That boy is the greatest magician in the world. He pulled a giraffe out of a hat and threaded a needle with a rope. And—you'll die, Floriani!—he really *did* saw Colombina in two and then put her together again as good as new. No, I'm not crazy. And you have heard nothing yet. It was not sleight of hand. He did it with a real saw and she thought it was the same old trick. And then he stood up for Filipon to throw his knives at him. I swear he threw them at him to kill! Right at his heart! And Heliotropo, smiling, changed them into golden lilies as they came at him."

Nobody slept that night, nobody in the town and certainly nobody in the circus. Filipon had fled, his teeth

chattering with terror. The Florianis made great plans for the future and dreamed of Heliotropo's becoming the star of their troupe. The other performers waited in a frenzy for morning to come to express their admiration to Heliotropo. Colombina spent the night interrogating the lofty stars with tearful eyes. After the show Heliotropo had left for the hermitage on the mountain, explaining that he wanted to spend the night alone. They had respected his wish.

At dawn, Colombina could wait no longer and knocked at the door of the Florianis' wagon. Mama Floriani, her hair disheveled and her eyes red from a sleepless night, opened the door.

"Mama Floriani," Colombina implored, "you must come with me to find him."

"Where did he go?"

"To the hermitage on the mountain."

They left Floriani snoring under layers of blankets and began their climb to the hermitage. The sky was tinged by the pink of dawn. Birds burst into early song to frighten away the last star. The scent of rosemary perfumed the air. From a pool a single frog stared at them with beady little eyes. Invisible cocks crowed, giving the sun the signal to rise. Colombina, pale and anxious, climbed the path lightly, followed by her hard-breathing companion.

The hermitage was small, white and sad, like the deep sigh of a tearful child. Outside the sun polished the roof with its gold emery board. Inside there were wooden benches, a small altar with a stone saint, the aroma of flowers, and an early-rising friendly hermit. When he saw the two women staring with ecstatic faces at the saint, he approached them with a benevolent gesture.

"Are you admiring the angel San Miguel? Fine manly figure of a saint. You won't believe it but he was a sinner in his youth. There is a beautiful legend about him. In his lifetime God punished him for breaking his vow of chastity with a girl. His penance was to return to earth time and again dispossessed of his miraculous powers, which he had abused once to please a woman. God commanded him to wander over the earth until he could withstand the temptation of a woman's love. Only then would he again recover God's grace and with it his power to perform miracles. The

Lord, however, allowed him in his penitential wanderings one little miracle: He could make flowers appear anywhere. But until he could prove that he preferred divine grace to a woman's arms, he would have to wander through the world, a young man of light head and yielding heart. This is his statue and these his flowers. Don't you smell the perfume of the blue heliotrope, the favorite flowers of the angel San Miguel?"

Once again night and silence have descended upon the circus. Performers and animals are in deep sleep. A moon as huge as heaven itself bathes the circus in its chaste light. The air suddenly stirs with the footsteps of a divine presence. And in the morning Cascabel wakes up in silk tights embroidered with gold; the horses are harnessed in the finest wrought silver; the twin sisters find bolts of gold cloth at their feet; Samson's weights are filled with precious jewels; the Florianis' wagon is a princely chariot, all precious metals, silk hangings and brocades. And Colombina opens her eyes and finds in her hand a sprig of heliotrope.

Isaac Bashevis Singer

(1904–)

Recipient of the Nobel Prize for literature in 1978, Isaac Bashevis Singer is the most prominent and popular Yiddish writer in the world today. His many stories and novels have been translated into dozens of languages, including Hebrew, French, Dutch, Norwegian, Finnish, Italian, German, and English. This international acceptance offers convincing proof that even though most of Singer's fiction deals with the somewhat esoteric culture of Polish Jewry of the past three centuries, it acquires universality through its sensitive treatment of common human concerns. Yiddish may be slowly dying, but there is no doubt that Singer's stories will live on.

Although Singer has lived in the United States for most of his adult life, he was born in Radzymin, Poland, on July 14, 1904. His family was financially poor, but abundantly rich in religious heritage: Isaac's father and his maternal and paternal grandfathers were all rabbis. In 1908, the four-year-old Isaac moved with his family to a ghetto tenement in the Polish capital city of Warsaw. There his religious education began in earnest. Although he received his formal education from the Tachenioni Rabbinical Seminary, Singer probably learned as much, if not more, from the spirited discussions taking place in his own home. In a biographical statement made to *World Authors* Singer reminisces:

My elder brother, I. J. Singer, who later wrote *The Brothers Ashkenazi*, began in Warsaw to paint, to write secular stories and to express doubts about the Jewish dogmas. My parents advocated religion with all their power and I listened to these discussions. In order to strengthen the cause of faith, my parents

told many tales of *dybbuks*, possessions, haunted houses, wandering corpses. I was fascinated both with my brother's rationalism and with my parents' mysticism (p. 1321).

His parents' stories made a deep impression upon Singer and later became the raw material for much of his own fiction.

At the age of thirteen Singer moved, with his mother and younger brother, to the Jewish village of Bilgoray, the home of his maternal grandfather. He spent a few years in this tiny *shtetl*, and then in the early 1920s, returned to Warsaw to live with his older brother, Israel. From his early youth Isaac had been interested in literature and writing, and had already tried his hand at both poetry and short fiction, writing mostly in Hebrew. Now, while working as a proofreader for the *Literarishe Bletter*, he began practicing his craft in earnest, publishing several stories and book reviews in both Yiddish and Hebrew. He became more and more immersed in a literary life-style, becoming co-editor of the literary magazine *Globus*, in 1932. It was in this journal that sections of his first novel, *Satan in Goray*, were published, along with several of his early pieces of short fiction.

The midthirties were difficult years for Singer: his brother Israel, with whom he had established a very close relationship, moved to New York in 1934; ominous sounds were coming from Hitler's Germany; and Singer's wife, Rachel, had decided to become a Communist. By 1935 the situation had deteriorated to such an extent that Singer packed his few belongings and set sail for New York, leaving behind his job, his wife and son, and his beloved homeland. Once in New York he joined his brother, Israel, and began working as a columnist for the *Jewish Daily Forward*. It is in this publication, New York City's leading Yiddish newspaper, that most of Singer's fiction has first appeared. Singer, an American citizen since 1943, currently lives in a New York apartment with his second wife, Alma, a refugee from Germany whom he married in 1940.

Singer's literary output is indeed prodigious. He has written a number of fine novels, including *The Family*

Moskat (1950), *Satan in Goray* (1955), *The Magician of Lublin* (1959), and *The Slave* (1962). Two other closely related novels, *The Manor* (1967) and *The Estate* (1969), were serialized as a single long work between 1952 and 1955. It is his short stories, however, for which Singer is best known. Some of his finest short fiction has been collected in such volumes as *Gimpel the Fool* (1957), *The Spinoza of Market Street* (1961), *Short Friday* (1964), *A Friend of Kafka* (1970), and the award-winning *A Crown of Feathers* (1973). His *A Day of Pleasure: Stories of a Boy Growing Up in Warsaw* received the 1970 National Book Award for children's literature as the best children's book of the year.

An anthology of Christian fantasy would not be complete without a story reflecting Christianity's rich Judaic literary heritage. "Jachid and Jechidah," embodying a number of tenets and concepts central to both Judaism and Christianity, is such a story. The key concept of reincarnation, or transmigration of souls, is one that, over the centuries, has provoked rather vehement disagreement among both Judaic and Christian theologians. This fact, we feel, makes "Jachid and Jechidah" all the more attractive as a selection.

The reader will find all of the Singer hallmarks in "Jachid and Jechidah": a vigorous, tightly woven narrative; evocative descriptions; and subtle character delineation. Perhaps the most intriguing aspect of the tale, however, is its use of reversal of perspective. Readers familiar with C. S. Lewis's description of Earth (*Out of the Silent Planet*) as a dead spot in a sea of space suffused with heavenly vitality and life will immediately see the similarity between this treatment of our planet and Singer's treatment in "Jachid and Jechidah." Lewis's Oyarsa reveals that Earth is the dominion of the Bent One (Satan) and calls it the "Silent Planet"; similarly, Singer has the Souls of Heaven refer to Earth as Sheol, the abode of the dead. The reversal of perspective goes even further in Singer's tale: what we think of as life is really a kind of death, and what we usually consider to be death is really true life. "Death," we learn, "is a laboratory for the rehabilitation of souls"; a "preparation of a new existence." Page after page shocks

us into seeing life and death from a different perspective. Have you ever, for example, considered the Earth as a "large necropolis where corpses are prepared for all kinds of mortuary functions"? "Jachid and Jechidah," a powerful moral fable, will force you to consider that very possibility.

JACHID AND JECHIDAH

by Isaac Bashevis Singer
(Translated by Isaac Bashevis Singer and Elizabeth Pollet)

In a prison where souls bound for Sheol—Earth they call it there—await destruction, there hovered the female soul Jechidah. Souls forget their origin. Purah, the Angel of Forgetfulness, he who dissipates God's light and conceals His face, holds dominion everywhere beyond the Godhead. Jechidah, unmindful of her descent from the Throne of Glory, had sinned. Her jealousy had caused much trouble in the world where she dwelled. She had suspected all female angels of having affairs with her lover Jachid, had not only blasphemed God but even denied him. Souls, she said, were not created but had evolved out of nothing: they had neither mission nor purpose. Although the authorities were extremely patient and forgiving, Jechidah was finally sentenced to death. The judge fixed the moment of her descent to that cemetery called Earth.

The attorney for Jechidah appealed to the Superior Court of Heaven, even presented a petition to Metatron, the Lord of the Face. But Jechidah was so filled with sin and so impenitent that no power could save her. The attendants seized her, tore her from Jachid, clipped her wings, cut her hair, and clothed her in a long white shroud. She was no longer allowed to hear the music of the spheres, to smell the perfumes of Paradise and to meditate on the secrets of the Torah, which sustain the soul. She could no longer bathe in the wells of balsam oil. In the prison cell, the darkness of the nether world already surrounded her. But her greatest torment was her longing for Jachid. She could no longer reach him telepathically. Nor could she send a message to him, all of her servants having been taken away. Only the fear of death was left to Jechidah.

Death was no rare occurrence where Jechidah lived but it befell only vulgar, exhausted spirits. Exactly what hap-

pened to the dead, Jechidah did not know. She was convinced that when a soul descended to Earth it was to extinction, even though the pious maintained that a spark of life remained. A dead soul immediately began to rot and was soon covered with a slimy stuff called semen. Then a grave digger put it into a womb where it turned into some sort of fungus and was henceforth known as a child. Later on, began the tortures of Gehenna: birth, growth, toil. For according to the morality books, death was not the final stage. Purified, the soul returned to its source. But what evidence was there for such beliefs? So far as Jechidah knew, no one had ever returned from Earth. The enlightened Jechidah believed that the soul rots for a short time and then disintegrates into a darkness of no return.

Now the moment had come when Jechidah must die, must sink to Earth. Soon, the Angel of Death would appear with his fiery sword and thousand eyes.

At first Jechidah had wept incessantly, but then her tears had ceased. Awake or asleep she never stopped thinking of Jachid. Where was he? What was he doing? Whom was he with? Jechidah was well aware he would not mourn for her for ever. He was surrounded by beautiful females, sacred beasts, angels, seraphim, cherubs, ayralim, each one with powers of seduction. How long could someone like Jachid curb his desires? He, like she, was an unbeliever. It was he who had taught her that spirits were not created, but were products of evolution. Jachid did not acknowledge free will, nor believe in ultimate good and evil. What would restrain him? Most certainly he already lay in the lap of some other divinity, telling those stories about himself he had already told Jechidah.

But what could she do? In this dungeon all contact with the mansions ceased. All doors were closed: neither mercy, nor beauty entered here. The one way from this prison led down to Earth, and to the horrors called flesh, blood, marrow, nerves, and breath. The God-fearing angels promised resurrection. They preached that the soul did not linger forever on Earth, but that after it had endured its punishment, it returned to the Higher Sphere. But Jechidah, being a modernist, regarded all of this as superstition. How would a soul free itself from the corruption of the body? It

was scientifically impossible. Resurrection was a dream, a silly comfort of primitive and frightened souls.

One night as Jechidah lay in a corner brooding about Jachid and the pleasures she had received from him, his kisses, his caresses, the secrets whispered in her ear, the many positions and games into which she had been initiated, Dumah, the thousand-eyed Angel of Death, looking just as the Sacred Books described him, entered bearing a fiery sword.

"Your time has come, little sister," he said.

"No further appeal is possible?"

"Those who are in this wing always go to Earth."

Jechidah shuddered. "Well, I am ready."

"Jechidah, repentance helps even now. Recite your confession."

"How can it help? My only regret is that I did not transgress more," said Jechidah rebelliously.

Both were silent. Finally Dumah said, "Jechidah, I know you are angry with me. But is it my fault, sister? Did I want to be the Angel of Death? I too am a sinner, exiled from a higher realm, my punishment to be the executioner of souls. Jechidah, I have not willed your death, but be comforted. Death is not as dreadful as you imagine. True, the first moments are not easy. But once you have been planted in the womb, the nine months that follow are not painful. You will forget all that you have learned here. Coming out of the womb will be a shock; but childhood is often pleasant. You will begin to study the lore of death, clothed in a fresh, pliant body, and soon will dread the end of your exile."

Jechidah interrupted him. "Kill me if you must, Dumah, but spare me your lies."

"I am telling you the truth, Jechidah. You will be absent no more than a hundred years, for even the wickedest do not suffer longer than that. Death is only the preparation for a new existence."

"Dumah, please. I don't want to listen."

"But it is important for you to know that good and evil exist there too and that the will remains free."

"What will? Why do you talk such nonsense?"

209

"Jechidah, listen carefully. Even among the dead there are laws and regulations. The way you act in death will determine what happens to you next. Death is a laboratory for the rehabilitation of souls."

"Make an end of me, I beseech you."

"Be patient, you still have a few more minutes to live and must receive your instructions. Know, then, that one may act well or evilly on Earth and that the most pernicious sin of all is to return a soul to life."

This idea was so ridiculous that Jechidah laughed despite her anguish.

"How can one corpse give life to another?"

"It's not as difficult as you think. The body is composed of such weak material that a mere blow can make it disintegrate. Death is no stronger than a cobweb; a breeze blows and it disappears. But it is a great offense to destroy either another's death or one's own. Not only that, but you must not act or speak or even think in such a way as to threaten death. Here one's object is to preserve life, but there it is death that is succored."

"Nursery tales. The fantasies of an executioner."

"It is the truth, Jechidah. The Torah that applies to Earth is based on a single principle: another man's death must be as dear to one as one's own. Remember my words. When you descend to Sheol, they will be of value to you."

"No, no, I won't listen to any more lies." And Jechidah covered her ears.

Years passed. Everyone in the higher realm had forgotten Jechidah except her mother who still continued to light memorial candles for her daughter. On Earth Jechidah had a new mother as well as a father, several brothers and sisters, all dead. After attending a high school, she had begun to take courses at the university. She lived in a large necropolis where corpses are prepared for all kinds of mortuary functions.

It was spring, and Earth's corruption grew leprous with blossoms. From the graves with their memorial trees and cleansing waters arose a dreadful stench. Millions of creatures, forced to descend into the domains of death, were becoming flies, butterflies, worms, toads, frogs. They buzzed, croaked, screeched, rattled, already involved in the

death struggle. But since Jechidah was totally inured to the habits of Earth, all this seemed to her part of life. She sat on a park bench staring up at the moon, which from the darkness of the nether world is sometimes recognized as a memorial candle set in a skull. Like all female corpses, Jechidah yearned to perpetuate death, to have her womb become a grave for the newly dead. But she couldn't do that without the help of a male with whom she would have to copulate in the hatred which corpses call love.

As Jechidah sat staring into the sockets of the skull above her, a white-shrouded corpse came and sat beside her. For a while the two corpses gazed at each other, thinking they could see, although all corpses are actually blind. Finally the male corpse spoke:

"Pardon, Miss, could you tell me what time it is?"

Since deep within themselves all corpses long for the termination of their punishment, they are perpetually concerned with time.

"The time?" Jechidah answered. "Just a second." Strapped to her wrist was an instrument to measure time but the divisions were so minute and the symbols so tiny that she could not easily read the dial. The male corpse moved nearer to her.

"May I take a look? I have good eyes."

"If you wish."

Corpses never act straightforwardly but are always sly and devious. The male corpse took Jechidah's hand and bent his head toward the instrument. This was not the first time a male corpse had touched Jechidah but contact with this one made her limbs tremble. He stared intently but could not decide immediately. Then he said: "I think it's ten minutes after ten."

"Is it really so late?"

"Permit me to introduce myself. My name is Jachid."

"Jachid? Mine is Jechidah."

"What an odd coincidence."

Both hearing death race in their blood were silent for a long while. Then Jachid said: "How beautiful the night is!"

"Yes, beautiful!"

"There's something about spring that cannot be expressed in words."

211

"Words can express nothing," answered Jechidah.

As she made this remark, both knew they were destined to lie together and to prepare a grave for a new corpse. The fact is, no matter how dead the dead are there remains some life in them, a trace of contact with that knowledge which fills the universe. Death only masks the truth. The sages speak of it as a soap bubble that bursts at the touch of a straw. The dead, ashamed of death, try to conceal their condition through cunning. The more moribund a corpse the more voluble it is.

"May I ask where you live?" asked Jachid.

Where have I seen him before? How is it his voice sounds so familiar to me? Jechidah wondered. *And how does it happen that he's called Jachid? Such a rare name.*

"Not far from here," she answered.

"Would you object to my walking you home?"

"Thank you. You don't have to. But if you want . . . It is still too early to go to bed."

When Jachid rose, Jechidah did, too. Is this the one I have been searching for? Jechidah asked herself, the one destined for me? But what do I mean by destiny? According to my professor, only atoms and motion exist. A carriage approached them and Jechidah heard Jachid say:

"Would you like to take a ride?"

"Where to?"

"Oh, just around the park."

Instead of reproving him as she intended to, Jechidah said: "It would be nice. But I don't think you should spend the money."

"What's money? You only live once."

The carriage stopped and they both got in. Jechidah knew that no self-respecting girl would go riding with a strange man. What did Jachid think of her? Did he believe she would go riding with anyone who asked her? She wanted to explain that she was shy by nature, but she knew she could not wipe out the impression she had already made. She sat in silence, astonished at her behavior. She felt nearer to this stranger than she ever had to anyone. She could almost read his mind. She wished the night would continue for ever. Was this love? Could one really fall in love so quickly? And am I happy? she asked herself. But no answer came from within her. For the dead are

always melancholy, even in the midst of gaiety. After a while Jechidah said: "I have a strange feeling I have experienced all this before."

"*Déjà vu*—that's what psychology calls it."

"But maybe there's some truth to it. . . ."

"What do you mean?"

"Maybe we've known each other in some other world."

Jachid burst out laughing. "In what world? There is only one, ours, the earth."

"But maybe souls do exist."

"Impossible. What you call the soul is nothing but vibrations of matter, the product of the nervous system. I should know, I'm a medical student." Suddenly he put his arm around her waist. And although Jechidah had never permitted any male to take such liberties before, she did not reprove him. She sat there perplexed by her acquiescence, fearful of the regrets that would be hers tomorrow. I'm completely without character, she chided herself. But he is right about one thing. If there is no soul and life is nothing but a short episode in an eternity of death, then why shouldn't one enjoy oneself without restraint? If there is no soul, there is no God, free will is meaningless. Morality, as my professor says, is nothing but a part of the ideological superstructure.

Jechidah closed her eyes and leaned back against the upholstery. The horse trotted slowly. In the dark all the corpses, men and beasts, lamented their death—howling, laughing, buzzing, chirping, sighing. Some of the corpses staggered, having drunk to forget for a while the tortures of hell. Jechidah had retreated into herself. She dozed off, then awoke again with a start. When the dead sleep they once more connect themselves with the source of life. The illusion of time and space, cause and effect, number and relation ceases. In her dream Jechidah had ascended again into the world of her origin. There she saw her real mother, her friends, her teachers. Jachid was there, too. The two greeted each other, embraced, laughed and wept with joy. At that moment, they both recognized the truth, that death on Earth is temporary and illusory, a trial and a means of purification. They traveled together past heavenly mansions, gardens, oases for convalescent souls, forests for divine beasts, islands for heavenly birds. No, our meeting

213

was not an accident, Jechidah murmured to herself. There is a God. There is a purpose in creation. Copulation, free will, fate—all are part of His plan. Jachid and Jechidah passed by a prison and gazed into its window. They saw a soul condemned to sink down to Earth. Jechidah knew that this soul would become her daughter. Just before she woke up, Jechidah heard a voice:

"The grave and the grave digger have met. The burial will take place tonight."

John R. Aurelio

(1937–)

In "The Good Samaritan," one of Christ's most moving and meaningful parables, we are told the story of a compassionate man who comes to the aid of a fellow traveler who has been robbed and beaten by merciless thieves. Other travelers have seen the injured victim, but they have simply passed him by. Some things have not changed much since Christ's time. Good Samaritans are still rare. One of the rare ones is Fr. John Aurelio, diocesan priest, social worker, and storyteller, who for the past twenty years has dedicated his life to the training and care of the disadvantaged and the downtrodden. Here is a man who does not simply turn his head and pass by; here is a true twentieth-century Good Samaritan.

The son of Sicilian immigrants, John Aurelio was born in New York City on September 19, 1937. Shortly thereafter, however, he moved with his family to Buffalo, New York, where he received both his elementary and secondary school education, graduating from Grover Cleveland High School in 1955. He then enrolled at St. Bonaventure University, receiving his B.A. in philosophy in 1959; his graduate work was done at Fordham University, where, in 1962, he was awarded his Master's Degree in psychiatric social work.

The early 1960s was a time of great challenge for John Aurelio. It was a time to put theory into practice; a time to move from the relative security of the classroom to the uncertainty and harsh reality of the slums and the streets. His first assignments as a social worker in Buffalo and New York intimately involved him with Cuban refugees, dependent and neglected children, street gangs, the mentally retarded, the destitute, and the hospitalized. As so often happens, the lives he touched also touched his; in this instance,

those whom he had helped in turn helped him to reach a decision he had been wrestling with for nearly a decade. Since his junior year in high school John Aurelio had been preparing himself for the priesthood. He had attended a seminary for approximately eight years and had found the experience fulfilling, but he was still not sure about taking his final vows. His experiences with the street gangs in New York served as a catalyst in the decision-making process. The devoted social worker soon discovered that the young people he was trying to help, desperately needed two things: love and God. Love he had already been giving as a field worker; the path to God, however, he thought he could chart best as a priest. Thus, he pursued his religious training at St. John Vianney Seminary, East Aurora, New York, where he was ordained to the priesthood in 1966.

Since then, Father John, as his parishioners affectionately call him, has been pursuing the dual role of priest and social worker. While serving as chaplain of the West Seneca Developmental Center in West Seneca, New York, he continues to bring love and God to the handicapped and the destitute. His selfless acts of Christian charity have not gone unnoticed. Since 1973 he has received several humanitarian awards, including the Buffalo Port Council AFL/CIO Humanitarian Award, the Buffalo *Evening News* Outstanding Citizen of the Year Award (1976), and the Bishop McNulty Youth Award–CYO of Buffalo (1978). It is not difficult to understand why a Buffalo-area journalist recently referred to him as "God's gift to the downtrodden."

A few years ago, on a hot Sunday in July, Father John conducted an experiment. He decided to forego his usual homily in favor of a faery tale-like story to be told directly to the children in the congregation. He invited the children to the front of the church, where they expectantly gathered around him. He then proceeded to weave his storytelling magic. Both the children and the parents responded so enthusiastically—they broke into spontaneous applause—that Father John began setting aside one Sunday each month for the delivery of one of his Christian parables. Thus was launched "Story Sunday" at St. Catherine of Siena Church. Since then John Aurelio, diocesan priest turned author, has had published *Story Sunday: Christian Fairy Tales for*

Young and Old Alike (1978), and *The Beggar's Christmas* (1979), both of which contain the stories he first told to his congregation on Story Sundays. In addition, he has submitted for publication two other manuscripts of Story Sunday tales and is currently working on a third.

"The Greatest Feat," one of Father John's Story Sunday tales, is a delightful mixture of high fantasy and Christian parable. It is the high-fantasy element that the reader first encounters: there are wizards, various feats of magic, shape shiftings, and various high fantasy motifs, including that of the trial. With the appearance of the young man who is violently struck down, however, we move into the realm of the parable. It is a parable whose message is uncomfortably clear. In the author's own words " 'The Greatest Feat' is a portrayal in symbolism of the condition of modern man. The marvelous deeds of the four wizards are nothing more than the fantasies of today acted out in real life. It answers the question: 'What would happen if Jesus were to come today?' " The great appeal of a parable, of course, lies in the fact that it entertains while it instructs. Father John's parable succeeds admirably on both counts. It is not difficult to understand why the parishioners of St. Catherine's look forward to Story Sundays.

THE GREATEST FEAT

by John Aurelio

Once upon a time, a long, long time ago, there was a great and mighty king. The kingdom he ruled was so big, extended so far beyond what any man had ever seen, that they called him the King of the Universe.

One day he sent a royal proclamation to be read in all the villages and towns throughout the kingdom:

HEAR YE, HEAR YE!
EVERYONE EVERYWHERE—
HIS SUPREME MAJESTY DECREES:

I WILL GIVE MY ENTIRE KINGDOM—
THE LENGTH AND BREADTH,
THE HEIGHT AND DEPTH—
TO THE PERSON
WHO PERFORMS THE GREATEST FEAT

One can imagine the excitement the royal decree caused among the people. It was rumored that the king had no heir and this undoubtedly meant he was in search of one. How great the feat would have to be to inherit such a kingdom. What marvelous feats would be performed for the king before he would make his judgment.

When the day arrived for the competition to begin, people flocked to the king's castle from the four corners of the earth. Wizards, sorcerers, jugglers, acrobats, scholars, magicians, musicians. They were all there in endless numbers and countless varieties. Into the courtyard they poured—a steady stream that grew into a river until the yard was filled to overflowing.

At last the king's minister appeared at the balcony that overlooked the assembled throng. He tapped his staff sol-

emnly, reverently, three times on the stone floor. The sound of trumpet blasts filled the air, calling the crowds to silence and heralding the imminent presence of the king. All eyes looked to the balcony.

The King of the Universe appeared. The crowd fell to utter silence. It was as if the ponderous weight of his awesome majesty had suddenly been felt by the crowd as it stooped under the magnitude of it. He sat.

The minister tapped his staff and announced, "Let the competition begin."

For many long hours jugglers juggled, acrobats tumbled and musicians played. Everyone who wished to compete was given the opportunity to perform. The king and his retinue sat silently in the balcony observing carefully all that took place below.

Day followed upon day until nearly everyone had performed. When the last contestant was finishing his feat, a murmuring began in the crowd. As it spread through the people, it gained intensity until it was no longer a whisper but a shout: "THE WIZARDS HAVE ARRIVED."

Everyone turned to the castle gate. As the four wizards entered, the crowds shouted and cheered in a wild frenzy. They had become tired of watching similar feats over and over again and yearned for something exciting and spectacular. Certainly the wizards would satisfy this craving for no one could perform the marvelous deeds they could. The only real competition should have been between them, but the king had insisted that everyone who wanted to perform could try. So the wizards waited until the end as if to save the best until last.

It was the Wizard of the North who came forward first. He was a tall and stately man of regal bearing. He would make a fine heir to the king. He was dressed in a long flowing robe of pitch black that covered his entire body. His face and hands, the only parts of him that were uncovered, were a pure and dazzling white. Slowly he walked through the assembly, stood before the balcony, and bowed. The crowds watched with absolute reverential silence.

Without a word, the Wizard of the North reached into a pouch which hung at his waist and withdrew from it a handful of powder. With a long, deliberate gesture, he

threw the powder into the air. It immediately began to sparkle in the sunlight like a million brilliant diamonds. The people watched in awe as the powder rose steadily higher, progressively faster, until it become a comet and burst into the sun in a dazzling explosion of white light.

At first the people were filled with fear, covering their faces against the blinding flash. Then a voice cried out, "Look! Look around you everybody!" The scene they opened their eyes to was a very strange one indeed. The world had become a stark contrast of black and white. The buildings that were light had suddenly become a brilliant, eye-squinting white. The buildings that were dark had become dense black. The same was true for the animals. Dark ones were black and light ones were white. It was on people, however, that it had the most peculiar effect. If they were light, their hands and faces became dazzling white. If they were dark, the bodies appeared deep black. The clothes they wore took on the same peculiar quality so that people looked like checkerboard patches of contrasting black and white. In truth, the world had become black and white.

The people, overwhelmed by such wizardry, began to shout and applaud with delight.

"Surely this must be the greatest feat. No one has ever seen the likes of this. The Wizard of the North should win the prize."

Seated in his balcony, the king remained silent. The wizard bowed obediently before the king, and everything returned to the way it was before.

The Wizard of the South then stepped forward. He was an old man with white hair and a long white beard. Instead of a staff as a walking stick, he carried a sickle. He bowed slightly but reverently before the King of the Universe. Again the crowds became silent.

Ever so slowly the wizard raised his right arm and with a bony finger pointed at the steeple clock. All heads were raised. All eyes looked to the clock. Deliberately, very deliberately, the wizard began to move his finger in a circle. As his fingers moved so did the hands of the clock. At first the movement was so slow that people wondered what the wizard might be drawing their attention to. Gradually they began to notice what was happening. With each rota-

tion of his finger, an hour would pass on the steeple clock. His finger moved faster. The clouds began to accelerate. Animals and people began to move more quickly. Shadows changed rapidly. Even the way people spoke was high pitched and peculiarly fast. Still the wizard moved his finger in a circle faster and faster. Time now began to fly by. In an instant the sun would rise, clouds streak across the sky; then it would rain and become dry in the batting of an eye; next the wind would blow and abate as quickly as a breath; then the sun would set only to rise again moments later and the same phenomenon would repeat itself.

When everything was moving as fast as time and imagination would allow, the wizard began to slow down the movement of his finger. The sun's trajectory, the clouds' progression, the earth's hectic pace began to diminish and become more normal. The people breathed easier, their voices became intelligible again.

The wizard stood there in the courtyard still pointing to the clock, still moving his finger slower and slower until it seemed that time had all but stopped. The sun was a fixed light in the sky that burned unbearably hot on an immobile world. All movement slowed to a labored infinitesimal progression. Once again speech was incomprehensible because of the length of time it took each word to be formed and uttered. The falling of a leaf took an eternity. Nothing changed, nothing seemed to move except the wizard's finger. Up it moved, up in weighted effort until it reached the summit; once beyond the drag of gravity the finger moved in descent with increasing momentum until at last, time returned to normal.

A deafening cheer rose from the crowd. Never had anyone experienced such a remarkable feat. The king must surely name the Wizard of the South as his heir.

Seated in his balcony, the king remained silent. The Wizard of the South bowed to the king and left the courtyard. The competition was not yet over. The Wizard of the East was about to perform.

The wizard had no sooner entered the gate when the people began to cry out in amazement. As he walked, the wizard changed. He passed beyond the castle gate walking straight and tall as a young, strong man. After several paces, his gait slowed, and before their eyes, he became a

221

doddering old man. As he continued towards the balcony, he changed again into a beautiful young maiden whose steps became as graceful as those of a ballerina. The ballerina twirled and jumped into the air becoming a young child as her feet touched ground again. A few skips and some hops and the wizard stood before the king as a stately and mature man.

The crowds were overwhelmed. They laughed and applauded with each change the wizard made. If this was just his entrance, imagine his performance. The wizard raised his arms to silence them.

"Bring me some fruit," he ordered. A vendor nearby with a basket full of apples in the crook of his arm stepped forward. The wizard took the basket and placed it on the ground before him. With great ceremony he raised his two arms and waved his hands over the apples. When he finished, there were no longer apples before him, but big, green watermelons. The crowd responded with shouts of delight. The wizard ordered the vendor to sell his new fruit to the crowds. As the people ate the watermelons, they began to shout with laughter. The watermelons, although they looked and felt like watermelons, tasted just like apples. The discovery delighted the people.

The commotion of the crowd caused a dog to start barking with excitement.

"Bring the dog here," the wizard commanded.

A young boy led the reluctant barking dog by the collar to where the wizard was standing. The wizard ceremoniously waved his arms over the frightened animal. In an instant, in place of the dog, there stood a cat with the exact same color and markings as the dog . . . but none the less, a cat. The crowd watched with quiet amazement. The animal, confused by the change and sudden silence, opened its mouth in protest. However, instead of meowing as one would expect, the cat began to bark. At first the people were startled by the unexpected turn of events. Then they became hysterical with laughter at the sight of a cat barking and growling in frenzy.

The boy looked at the wizard pleadingly. The wizard waved his arms over the boy, and in an instant, the boy became a beautiful young maiden. Once again the feat brought everyone to silence including the barking cat. The

maiden who stood there with long, golden hair and red ruby lips was the most beautiful woman the kingdom had ever seen. The boy made maiden looked at his dog made cat and called out to him in a voice quite unmistakably masculine. At that, the frightened cat began to bark; the crowd roared with laughter; and the maiden cried with a man's voice.

The wizard raised his arms over the scene and waved them solemnly. The maiden changed back to the boy, the cat became a barking dog again, and the people were holding apples and not watermelons.

Thunderous applause echoed throughout the castle walls. Never had the world seen such a feat. The Wizard of the East would win the throne.

The king remained silent. The contest was not over yet. The wizard bowed and walked away.

The Wizard of the West now entered the courtyard. As the crowd made way to let him pass, they were struck by the peculiar robe the wizard wore. The robe was covered with mirrors, hundreds of mirrors of different sizes and shapes. Mirrors that hung down in front and cascaded down his back. Mirrors on his sleeves, and shoes and in his hair. Mirrors on his wizard's hat. As he walked the mirrors tinkled against one another as an oriental chime does in the breeze. As he bowed before the King of the Universe, it seemed as if every person in the courtyard was reflected in his mirrors.

He turned to the hushed crowd.

"You have seen great feats performed before you. Now, I shall perform the greatest of them all."

In a solemn voice that all could hear, the wizard said, "Ask of me anything!"

The announcement startled the people. They had seen so many marvelous feats by the other wizards, that they could not suddenly think of their individual needs and desires. As they began to ponder his words, and in the light of the miracles they had witnessed, they began to think of the spectacular, of the astounding things they could ask him to do. A voice cried out from the crowd, "Make us fly."

Quite unlike other wizards, without any hesitation, without any ceremony, he clapped his hands and announced, "YOU CAN FLY."

Cautiously, suspiciously, they listened to what he said but no one moved.

"You can fly," he repeated matter-of-factly.

Finally, someone began to beat his arms in the air, like a bird with wings, testing to see if the wizard spoke the truth. In a moment he was in the air flying. The others looked in amazement. They too began to flap their arms in happy anticipation. Soon everyone was in the air, young and old, man and woman, flying and soaring above the castle courtyard. Only the wizard remained on the ground. All the flying people were reflected in his countless mirrors.

When the excitement of their flying had passed, they returned to the courtyard to see what other marvelous things the Wizard of the West would do for them. Someone cried out, "Let there be music and dancing."

"So be it," said the wizard as he clapped his hands.

All kinds of musical instruments appeared. Curiously the people picked them up and began to play. Flutes, harps, oboes, horns, clarinets, trumpets, pianos; instruments of every kind. Without ever having had a lesson the people began to play. Happy, beautiful music filled the air while people laughed and danced for hours.

"We are hungry now; we want food."

"As you wish," said the wizard.

There before them were large banquet tables covered with every kind of food they had ever heard or dreamed of. Some people ate and drank, while others of them danced, others made music and still others flew in the sky. All of this was reflected in the wizard's mirrors.

Finally, people began asking for possessions for themselves.

"Give me jewels," and at once they had jewels.

"Give me a farm," and there in the courtyard was a farm.

"Give me horses."

"Give me cows."

"Give me pigs."

"Give me money," and at once the courtyard began to fill with the growing demands of the people.

On and on they asked as the courtyard filled to overflowing with houses, carriages, clothes, animals, an endless va-

riety of different things. People could no longer move because there were so many things, so much confusion.

In the midst of the tables filled with goodies, in the midst of the yard filled with whining and bleating animals, a young man stood, calling loudly to make himself heard above the din of the crowd. He tried pushing his way forward to where the wizard was, but the crowds would not let him pass, for they still had needs that they shouted to the wizard. The young man tried harder to move forward but all his attempts were thwarted. When he began to kick over the tables to make headway, he infuriated many in the crowd. After all, these were their gifts that the wizard had given them. He had no right to destroy them. In a fury they turned on him and struck him down. The degree of their own violence surprised them. The incident took but a moment; it was unpleasant, but over. The people turned back to the wizard, continuing to shout their requests.

The King's minister rose and walked to the edge of the balcony. He solemnly tapped three times with his staff then all became quiet. The King rose from his throne and looked down at the courtyard below him. The contest was over.

His voice was calm but powerful as he addressed the people.

"Who, say you, performed the greatest feat?"

"The Wizard of the West," they shouted in reply. How quickly they had forgotten the others. It was unanimous. The Wizard of the West should be the heir and inherit the kingdom.

"Not the Wizard of the West," announced the King to the crowds' bewilderment. They felt that he certainly had performed the greatest feats.

The King of the Universe continued, "The Wizard of the West gave the people everything they wanted, everything they asked for. Truly that was great, but he took the struggle out of life. By so doing, he took the meaning out of life. No, not the Wizard of the West."

There was a quiet pause in the crowd as they gathered their recollections.

"The Wizard of the East," they clamored. Since he was the next to the last, he was the next remembered.

"Not the Wizard of the East," replied the King. "True, his feats were marvelous, but he made things change. He made things appear to be what they were not. He took the truth out of life."

The silence lasted longer. Some voices cried out, "The Wizard of the South."

"Not the Wizard of the South either. He could control time. However, when he made the time pass quickly, the young were happy but the old were sad. When the time moved slowly, the young were sad and the old happy. He stole the meaning of time from life."

From those who could still remember the suggestion came, "The Wizard of the North."

"Not the Wizard of the North. He made the world and everything in it black and white. He took the color out of life. He took the beauty out of life. Not the Wizard of the North."

The people now were silenced into total bewilderment. Who then performed the greatest feat? Surely no one had done anything to equal what the wizards had done. Slowly, the people began to murmur and mumble. It was all a ruse. The King will not give away his kingdom. Their anger grew like the tide, rising higher and higher beating up against the castle walls.

"What greater feat can any man do than those which were performed by our wizards? There can be no greater feat," they shouted.

The King's minister struck his staff on the stone balcony floor. The crowd became silent.

"There was one among you," the King said solemnly, "who rose from the dead."

The news staggered the crowd. It was incredible. Rise from the dead? Impossible! No one had died during the contest. Or hadn't they noticed?

"Did anyone die?" they asked among themselves. The inquiry was repeated until those near the tables heard it. Embarrassed and ashamed, they remembered the struggle with the young man. They apologized for striking him down, claiming that in the confusion, they did not know what they were doing.

"Where is he now?" they asked. To everyone's amaze-

ment he was no longer there. Try as they might they could not find him anywhere. They looked . . . but he was gone.

The King repeated his statement, "There was one among you who rose from the dead. To him belongs my kingdom from the length to the breadth, from the height to the depth. I hereby further decree that anyone who finds him will share the kingdom with him forever."

Having said this, the King left the balcony and returned to the castle. The people in the courtyard hurried over to where the young man had been. Some of his friends had gathered there.

"What does he look like?" they asked. "How will we recognize him?" Slowly, the people left the courtyard. Out through the castle gates they left and returned to their homes telling everyone they met of the greatest feat.

Vera Chapman

(1898–)

Vera Chapman, whose first publication appeared just six years ago, continues to be vigorously productive. The present story is the third that she has written for one of our anthologies. "Crusader Damosel" appeared in *The Fantastic Imagination* II (Avon, 1978), and "The Thread" in *The Phoenix Tree* (1980). But these three stories represent only a fraction of her prodigious output, which first bore fruit in 1976 with the appearance of *The Green Knight*, *The King's Damosel*, and *King Arthur's Daughter*, her fine Arthurian trilogy that has subsequently appeared in a single-volume edition entitled *The Three Damosels*. The year 1977 saw the publication of her children's book, *Judy and Julia*, and 1978 of two further works, *The Wife of Bath*, an extrapolation from Chaucer, and *Blaedud the Birdman*, about a legendary king in Druidic England. Finally, forthcoming from Avon in the United States and Rex Collings in England is an illustrated work, *Miranty and the Alchemist*, which the author tells us is a tale for younger children. The fact that all of these works measure up to a high standard of performance makes the rates of productivity more impressive still. It also prompts us to look forward to her next production.

Three years ago Mrs. Chapman graciously wrote an autobiographical sketch for us. We quote much of her sketch here, rather than recasting her words, because her manner of describing herself gives us a glimpse of her charming personality.

I was born in 1898, in Bournemouth, Hampshire, England. I went to Oxford (Lady Margaret Hall) in 1918, and was one of the very first women to be

granted full membership of Oxford University in 1919, to wear the gown, and to graduate in 1921. I married a clergyman of the Church of England in 1924, and my first married home was in Lourenço Marques, which was then Portuguese East Africa (Mozambique). I returned to England in 1925, and for many years lived in country vicarages. Shortly after the 1940 war, I worked in the Colonial Office as a student welfare officer. I have now been retired for many years. I live in a Council flat (apartment) in Camden Town, London, and I have two children and four grandchildren.

In her self-portrait, Mrs. Chapman also commented on becoming a new author in her late seventies.

There are several reasons why I have not attained publication until so late in life: chiefly that although I always meant to write, I have had so many other things to do—and also that until recently, there has not been much opening for "fantasy" writing—I had to wait till the present interest in imaginative writing gave me a chance.

I have certainly accumulated the proverbial "rejection slips enough to paper a room."

One of the activities, other than writing books, of which Mrs. Chapman is justly proud is her founding of The Tolkien Society in London in 1969 to provide a forum for discussing the works of J. R. R. Tolkien. Tolkien, with whom Mrs. Chapman was personally acquainted, accepted the position of honorary president of the group in 1972. Vera Chapman continues her active association with the Society.

"With a Long Spoon" appears here in print for the first time, but soon it will take its place, along with "Crusader Damosel" and seven other stories, in the episodic novel *The Tales of the Notorious Abbess*, about the adventures of the unique Abbess of Shaston. The abbess, as we have noted elsewhere, is a blend of Chaucer's vibrant Wife of Bath and his demure Prioress, with the balance falling

more on the side of the Wife, as we see in the present story, the tone of which is predominantly humorous but with an underlying seriousness.

The story uses the suave, attractive figure of the devil, though the coarse, repulsive side shows through at one point. Another more biblical element in the story is the temptation scene, which contains some parallels to the temptation of Christ in the desert. The abbess, like Christ, is tempted by visions of wealth, power, and the near-adoration of the multitudes. In addition, she is, appropriately, tempted by undying beauty. Quite unlike Christ, however, the abbess is presumptuous to a fault in exposing herself to temptation. And, while she apparently triumphs, the title of the story hints that she might not have gone unscalded, or, as Chaucer puts it, "yscalded for al his long ladel (spoon)." Nonetheless, she does, in an ironic reversal of the biblical expulsion of Adam and Eve from paradise, require the devil to leave her walled-in garden, a metaphor for Eden, and she puts a guard of sorts at the gate to block any possible return.

WITH A LONG SPOON

by Vera Chapman

The Abbess of Shaston was bored. So she decided to raise the Devil.

It was unusual for her to be bored—she had so many interests, and such ample means of pursuing them. What with her extensive lands, and her deep studies, and her strange and much-rumored disguises, her travels to and from Outremer, and her political manipulations. . . . Nor was that all. . . . And of course, the proper conduct of the religious life in her convent of Shaftesbury in her beloved Wessex—

But at the immediate moment she was not able to do very much, being a guest in the house of her fellow-abbess, the royal lady Jovetta, abbess of the Holy Alabastrona in Bethany. The Abbess Jovetta followed her rule very strictly, and there were so many things one couldn't do. There one had to sit, in the hot weather, just outside the Holy City of Jerusalem, it being the middle time of the Crusades—most of the knights away on campaigns, and the surrounding country not really safe to venture into without the help of disguises for which she hadn't the means handy—oh, and all sorts of reasons why things couldn't be done—

So she decided to have a try at raising the Devil.

She had various books with her—grimoires and the like—and carefully read up her technique beforehand. She took great care to select from among the numerous methods. Being fastidious, she rejected those that required animal sacrifices, or blood, or anything messy like that. Also she rejected anything really dangerous—that is, anything requiring her to abjure her faith, or affront the Powers Above, or commit herself to any allegiance to the Powers Below. She didn't intend to go all the way. Just a little experiment. Eventually she found a method, sure and reli-

able, that seemed suitable; and having procured what was necessary, she made her preparations.

She gave out that she intended to make a three days' retreat for prayer and devotion, in the guest quarters to which the Abbess Jovetta had assigned her—though it was known as her "cell," it was a very comfortable suite of rooms giving on a pleasant enclosed garden, walled all around, opening with a small wicket gate on the wild country beyond, and not overlooked. She had a spacious parlor with a marble floor, and here she cleared all furniture back to the walls, and in the clear space set up her circle, with her brazier, herbs, holy water, dagger and cup, and all the rest of it, within the circle; and proceeded according to the book. It was about sunset on a Saturday when she began her conjurations—a warm, still summer evening. But after a full two hours by the convent bells, nothing had happened.

"Oh well," she said to herself, "it seems it just doesn't work. No matter." And she broke her circle, put all the apparatus carefully away, and stepped out into the garden.

The garden was very beautiful in the moonlight—the high walls sheltered it from all but the lightest breezes; tall palms drooped overhead, their fronds hardly moving, and below them, in the blue-green dimness, white flowers bloomed—lilies and fantastic bell-shaped moonflowers that gave off an intoxicating scent. Beside them was the mystery of a deep-red rose, black in the strange light, yet somehow keeping the secret of its crimson. She moved slowly across the garden, and then—someone knocked at the wicket gate.

"Who is it?" she asked sharply. A man's voice replied.

"May I come in? You called me."

Her heart beat violently.

"Oh, yes, come into the garden," she said, and opened the wicket gate.

The man who entered was tall and richly dressed—he moved with a very royal grace, swinging a long dark cloak behind him. His face was powerful, formidable, yet strangely handsome in a swarthy and shadowed way, with intensely black hair and a little neat black beard. His dress was the usual court dress of a knight, but he wore no

distinguishing blazon. Jewels glinted at his ears and on his long well-shaped fingers. He bowed low over her hand, as the wicket gate clicked shut behind him.

"Madame."

"Monsieur—what may I call you?"

"My name for the present," he said, "is the Sieur Janicot de Partout."

"Then, Monsieur Janicot de Partout, I bid you welcome."

"And what, dear lady, do you ask of me?"

"Why—nothing," she said.

"Nothing?" He frowned a little. "But madame—is it possible you have wasted my time?"

"Oh, sir!" she laughed reproachfully. "That is not a very gallant thing to say to a lady who has invited you into her garden!"

"Oh, your pardon, madame. Believe me, I do appreciate your invitation. But it is usual for such an invitation to have a purpose . . . ?"

She looked at him with a very sweet smile.

"I just wanted to meet you—to see what you were like. Mere female curiosity—but I'd hate to think I'd wasted your time."

"So?" He smiled back at her. "And since I am here, what do you think of me? What am I like, then?"

"A gentleman," she said. He gave a little bow.

"Then will you not invite me into your pleasant little parlor yonder?"

"Oh, pardon me, but I think not," she said, remembering that she had broken up and released the Circle. "You might find things there that were not to your liking." (After all, it would be bad manners to confront him with a crucifix?) "And on the other hand, I must not bring you under the same roof with my girls, now must I? They are far too young. Or rather, not *my* girls, but my sister Jovetta's girls. Or come to that, my sister Jovetta—though possibly she has encountered you already?"

"Possibly," he said, smiling and showing his white teeth. "But only, of course, in a metaphysical sense."

"Come," said she, turning away from the door leading into the convent building, "let us walk in the garden. It is very pleasant there."

"Yes, let us walk in the garden," he assented, and offered her his right arm. She laid her hand lightly upon it, and he placed his left hand, softly and warmly, on hers.

The sensation was wonderful. A deep sensuous warmth spread from his hand, sending a thrill all over her body. "Careful," she said to herself, "I must be careful. But it's delicious—forbidden fruit—oh yes, I can look at it, smell it, perhaps caress its velvet surface, but never taste it—meantime enjoy, enjoy—but careful, careful."

They strolled together in the moonlight, along the smooth tiled paths, between the formal dwarf hedges of lavender, under the palms. For anyone who could have seen them, they made an impressive pair—he in his falling dark cloak, red or black in the bluish light, she in glimmering white falling straight from head to foot.

"Permit me to say, madame," said the dark gentleman, "that I am greatly honored that you should invite me here. I am not often invited consciously and sincerely." He sighed. "Those that invite me in so many words usually do not want me at all. . . . But such an attractive woman as you are, madame—"

He pressed her hand. Oh, delightful, delightful, she thought to herself, thrilling to the roots of her hair—but careful, careful. . . .

"You are very flattering, sir."

"Indeed I do not flatter, madame. I am greatly attracted to you. But attractive as your body is, there is something else I desire far more. Your beautiful soul. You have a most remarkable, strangely gifted soul. In return for it, I would give you anything you cared to name. Anything!"

Now, she thought to herself. Oh yes, here it comes, his fair offer. Just to sell my soul. Oh, I know some people who would consider it a good bargain, for a sufficient consideration—just to offload a vague something they suppose they possess, but have never found a use for. But it isn't like that at all. My soul is myself—and *he* wants it so that he can change it, pervert it—whatever quality a man values and admires, that he must lose—the man who values courage must become a coward, the one who admires compassion must become a brute. The one who loves loyal friendship must become a betrayer of friends. Oh, I know your methods, my noble lord.

"Come now," he was saying, "you know how wide my powers are. What do you wish for?"

Don't ask him for anything, she thought. If you ask for anything he'll give it to you, and the bargain will be made, and you'll be lost. . . . The thrill of his hand's touch began to cool, and she withdrew her hand from his arm.

"Well now," she said lightly, "first let me know what you have to offer."

"Oh!" he laughed. "How like a lady. . . . You want to look round before you buy. Very well then, let's see. First of all, there's Beauty. Most of you ladies want that."

"Thank you, she said, "but I think I have sufficient good looks already. Don't you think so?"

"*Touché!*" His smile broadened. "I've already admitted that you are attractive, and I'm considered a judge. How could I say that you lacked anything?—Oh, but such immortal beauty as I could give you—and to last forever—"

Against the glimmering dark green of the palm in front of her, a mist seemed to form, and on it a picture—a picture of a face of such surpassing beauty as was never seen on earth. The picture grew and extended, till she could see the whole form—lightly clothed, adorned with the most glorious jewels, which yet did not take the eye from the wonderful face and body. And the Abbess knew she was looking at herself, transfigured. One moment the picture hung like a shadow on a screen of raindrops, and then it was gone.

She turned her eyes back to the dark gentleman.

"Well?" he said.

"Oh, very beautiful, very lovely—but no, I thank you. I have never heard of a woman yet who was the happier for more than her due share of beauty. I do not wish to be another Helen of Troy."

"As you wish, but—to keep the looks you have, for many, many years—perhaps forever—how would that be?"

She appeared to consider. "All very fine, but I should be cut off from my generation, like that poor Wandering Jew. Century after century, unable to pass through the Other Door. And a young face I might have, but how old my heart would grow! No thank you, sir. I will not have everlasting beauty and youth in this world. I have to consider the Next."

His fine black eyebrows shot up.

"So? Then we must think of something different. Let us walk again—please take my arm." She took his arm again, and once more felt the strange, exciting current. "Playing with fire," she said to herself. Could she keep sufficient command to drop it before it burned her?

"There are other things," he went on. "For one thing, there is wealth. So many people want that. Would you not like to be as rich as I could make you?"

"Thank you," she said demurely, "but I am already sufficiently rich. You know the saying—if the Abbess of Shaston wedded the Abbot of Glaston, their progeny would own more land than the King of England. I think I have enough and should not covet more."

"You are modest," he said with his charming smile. "Your requirements are simple. But that is not wealth. Look!"

And again the airy picture hung before her like a spider's web.

She saw a palace with wide marble floors, and herself seated upon a throne. People were bringing wonderful things before her. First were dresses—velvets like the downy skin of peaches, silks and lawn so fine that they floated high in the air like vapor—it seemed that she could feel the lovely textures. In a vast oval mirror she saw herself in garments made of all these stuffs in turn, strangely fashioned; and other garments of soft warm wool, even more richly colored than the silks. She felt a gentle touch at her side, and there was a girl holding a casket, where in a nest of silk faintly rose-tinted, there lay coiled ropes and ropes of pearls, all perfect, all white as drops of cream. The girl held the casket while she ran her fingers over them, picked them up in handfuls, caressed them, displayed them against her bosom and her arms. But her hands, she saw, were already ablaze with jewels—not only rounded rubies like drops of blood, and sapphires like the night sky, but other gems she had not seen before—white adamants cut into facets like tiny mirrors, so that each one blazed like the sun. . . . All up her arms were bracelets that shimmered with such gems, and round her neck more jewels glittered. A movement drew her eyes away, and there on a divan were heaped furs, more rich than any

she had seen or heard of—skins of strange and beautiful beasts, supple as fine cloth, the delicate hairs bristling softly—leopards and tigers and northern white bears, and the soft gray hair of squirrels. She ran her hands through them all. Then there were people that brought her great baskets of flowers, of new and exciting kinds, of unknown colors and shapes and fragrances; and fruits, from far away, offering their luscious juices (just in time she remembered not to taste, but that was hard—she had to content herself with smelling their deliciousness). Enchanting little animals were brought for her to play with—furry, small beasts like kittens but much, much more beautiful. Clasping one such in her arms, and trailing her silken robes, she stepped slowly down the wide marble steps to where a boat, a beautiful boat, floated easily on a shining lagoon, all ready for the strong rowers to take her anywhere, anywhere in the wide wonderful world, and safely back again. There was more, there was more waiting for her to enjoy, but . . .

Softly it all broke up, and dissolved into raindrops. The dark man was smiling at her. "Well—?"

She sighed. "Oh, it was beautiful! I did enjoy it so much. Thank you for letting me see it all. But no, thank you. I will not choose it."

"No?" he said, surprised. "But why not? I can show you more if that isn't enough."

"Why not?" said she. "Oh, just because I feel the price is a little too high."

"Well then, we must consider something else. All women want Love, do they not?"

She avoided his eye.

"You know I am vowed to religion."

"Yes, I know—and lady, forgive me, but I know a great deal else besides."

She drew back and flashed out at him in anger.

"Then you will leave all that alone."

He saw his mistake.

"I do crave your pardon. I would not be so ungentlemanly. Forgive me. But let us consider what is past. Dear lady, the tender memories of the past are not subject to reproach. If I were to turn time back, and restore to you certain times, certain encounters, certain moments now

lost . . . If I were to give back to you some whose names are written in your heart—"

Against her will she felt tears spilling down her cheeks. Pictures rose—faces and voices—

"No," she said, tremulous but resolute. "Such things would only be a mockery. I should go mad with living amongst phantoms."

"As you wish, lady. We will not consider Love. But what of Power?"

"Power?" Dry-eyed again she met his look, smiling. "I think I have power. All over Europe and Outremer I pull a string here and a string there, and their jealous crusading princes and barons rise and fall at my bidding—when I need them to, and when I can give myself the trouble. Everyone knows that behind them all it is I, the Abbess of Shaston. What more power do I want?"

"Ah, yes, madame, but look what might be. Power to do all the good in the world that you would like to do."

Again the misty curtain hovered, and the picture became clear. The Abbess saw herself on a high throne, and before her came all the afflicted of the world—the diseased, the lame, the blind, the distressed, the hideous. From her hands flowed out virtue, and she saw them going away healed and happy. Outside her palace they danced for joy on the steps. Away from her, as it were rivers flowing, went messengers at her mandate, to comfort misery all over the world—to pacify warring peoples, to build ruined cities, to bring prosperity to the poor.

Watching it, the Abbess felt her heart expand with the beauty of the perfect peace she might be able to give. She was almost ready to cry, "Yes, yes, my soul is yours for the sake of this, the power to do universal good!" But she watched further. The people who had been healed and helped poured their praises at her feet, and at the feet of the one that stood behind her. She herself bathed in their thanks and flattery. Then she noticed that the stream of miserable ones who came to beseech her grew never less, but still flowed.

"Your lordship," she said, "how is it that the stream of misery never dries up? The sicknesses return, the wars break out again—I do not see one evil being healed at its source and done away with."

"Why," he said with a little laugh, "you would not have us abolish the reason for all our good work? Dear lady, in some five hundred years from now, a poet is to write:

> Pity would be no more
> If there were nobody poor—
> And Mercy could not be
> If all were as happy as we:
> So Misery's increase
> Is Mercy, Pity, Peace.

So you see, lady, we must not altogether cure the evils we heal."

It seemed to her, then, that the power of benevolence that went out from her on the throne where she saw herself had, as it were, a curve. It turned upon itself and went back and back. But all redounded to her glory, and that of the Dark Man behind her. . . .

"No," she said, "no and no and no. In the end it would not be good. My dear sir, I reject your offer, totally and finally."

"So?" He loosed her arm and turned to face her, frowning. "Madame, I have made you a number of very good offers, and none of them seems to please you."

"I know, but I have enjoyed the showing of them so much," she said sweetly.

"Then will your ladyship tell me, once and for all, what you really want?"

"Yes," she said, and lifted limpid eyes to him. "The Kingdom of Heaven."

Suddenly there was a violent hissing sound as of water thrown on hot coals, and a flash of red light, in which she saw the stranger's face transformed into a mask of such horrible malignity and hideousness that she staggered backward and nearly fell.

Almost at once the stranger recovered his poise and his appearance.

"Oh, I am sorry, madame. For a moment I lost my temper. So unlike me. Forgive my unfortunate lapse."

"I think I had better say good-night to you, sir," she said, mastering her tremor, though her voice still shook a little. "It has been a very pleasant evening's entertainment,

but it is over, and I think very soon the cocks will begin to crow. I thank you, and wish you a good journey to—wherever it is you go." She did not hold out her hand to him, but she opened the wicket gate. "Depart in peace, and I do not think you should call on me again." He bowed and went out without a word. She carefully shut the wicket gate, and made over it the sign of the cross, and also the Pentagram.

She sighed a little—it had all been so enjoyable.

Then from a clump of lignum-vitae bushes beside the wicket gate, there stepped out a very tall, thin, golden young man in a long white robe.

"You took a very great risk, Madam-my-child," he said.

"Oh," she said laughing, "I knew you were there all the time."

"You did, did you? And do you think of the trouble you give us?" replied her guardian angel.

"Oh, I do beg your pardon," she said, "but you see, I have absolute faith."

He frowned, shaking his smooth blond head.

"Pride, and presumption, and tempting Providence . . . Absolute faith my—*wings!*" said the guardian angel.